# HALLOWED GROUND

## GOLF'S GREATEST PLACES

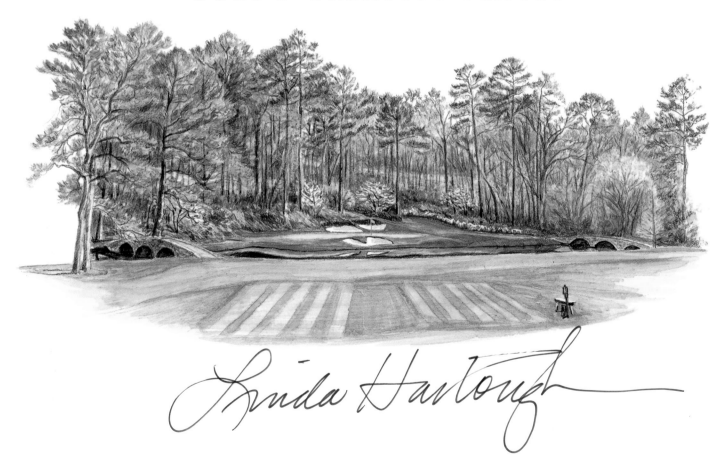

*Linda Hartough*

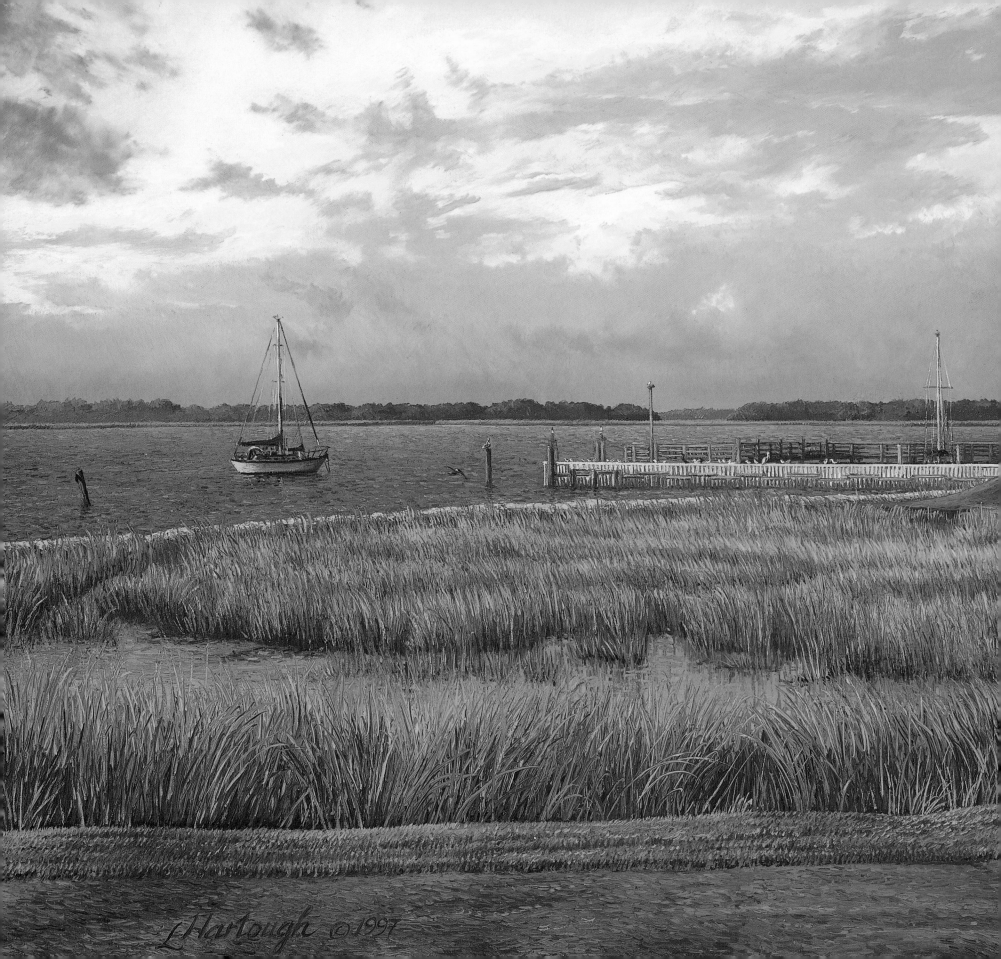

Hartough ©1997

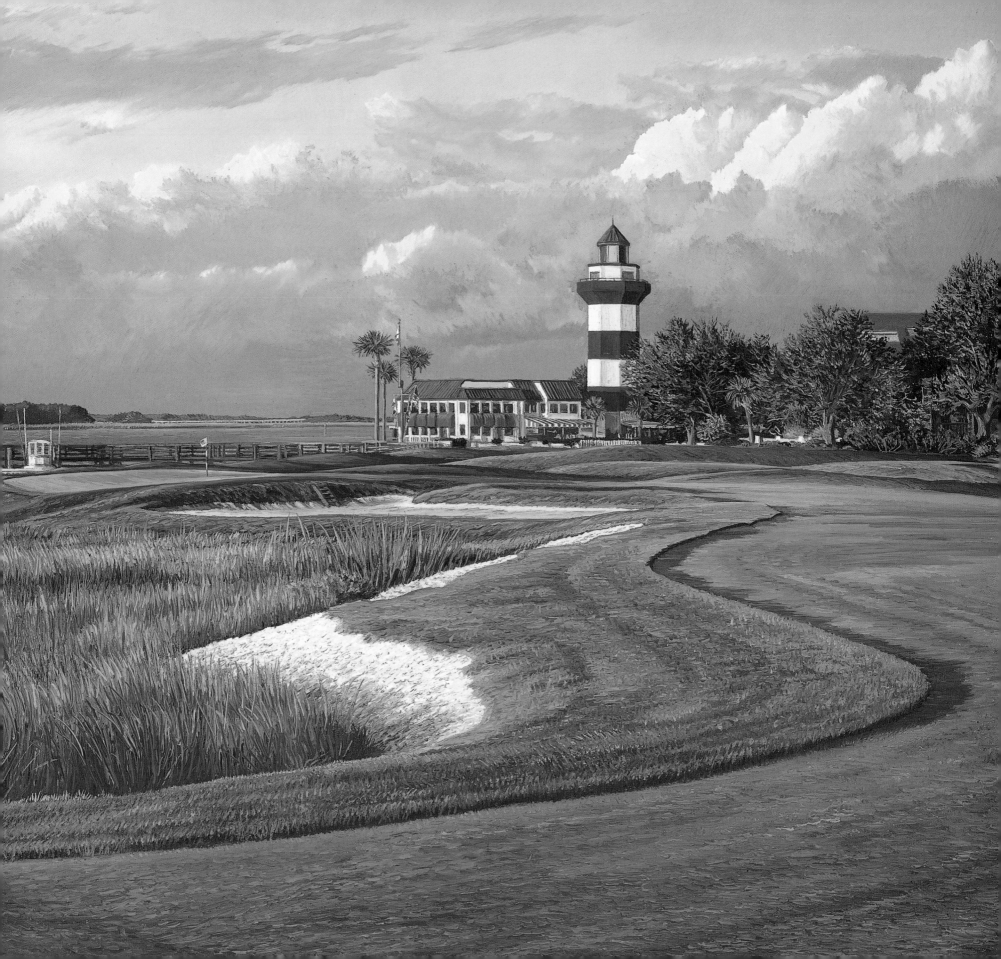

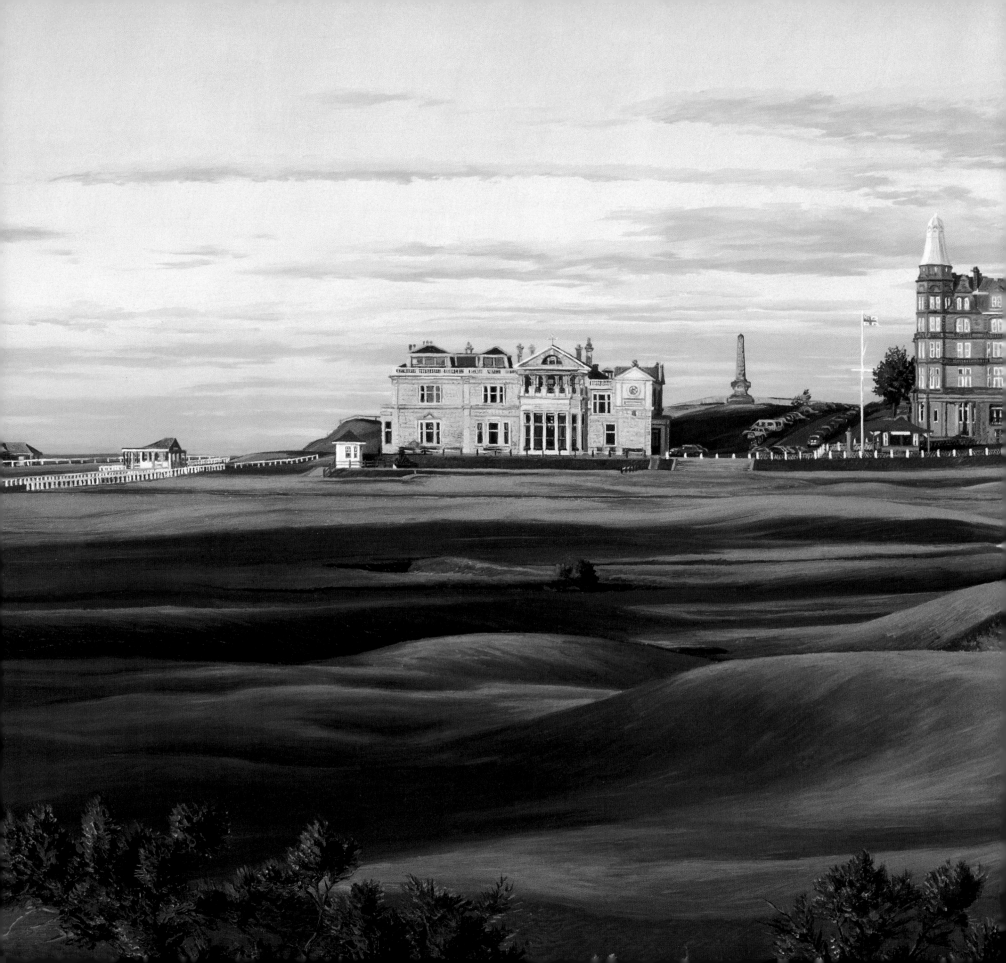

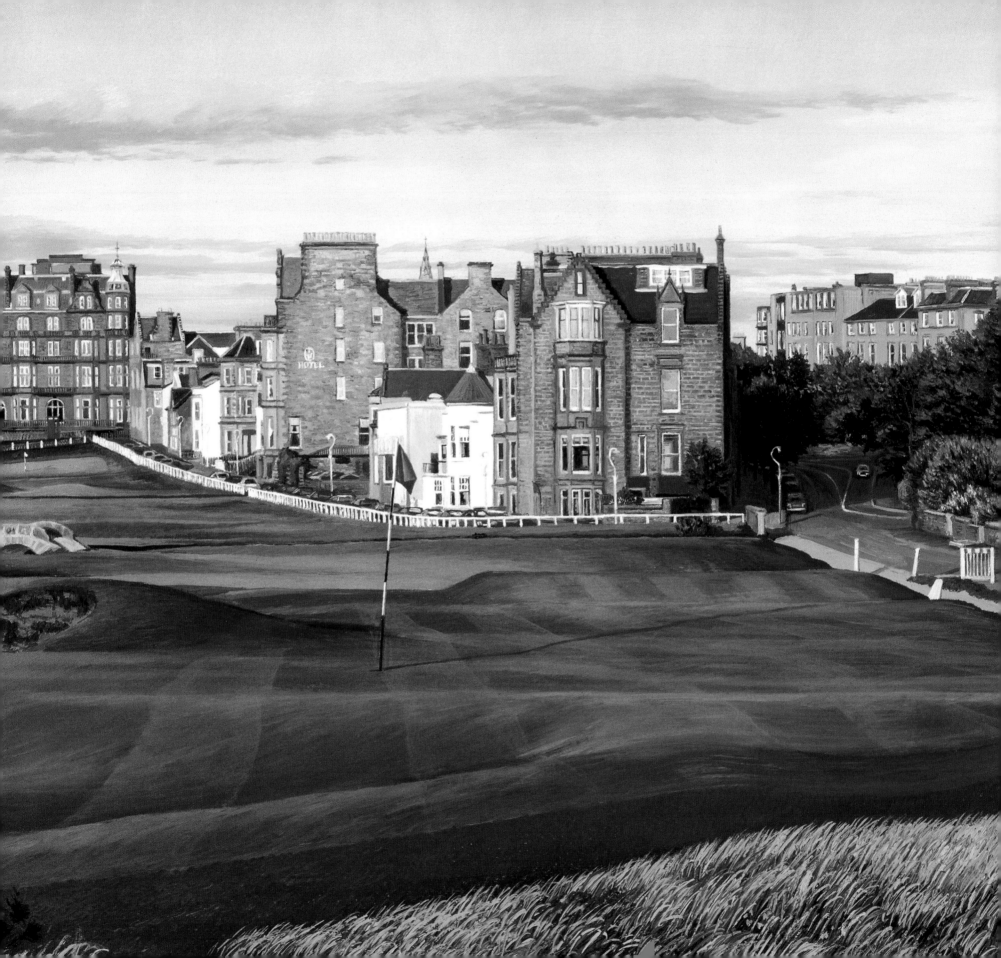

TEXT BY
# JAIME DIAZ

PAINTINGS BY
# LINDA HARTOUGH

FOREWORD BY
# JACK NICKLAUS

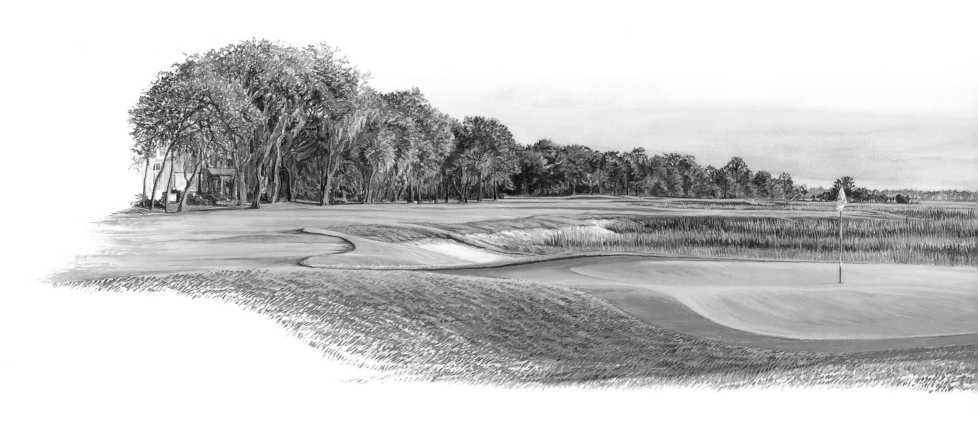

# HALLOWED GROUND
## GOLF'S GREATEST PLACES

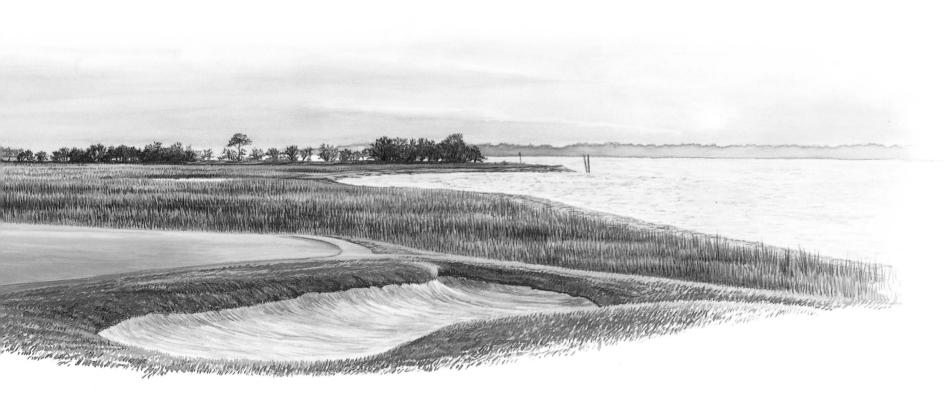

THE GREENWICH WORKSHOP PRESS

*To my father, who introduced me to the game of golf, and to my mother, who always believed in me. —LH*
*To Stephanie, for your patience, your laughter, and your love. —JD*

*Library of Congress Cataloging-in-Publication Data:*

Diaz, Jaime, 1953- . Hallowed ground: golf's greatest places / text by Jaime Diaz; paintings by Linda Hartough;

introduction by Jack Nicklaus. p. cm.

ISBN 0-86713-057-1 (alk. paper)

1. Golf courses—United States—History. 2. Golf courses—Great Britain—History. 3. Augusta National Golf Club—History.

I. Hartough, Linda, 1946- . II. Title. III. Title: Golf's greatest places.

GV981.D53 1999

796.352'06'8—dc21    99-35011 CIP

## ACKNOWLEDGEMENTS

The author and the publisher have made every effort to secure proper copyright information for works cited in this book. In the event of inadvertent error, the publisher will be happy to make corrections in subsequent printings. The Author is grateful to the following for permission to reprint quoted matter: p.94 excerpted with permission of Doubleday, a division of Random House, Inc. for the quote from *Golf Is My Game,* Robert Jones ©1959-1960; p.106 excerpted with permission of Sleeping Bear Press, Inc., (734) 475-4411, www. sleepingbearpress.com, for the quote from *The Spirit of St. Andrews,* p.41-42. Bibliography appears on page 152.

Half title page: Augusta National Golf Club, watercolor remarque of the 12th green
pp.2-3: Harbour Town Golf Links: The 18th Hole
pp.4-5: The Royal & Ancient Golf Club of St. Andrews: The 17th Hole of the Old Course
Title page: Harbour Town Golf Links, watercolor remarque of the 18th green from behind

Major works of Linda Hartough are available as fine art prints published by The Greenwich Workshop, Inc. For more information visit our website www.greenwichworkshop.com, or call us at 1-800-243-4246. Information about the artist is available at www.hartough.com

Book design by Marc Zaref Design, Inc.
Manufactured in Japan by Toppan
Published simultaneously in the United States, Canada, and the United Kingdom
99 00 01 02  9 8 7 6 5 4 3 2 1

# TABLE OF CONTENTS

# FOREWORD

My introduction to the work of Linda Hartough came in late 1991, when our production company was putting together a one-hour special for ABC television called "The Most Dramatic Holes in Major Championship Golf." The producer, Terry Jastrow, had the idea of using individual paintings to introduce each hole to the audience, and we looked at the work of various artists. When we were shown Linda's, we knew it was among the best golf art we had ever seen.

We commissioned Linda to do five individual holes: the 17th hole at Pebble Beach, the 18th hole at Baltusrol, and three holes at Augusta National—the 11th, 15th and 16th. With only six months to complete the project, Linda turned her life upside down to meet our deadline. She did it, of course, and the finished products were extraordinary. Her style added beauty and mystique to some of the most famous holes in the game. When I think of Linda's work, the word "timeless" seems to fit. I suppose it's because even though golf holes are man-made, the best ones are monuments to nature. Linda is a landscape artist, and she has a gift for capturing the natural world in a wonderful and captivating way. But while I am fascinated by nature and own several pieces of wildlife art, my strongest connection to Linda's work is as a lifelong golfer who loves the aesthetic qualities of great golf holes.

Linda may not play golf, but I know she recognizes these same qualities. Her conception of a golf hole is very true to the architect's vision, both in her depiction of overall harmony and her precise attention to detail. Whether it's the colors she chooses, the hues and texture of the grasses, the contours of the green, or the precise proportions of everything from the tee markers to the flagstick, Linda gets a golf hole right.

For all its realism, her work goes beyond being photographic. Her paintings always convey a strong sense of place, so that you feel, for example, the charm of St. Andrews, or the majesty of Pebble Beach. A Linda Hartough painting makes me want to play golf.

I'm very happy for Linda's well-deserved success. Barbara and I are the proud owners of seven of her originals. Four of them hang in our home,

one in my office at Golden Bear, and one each in the homes of our sons, Jack II and Steve. All of the paintings elicit great memories, and even when my mind is on the farthest thing from golf, they always bring me back to the sport I love. I know this book will do the same for you.

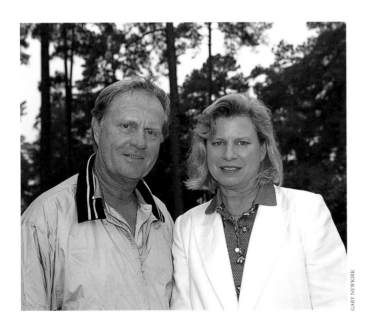

# ABOUT THE ARTIST

One of the rising stars in the golf world holds an oil paintbrush in one hand and a canvas in the other and hasn't played golf since childhood. Linda Hartough's name is known by golfers, courses, and architects, and her golf landscape limited edition prints and canvas reproductions are as in demand as the original paintings that spawned them.

Born in New Jersey and raised in Delaware and Kentucky, Hartough was a confirmed artist at age six. She has always made her living as an artist, first in Chicago, where she received her Fine Arts degree from the Art Institute of Chicago, and later sold her landscape paintings. In 1980, Linda moved to South Carolina near Hilton Head where she continued to paint portraits and landscapes, and where she began painting horses, particularly the miniature horses she raises. Her first golf commission came in 1984 as an invitation to paint the 13th hole at Augusta National. Other commissions followed, and she now focuses her career exclusively on golf landscapes. When an agent presented her work to the Royal & Ancient Golf Club of St. Andrews, she was invited to paint a hole from each of the eight courses of the British Open rotation, and shortly thereafter the United States Golf Association followed with an ongoing commission to paint a signature hole for each US Open championship course starting with the 13th hole at Medinah for 1990. Hartough opened her own gallery in Hilton Head in 1997, where she sells canvas and lithographic reproductions of her paintings, and often has several original paintings on display.

Linda researches each course painting on-site. Only after she has walked the course at various times of day does she begin to narrow down

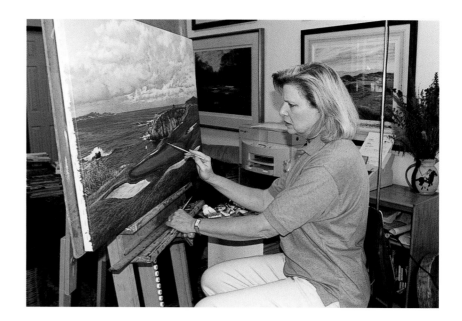

*Linda Hartough*

which hole to paint, and which hole best conveys the unique characteristics of the course. Regardless of the hole, Hartough sees it from two perspectives: what the golfer likes about it, and as a fine art landscape. Once the hole is identified, she takes literally hundreds of photographs from various viewpoints and lighting ranging from dawn to dusk. She includes all the details such as wildflowers and birds or animals that reside there. And she looks for the details that make people remember a hole. No single photograph "becomes" the painting.

Back in the studio, she takes the best of everything and puts them together in her mind. "I have to figure out what it is that's important, and make sure it's included whether it's in the photographs or not." Linda's paintings surpass photography, which is often stiff. She uses her visual memory to serve as an emotional guide to the hole—*this* is the way the golfer will remember the hole—even if a particular detail might not be visible from the angle of the final painting. Once the artist's vision of the hole is set, the process of executing the painting is painstaking and technically difficult. Working in oil in one area at a time, she completes a small section in each sitting. All of the variations of green in her paintings come from a base of viridian green which she gets from a single manufacturer.

The final painting may be at once more, and less, than the actual photographic view. There are no leaderboards, no asphalt cart paths, no peo-

ple or homes, and perhaps a tree has moved a few feet one way or the other in order to re-create the sense of the golfer's experience. All of the distracting elements are left out, which gives the final paintings a timeless feeling. The ultimate satisfaction comes at the presentation of the finished piece to the club or owner who commissioned the work.

"It's a challenge to make a great painting and still depict a golfer's favorite scene, but my goal is to make any work of art I create transcend the scene depicted. When you look at a golf hole, you have to see what players like about it—how a golfer plays it. Then you have to see it as a landscape—as a work of fine art." While she grew up with an avid golfer in her father, Linda doesn't play herself, but she is a big fan of the game and the golf world, and the affection is now mutual.

MUIRFIELD VILLAGE, THE 18TH HOLE

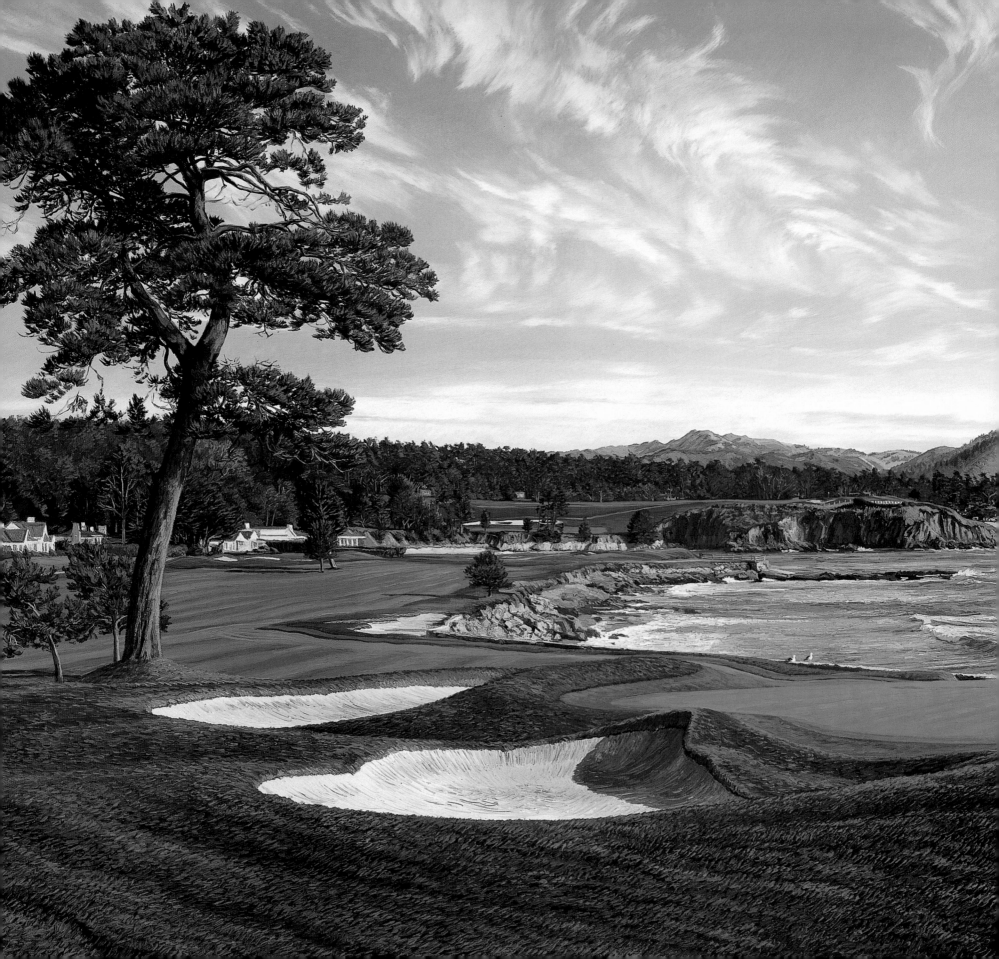

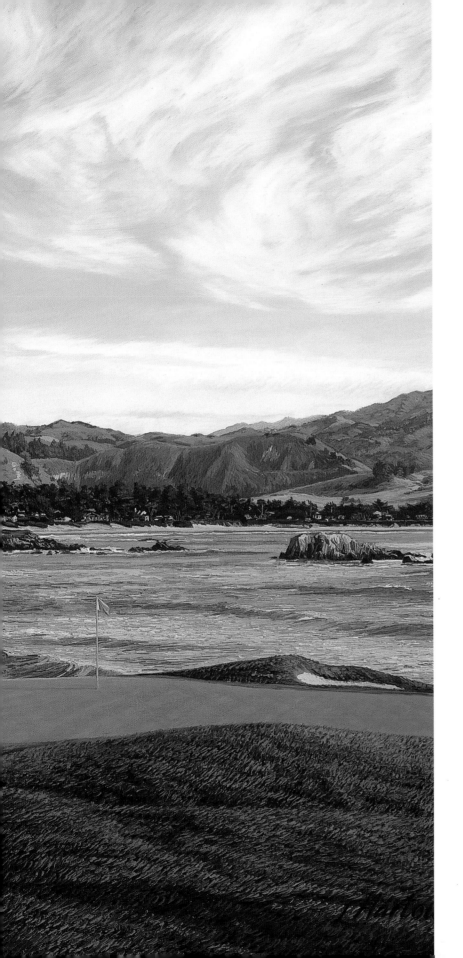

# UNITED STATES CHAMPIONSHIP COURSES

BALTUSROL GOLF CLUB

CONGRESSIONAL COUNTRY CLUB

THE COUNTRY CLUB

HAZELTINE NATIONAL GOLF CLUB

LAUREL VALLEY GOLF CLUB

MEDINAH COUNTRY CLUB

MUIRFIELD VILLAGE GOLF CLUB

OAKLAND HILLS COUNTRY CLUB

OAKMONT COUNTRY CLUB

THE OLYMPIC CLUB

PEBBLE BEACH GOLF LINKS

PINE VALLEY GOLF CLUB

PINEHURST RESORT & COUNTRY CLUB

SHINNECOCK HILLS GOLF CLUB

WINGED FOOT GOLF CLUB

PEBBLE BEACH GOLF LINKS
THE 18TH HOLE, 540 YARDS, PAR 5

*The 18th, perilous from tee to green, doglegs along
the edge of the sea where the wind is often filled with the
sound of barking sea otters.*

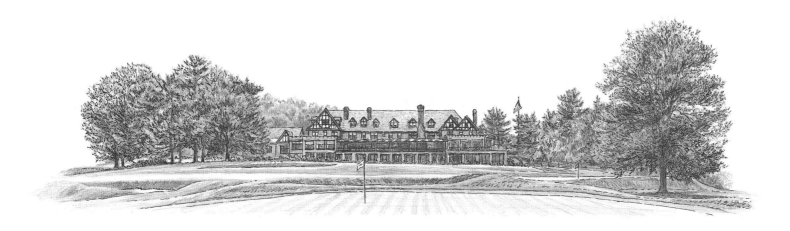

# BALTUSROL

As a sprawling landscape of woods, hills and streams harmoniously accented by verdant ribbons of fairway and classic architecture, the Baltusrol Golf Club is a stunning place. When it hosts a championship, however, aesthetics take a back seat to efficiency. As a setting for big time golf, Baltusrol essentially becomes a big, venerable and very well run machine—a place that, above all, works.

Which is precisely what Baltusrol does for the United States Golf Association. With its Far Hills, NJ headquarters just a few miles away, the association has chosen Baltusrol as the site of fifteen of its national men's and women's championships, including, since 1903, seven US Opens. Over the last half-century, Baltusrol has hosted the Open every 13 years, which makes it likely the championship will return in 2006. As a golf course, and as a complex, Baltusrol has everything a major championship site needs. Just the kind of old-line East Coast club that the USGA favors, it has the preferred ambiance. Its 470 acres hold two courses, with plenty of room for parking and corporate tents. Only 35 miles from Manhattan, it is ideally situated in a heavily populated, affluent area. And most importantly, its two courses are timeless classics from the "golden age" of golf architecture that have produced great events, great champions and great history.

Baltusrol's Upper and Lower Courses were both designed in 1922 by the legendary A.W. Tillinghast, who summed up his overall philosophy simply: "Produce something which will provide a true test of the game," he

wrote, "and then consider every conceivable way to make it as beautiful as possible." Tillinghast's holes at Baltusrol, like the club's name, flow gracefully over gentle terrain, with the shot-making challenge to the golfer presented primarily by the masterful placement and shaping of bunkers. "The layout had a natural, uncontrived, unprettied-up quality," Jack Nicklaus wrote of Baltusrol in his autobiography, recounting his first impression of the Lower Course as he prepared for the 1967 US Open. "I felt this was the best balanced US Open course I had yet encountered: consistently demanding from the tee, invariably challenging on approach shots, never a cinch if you missed a green, but, taken in the round, a fair and enjoyable test of golf."

Not a torture chamber, Baltusrol, among America's classic courses, has consistently given up scoring records in the US Open. In 1936, Tony Manero's closing 67 on the Upper Course gave him a total of six under par 282, which broke the 72-hole scoring record for the Open by four strokes. In 1967, Nicklaus out-dueled Arnold Palmer with a final round 65 that gave him a total of 275 to break the record by one. In 1980, again on the Lower Course, Tom Weiskopf and Nicklaus shot opening 63s to tie the Open's 18-hole scoring record, and then Nicklaus broke his own 72-hole record again with a total of 272. In winning on the Lower Course in 1993, Lee Janzen tied that record, which still stands.

The relatively low scoring has generally excluded Baltusrol from the very short list of America's greatest courses, but it remains an insider favorite

for the same reasons that Nicklaus was drawn to it. Baltusrol has never been "tricked up" with excessive rough or silly pin positions. And while it will yield to excellent play, it gave up only seven rounds in the 60s during the entire 1954 championship, and in both 1967 and 1980, the field averaged a score of more than four over par 74. As Tillinghast said, "Any great course will now and then take a good beating from good men, and there is nothing that can be done to fairly stop it, nor any reason why there should."

Visually, Baltusrol makes a profound first impression with its immense clubhouse. A seventeenth century style Tudor in red brick with brown and white trim, it is one of the grandest in the game. The front of the four-story edifice has three different facades, while the back has a huge veranda that tumbles down to the golf course. Built after the original clubhouse was destroyed by fire in 1909, it was designed by architect Chester H. Kirk as a vast country manor set above the golf course at the base of Baltusrol Mountain. Legend has it that one adulterous member returned to his New York home the morning after the fire and told his wife he had spent the night at Baltusrol. She then handed him the newspaper reporting the destruction of the clubhouse.

Baltusrol feels like old money and, in fact, it was founded in 1895 on just that. Louis Keller, an upper-crust gentleman farmer, owned 500 acres in the bucolic Watchung Mountain range. As the founder of the New York Social Register, (a listing of the 400 most prominent families in the New York area), Keller was attuned to the habits of the rich and famous, and as golf became popular with the smart set, he decided to convert his pastoral setting into a golf club. Keller called his friends on the register, charging them each $10, and the club was born. The name Baltusrol derived from the original owner of the property, one Baltus Roll, who was murdered in 1831 during a robbery in his hilltop farmhouse. A prominent socialite, Miss Louise McAllister, put the deceased farmer's first and last name together and dropped the final "l," to create one of the more lyrical titles in American golf.

Baltusrol was quickly accepted into the golf club elite. The first time it hosted the Open in 1903, Willie Anderson began his unprecedented streak of three straight Opens. (He would go on to win four, a feat equaled by only Bobby Jones, Ben Hogan and Nicklaus.) The Open returned in 1915 when amateur Jerry Travers won. After World War I, the club commissioned Tillinghast to build the courses that would act as the stages for Baltusrol's greatest dramas.

In 1954, Baltusrol became the first Open site where gallery ropes were used, and the first national championship in which the final four holes were televised. Ed Furgol, needing a par to win on the 72nd hole of the Lower Course, hooked his drive on the 540-yard, par-5 18th into deep woods. Faced with a difficult chip out just to get back to the fairway, Furgol asked officials if he could play along the adjoining 18th fairway of the Upper Course, and because no out of bounds had been marked, was told he could without penalty. Furgol hit a full 8-iron out of the trees onto the Upper Course, then a 7-iron short of the green, and chipped to five feet. He made the putt to win by one over then amateur Gene Littler.

In 1967, Baltusrol was the site of one of Nicklaus' greatest victories. He was in a putting slump when he arrived, but during practice rounds, a friend gave him a center shafted Bulls-Eye putter that had been painted white to lessen sun glare. Nicklaus named it White Fang, and further improved his putting when another friend suggested he shorten his stroke. Nicklaus shot

BALTUSROL GOLF CLUB
THE 4TH HOLE, LOWER COURSE
194 YARDS, PAR 3

*Ranked among America's best, the 4th is where
Robert Trent Jones' debonair ace served as the last word
on the fairness of this demanding hole.*

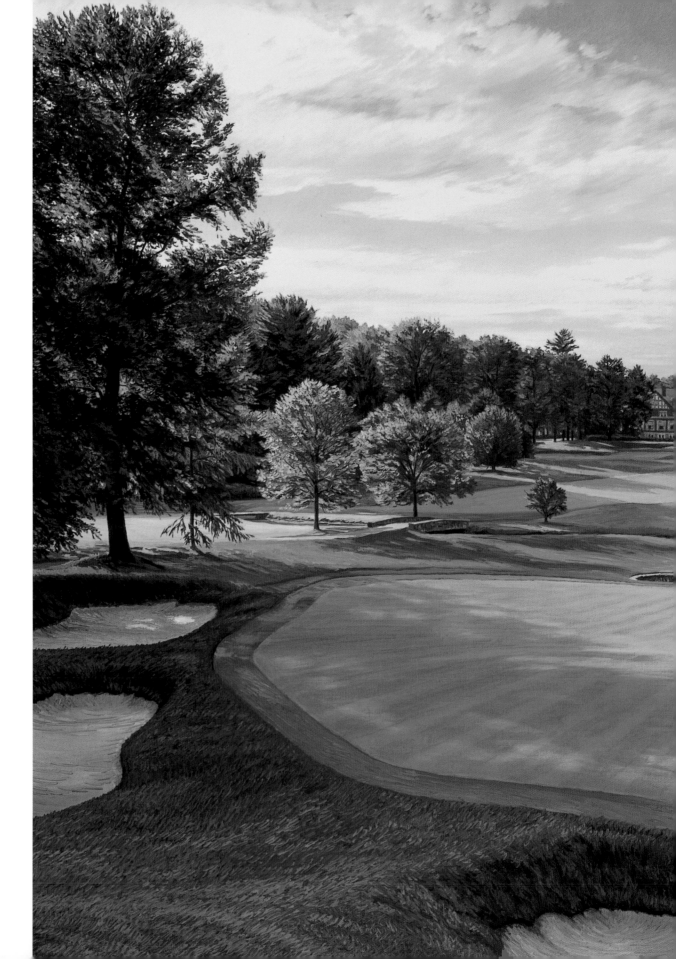

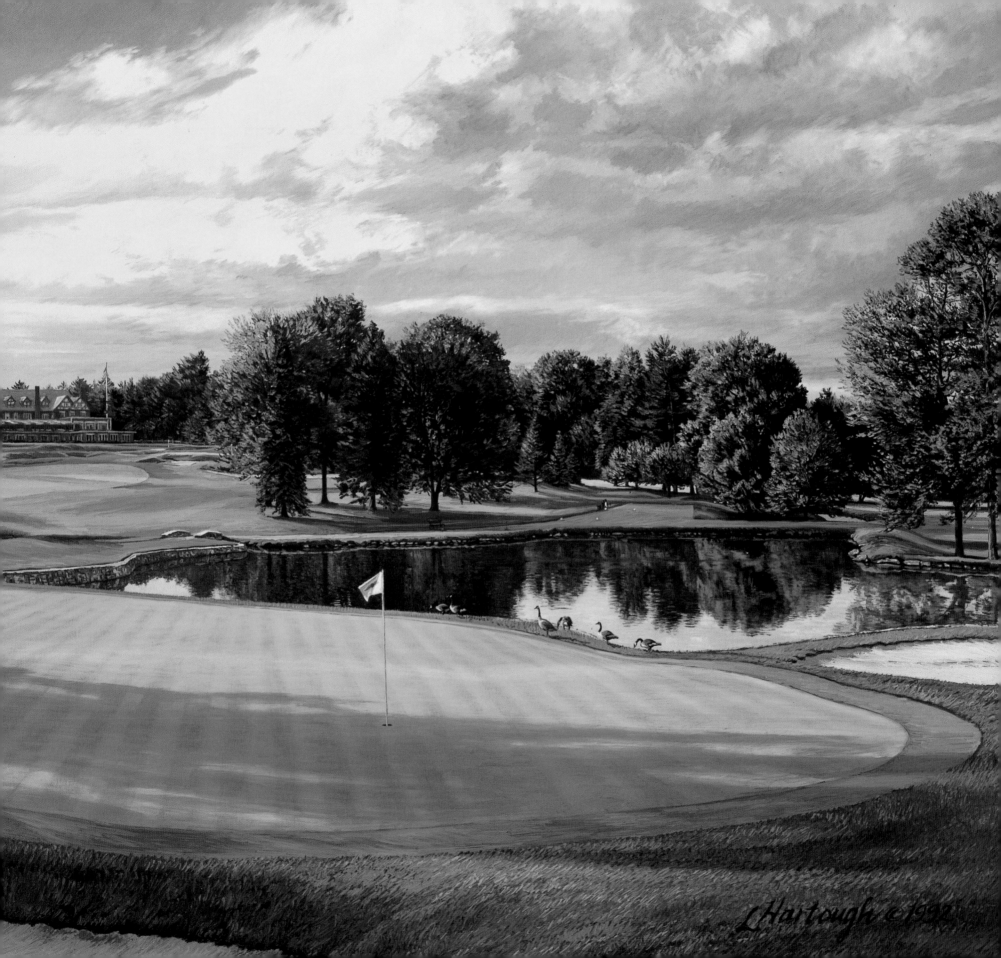

LHartough © 1992

a 62 in his final practice round. The putting magic left during the first round, but when Nicklaus holed a twelve-foot par putt on the fourth hole of the second round, "everything changed." In the final round, Nicklaus was paired with Palmer, the overwhelming gallery favorite. Before hand-held signs that read, "Hit it Here, Jack," the determined Nicklaus shot a closing 65 capped by a final twenty-footer for birdie that broke Hogan's nineteen-year-old 72-hole scoring record.

In 1980, Tom Watson was supplanting Nicklaus, now forty, at the top of the game. Motivated to regain his place, Nicklaus went back to work with his teacher since childhood, Jack Grout. When Nicklaus arrived at Baltusrol, he had gained confidence from his sessions with Grout and was further buoyed by the great memories from his 1967 performance. He opened with a 63, missing a three-footer for birdie on the 18th. That round started an unprecedented surge of gallery support for Nicklaus. Now the

signs read, "Jack is Back." The sentiments heartened Nicklaus, and gave him momentum and a sense of destiny. In the final round, he met every challenge from the pure-putting Isao Aoki of Japan, and finished with a 68 to break the scoring record again and win his fourth and final Open.

Not all of Baltusrol's magic takes place in championship competition. When architect Robert Trent Jones was hired to renovate the course for the 1954 Open, his most drastic change came on the fourth, a par 3 of 183 yards that holds the reflection of the clubhouse in the lake that fronts the green. When the membership complained that the newly installed back tee made the hole too difficult, Jones went out to play the fourth with three recalcitrants. After the others hit tee shots, Jones knocked his 4-iron shot into the hole for an ace. "As you can see, gentlemen," he said airily, "this hole is eminently fair." It was just another case of how well Baltusrol works.

# CONGRESSIONAL

The Congressional Country Club will always be known for its finish, which presents a panorama as lovely and distinctive as any in the game. From the 17th tee, the eye follows a long swath of fairway downhill to a pair of distant greens rising out of the blueness of a graceful pond. The first is the wide putting surface of the 17th green, set on a peninsula that makes for one of

the most demanding approaches in golf. Behind it and on a higher plateau, is the green to the par-3 18th hole, backed by a majestic white stucco and red tiled Mediterranean-style clubhouse. Nowhere else in championship golf does the beauty and challenge of the final two holes so explicitly lie before the golfer.

It was the sight that Ken Venturi saw on the 72nd hole of the 1964 Open as he trudged down the fairway, limp with exhaustion from heat but radiant with victory, to a sustained ovation. It was what Dave Stockton saw at the climax of the 1976 PGA Championship, as he steeled himself to squeeze out one more par even as his tee-to-green game was running on fumes. And it was what Ernie Els saw moments before he flushed the 5-iron approach that won him the 1997 US Open.

But as harmonious as the end result looks, Congressional is the composite of many changes. Located in Bethesda, Maryland just outside Washington, DC, it has been massaged and made over by four of the game's preeminent designers—Donald Ross, Robert Trent Jones, Tom Fazio and Rees Jones—all of whom revised the original work of Devereux Emmet. Although it has remained a rung below the greatest Open sites, Congressional is now considered as solid a test as the championship has. At 7,213 yards, it's the longest course the Open is played on, and according to Jack Nicklaus, plays even longer because "you hit so many shots uphill."

The club opened in 1924 as a kind of large-scale Camp David, where relaxation for the political elite could be coupled with deal-making. Founded by two US representatives from Indiana, Oscar Bland and O.R. Luhring, it was to be, according to its charter, the "Playground of Official-dom." An early mission statement read: "Destiny has marked this incomparable place for high purpose. The official or the Member of Congress, brain cleared by the bracing air, and exhilarated by the play in which he is engaged, finds a new and more adequate conception of his problems of government; and from his contact with minds which know the nation's needs, develops more surely the solutions essential for America's well being." The club's bylaws mandated that a majority of the board of governors be members of Congress, and early members included John D. Rockefeller, Hiram Walker, William Randolph Hearst and Charlie Chaplin. Tommy Armour was the first head pro, and gained the club fame by winning the 1927 US Open.

Congressional was opulent. It's clubhouse remains one of the biggest in all of golf. The original design included a Presidential Suite, which was to be reserved at all times for visits by the chief executive, a rare indoor swim-ming pool, a four-lane bowling alley, and a two-story gym. All this overhead was staggering, and without income from liquor during Prohibition, the club quickly ran into financial trouble. By 1940, Congressional was in near disrepair, but it was saved by World War II.

In 1943 the precursor to the CIA, the Office of Strategic Services (OSS), took over the club grounds for thirty months. A mockup of a C-47 fuselage was placed on the practice green for paratrooper drills, the 15th tee was the site of machine gun training, and test missiles were fired from the 16th fairway. By the end of the war, the club was fairly well trashed, but the well-connected membership was able to bargain for an extremely generous settlement from the government. With the influx of money, the club was renovated, and the membership again flourished, although it had decidedly fewer politicians.

Mirroring the changes in the membership have been the alterations to the course. It began as a long layout that opened each nine with a par 6. In 1930, Ross redid the original course, getting rid of the par 6s, and adding new tees, bunkers and greens. In 1957, Robert Trent Jones built a new nine and further revised the layout, then returned with more work before the 1964 Open. In late 1989, Jones' son, Rees, did yet another extensive overhaul, rebuilding every green, adding mounds and bunkers, and designing a new nine. Along with the championship Blue Course, the less severe Red 18 plays at 6,588 yards.

Congressional held the 1949 US Junior Amateur and the 1959 US Women's Amateur, after which it was awarded the 1964 US Open, destined to be one of the most dramatic ever. It's central character was Venturi, a thirty-two-year-old pro who a few short years before had been considered one of the best players in the game. But after narrowly losing three Masters, the last in 1960 to a birdie-birdie finish by Arnold Palmer, Venturi had gone into a three-year skid, his confidence in shambles and his once flowing swing now a flat, truncated version of the original. He gave every indication of being a professional at the end, and, in fact, untimely problems with circulation in his hands and wrists would force him to quit competition within five years.

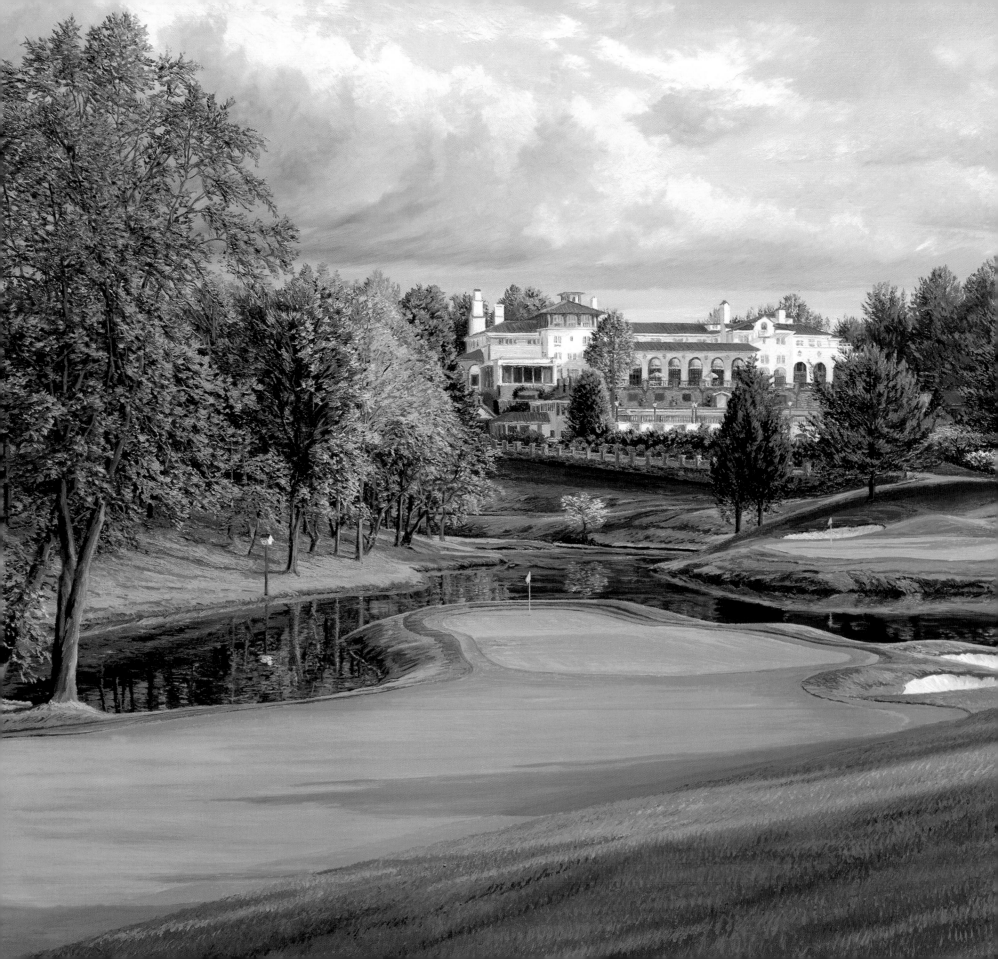

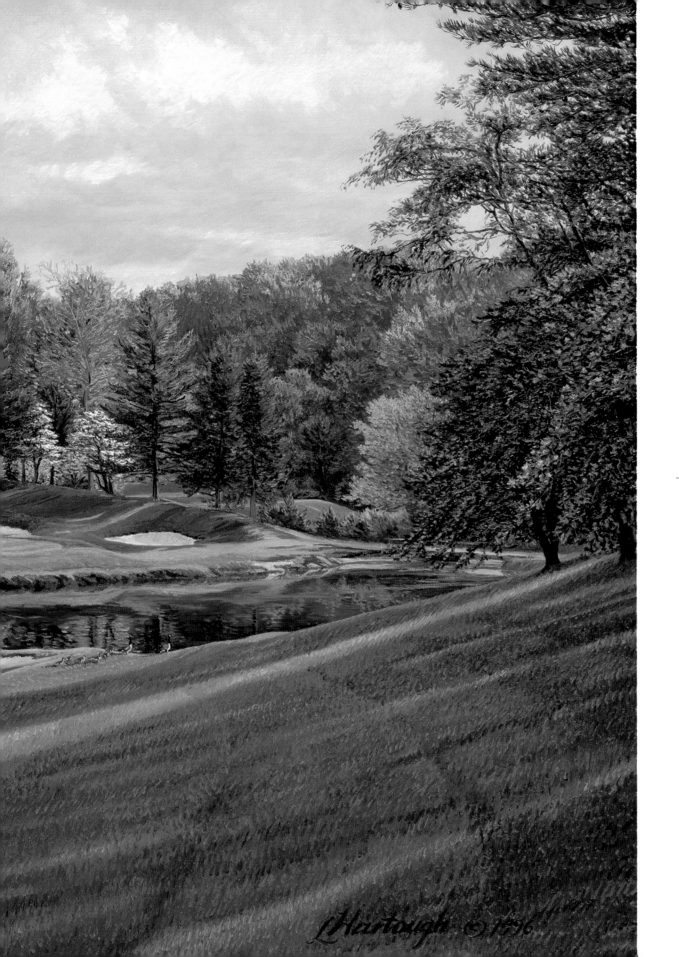

CONGRESSIONAL COUNTRY CLUB
THE 17TH HOLE, BLUE COURSE
480 YARDS, PAR 4

*The finest hole at Congressional, it served as the
stage for Ken Venturi's dramatic victory walk
in the 1964 US Open, and Ernie Els' pivotal 5-iron
approach at the 1997 Championship.*

23

But Venturi had been working to rediscover his game by embarking on a mission of self-discovery with the help of Father Francis Murray, a parish priest who lived near the golfer's hometown of San Francisco. A few weeks before the Open, Venturi began to play better, and Father Murray wrote him a letter that began, "Dear Ken, For you to become the 1964 US Open champion would be one of the greatest things that can possibly happen to our country this year…you would prove, I believe, to millions everywhere that they, too, can be victorious over doubt, misfortune and despair… You are truly the new Ken Venturi, born out of suffering and turmoil, but now wise and mature and battle-toughened."

The letter gave Venturi perspective to deal with the rigors of Congressional. Still, his opening of rounds 72-70, which put him in fourth place heading into Saturday's final 36 holes, got little attention, for no one expected Venturi to be a serious factor at the end. That all changed when he went out at the beginning of the third round in 30, shooting him to the top of the leaderboard. But the heat and humidity in the low valley of the Potomac River was like a steam bath, and Venturi began to list on the back nine, missing short putts on the final holes to complete a 66. Severely dehydrated, he was already suffering from the beginnings of heat stroke when he stumbled into the locker room and lay down. Advised to withdraw, Venturi refused, and was revived by fluids and a fifty minute rest in one of the bedrooms in the clubhouse. He went to the first tee two strokes behind Tommy Jacobs, with Congressional member Dr. John Everett nearby carrying ice cubes and salt tablets. Venturi said he played the final 18 with his only thought to keep putting one foot in front of the other, and at times appeared near collapse. Touched with magic, he somehow ground out an even par 70 and a winning score of 278, the second lowest in Open history at that time.

"I shall never forget the expression on his face as he came down the hill," wrote Herbert Warren Wind of Venturi's march down the final hole. "It was taut with fatigue and strain, and yet curiously radiant with pride and happiness. It reminded me of another unforgettable, if entirely different, face—the famous close-up of Charlie Chaplin at the end of *City Lights*, all anguish beneath the attempted smile."

At the 1976 PGA Championship, Dave Stockton came to the same hole with a one stroke lead. Because he had been driving so poorly, he hit a 3-wood off the tee, but still left himself 235 yards to the green. One of the great short game artists ever, Stockton chose to lay up short of the green, pitched on to twelve feet, and under tremendous pressure, ran in the putt to win his second PGA. "One of my attributes is when I get ahead, I seldom fold," said Stockton, in a career summary. "The trouble is, I don't get in the lead often enough."

After Rees Jones' alterations, Congressional decided to make the 18th hole for the 1997 US Open the downhill par-3 18th on the Blue Course as played by the members. The quirky finish was judged a success, but the most crucial shots were again hit on the former closing hole, now the 17th. Locked in a battle with Tom Lehman and Colin Montgomerie, Els won the championship when he hit a classic 5-iron from 212 yards to within ten feet that ensured a par while Montgomerie and Lehman made bogeys. When his 6-iron tee shot on the 18th stayed dry and found the green, Els had his second US Open before the age of 30. The Open's return to Congressional generated tremendous excitement in the nation's capitol, and Bill Clinton became the first sitting president since Warren Harding in 1921 to attend the championship. Considering that Congressional is now firmly in the Open rotation, it won't be the last time the club designed as a refuge for politicians will host the nation's highest ranking one.

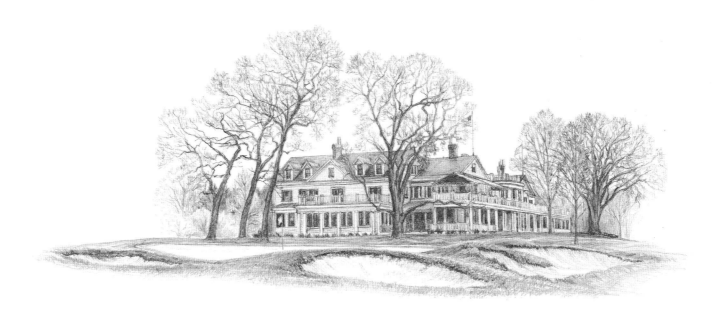

# THE COUNTRY CLUB

History will forever remember The Country Club in Brookline, Massachusetts as the first real launching pad for American golf. Francis Ouimet's defeat of English luminaries Harry Vardon and Ted Ray in the 1913 US Open had such monumental impact, that even now it makes the definite article in the club's title seem more sage than snooty.

Ouimet, then a twenty-year-old amateur who lived across the street from the golf course, remains the game's ultimate Cinderella story, a David who defeated two Goliaths. In the most immediate sense, his victory meant once and for all that American golfers could actually beat the best of the British in the biggest championships. But more importantly, it made a rich man's sport more appealing to the masses by proving a person of modest means could become champion. The facts are irrefutable. In 1913, there were 350,000 golfers in the United States, and the best golf was being played in Great Britain. Ten years later, there were more than two million US golfers, and the best players in the world came from this side of the Atlantic. Ouimet was America's first golf hero.

The Country Club provided an ideal setting for the making of seminal history. Founded in 1882 as a Back Bay retreat for Boston Brahmins, it was the first club in America established for sport and social communion.

(Brookline itself was settled in 1634, only fourteen years after the Mayflower.) Given Ouimet's later exploits and their effect, The Country Club can justifiably be called the Plymouth Rock of golf. But back in 1882, golf was very much an afterthought at The Country Club. Its first members were much more interested in horseback riding, shooting, tennis, lawn bowling, figure skating, and curling. The founder, J.M. Forbes, a merchant who spent his youth in China, was familiar with a social and recreational establishment in Shanghai called The Country Club and he appropriated the name which became, over time, a common term in American English.

Forbes picked Brookline's Clyde Park location largely because of the existence of a half mile oval for horse racing. The old track, which was in operation until 1935, used to be part of the golf course on the 1st and 18th holes, and equestrians were such a dominant part of the club that early golfers complained of hoof prints on the greens.

The Clyde Street Hotel, a colonial-style mansion, was also an attractive part of the property, and the club quickly converted it into the main clubhouse. The edifice, which remains a trademark of the club, is painted a distinctive pale yellow with a green and white canopy, and is perched grandly on the hill behind the home green, surrounded by huge elm trees.

Golf was introduced to The Country Club in the autumn of 1892 when a young woman named Florence Boit, who had played the game in Pau, France, put on a demonstration at a Brookline garden party attended by Laurence Curtis, a member of the club. Curtis was captivated, and persuaded the membership to lay out a course. Two years later, Scottish professional Willie Campbell had built nine holes, acquired twenty head of sheep to keep the grass cut, and The Country Club became, along with Shinnecock Hills, Newport, St. Andrews, and Chicago, one of the five founding clubs of the USGA.

A strong sense of being in an original place in the game's history pervades The Country Club. Like an old Yankee, it is spartan, craggy and tough. It possesses an abundance of that most desirable, rare but unmistakable quality in a golf course—character. Although it now has twenty-seven holes, and has undergone many alterations, The Country Club conveys the feeling of elemental golf. The three nines covering rugged New England terrain are composed of a rich mixture of native grasses that surround jutting promontories of rock. Between thick but not obstrusive groves of elms, its fairways wind and twist over uneven land in the way of old-fashioned architecture, just as the smallish greens are often protected by the cross-bunkers favored in the era of the gutta-percha ball. The championship course is a composite. In fact, the toughest stretch of holes—11th, 12th and 13th—are taken from the last edition to the course, the Primrose nine built by William Flynn in 1927.

Since holding the 1902 US Women's Amateur, the The Country Club has hosted thirteen additional USGA events, including the 1934 US Amateur that began Lawson Little's two consecutive "Little Slams" comprised of the US and British Amateurs. All are dwarfed, however, by the 1913 Open and Francis Ouimet. Born in Brookline in 1893, the son of a French Canadian

THE COUNTRY CLUB
THE 3RD HOLE, 448 YARDS, PAR 4

*"Pond," one of the most scenic holes at this site of the 1913, 1963 and 1988 US Opens, and 1999 Ryder Cup.*

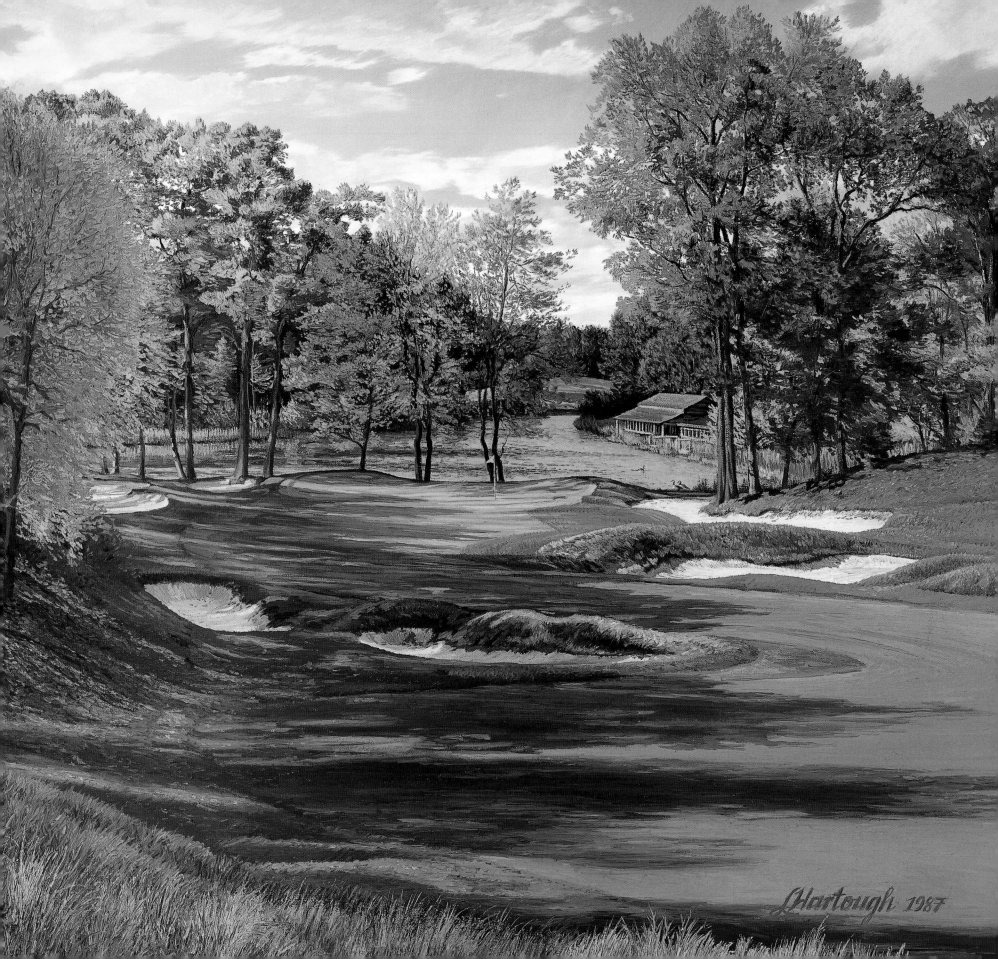

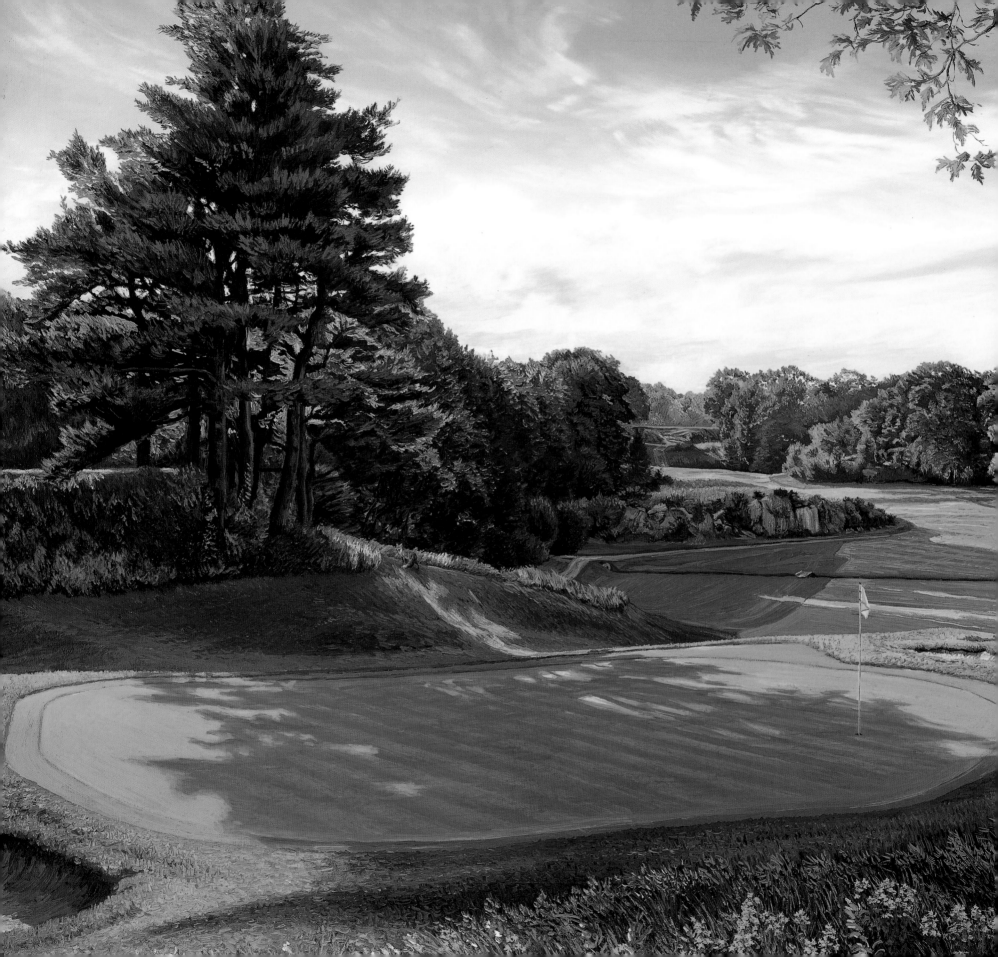

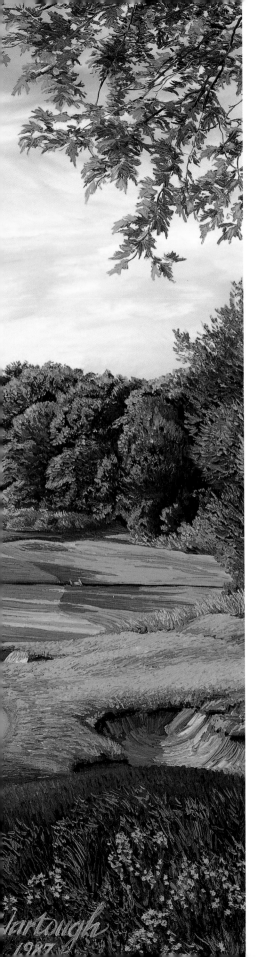

gardener, Ouimet grew up in a humble home at 246 Clyde Street just a few yards from the 17th green at The Country Club. Taking a shortcut to school through the golf course, Ouimet began to acquire a collection of golf balls, and soon he and his older brother Wilfred fashioned a crude three hole course behind the family home. Ouimet caddied at the club for about twenty-eight cents a round from ages eleven to sixteen, when he had to give up that job in order to keep his amateur status, and began working as a store clerk for the sporting goods manufacturer Wright and Ditson. By 1913, he had won the Massachussetts Amateur and reached the semi-finals of the US Amateur. He entered the Open, but was sure he wouldn't be able to play because he had no more vacation time from his job. When his supervisor, John Merrill, saw Ouimet's name printed among the entrants in the local qualifying, he gave him permission to play, putting history in motion.

The field for the Open was the strongest the championship had ever had. Vardon was the game's best player and the long hitting Ray was nearly as good. The leading American was Johnny McDermott, who had won the last two Opens. No one considered Ouimet a serious contender. But Ouimet was in a state of mind that sports psychologists now call "the zone." He was playing for the sheer joy and on his favorite ground. "To me," Ouimet would say in 1932 on the occasion of The Country Club's 50th anniversary, "the property around here is hallowed. The grass grows greener, the trees bloom better. There is even warmth in the rocks that you see around here. And I don't know, gentlemen, but somehow or other, the sun seems to shine brighter on The Country Club than on any other place I've seen."

To help keep him on even keel, Ouimet had a diminutive ten-year-old caddy named Eddie Lowery, who could barely keep the bottom of the canvas bag containing the player's ten clubs from dragging along the ground.

THE COUNTRY CLUB
THE 9TH HOLE, 510 YARDS, PAR 5

*The 9th hole is called "Himalayas," for the hilly terrain the golfer sees when looking back from the green to the tee.*

29

But Lowery himself was a focused little man, and he unfailingly repeated the two mantras that Ouimet wanted to hear before every shot. "Take your time, you've got all day," and then, "Keep your eye on the ball." Ouimet played well for the first three rounds, tying Vardon and Ray for the lead, but when he went out in 43 in the final round, all hope seemed lost. He would have to shoot even par on the back to again tie Vardon and Ray, who had both shot 79s to finish with 304. After Ouimet double-bogeyed the short 10th, he needed a miracle. Somehow, he got it. He played the last eight holes in two under par, first chipping in for a birdie on the 13th, and then on the 17th, in the shadow of his family home, holing from twenty feet for another birdie. In the dusk and drizzle on the final hole, he parred with a chip and a brave five-footer.

Despite dank conditions an estimated 10,000 spectators, the largest gallery ever to watch golf in America, came to watch the playoff. Ouimet had slept well, and was amazingly relaxed. "I realized I was just an amateur," he said later. "I played golf for fun. I considered professionals as something like magicians who had an answer for everything. I felt I was in a playoff by mistake... It was a wonderful mood to get into. I was numb." Ouimet made a couple of early errors, but from the 7th hole on, played nearly flawless golf. The correspondent for the *Times* of London, Bernard Darwin, was the official scorer for the American, and wrote, "Mr. Ouimet was so obviously the master of himself and never looked like breaking down." Vardon and Ray strained to keep up, but finally cracked. The 17th was the clincher. Vardon trailed by a stroke but drove into a bunker in a vain attempt to cut the dogleg, while Ouimet reached the green in two and again birdied. He parred the last for a 72, including a 34 on the final nine, and was carried on the shoulders of the crowd. It remains the most momentous single round in the history of golf.

Not only had Ouimet toppled two giants and everything they symbolized, his modest manner and poise under pressure was wonderfully appealing. "Overnight, the non-wealthy American lost his antagonism toward golf," wrote Herbert Warren Wind. Ouimet went on to have a distinguished career in golf, winning the US Amateur twice, and in 1951, becoming the first American to be chosen as Captain of the Royal & Ancient Golf Club of St. Andrews. "The more Americans learned about Francis Ouimet, the more they admired him," wrote Wind. "American golf was lucky, very, very lucky, that it was Francis who won at Brookline."

On the 50th anniversary of Ouimet's triumph, the Open again returned to Brookline, and this time Arnold Palmer was the hero of another surge in American golf's popularity. With The Country Club playing at its hardest because of high winds and the ill effects of a harsh winter on the greens and turf, Palmer got into a playoff with Jackie Cupit and Julius Boros at nine over par 293, the highest winning score in the Open since 1935, and the highest since. The playoff belonged to the smooth Boros, Brookline becoming one of the three Open playoffs Palmer would lose.

When the championship came back to The Country Club in 1988, the course had undergone a major restoration under Rees Jones. The architect, who at Brookline established himself as "The Open Doctor," studied old pictures and questioned old heads to bring the look of the course back as much as possible to 1913, while keeping it a demanding test for modern shot-makers. "We took it back in style, not in design," said Jones, whose efforts were unanimously praised. In a thrilling Open, The Country Club produced yet another playoff, with Curtis Strange defeating Nick Faldo.

The 1999 Ryder Cup was a spiritual homecoming for US team captain Ben Crenshaw. The Texan had become a lover of golf history and course architecture after participating in the 1968 US Junior Amateur at Brookline, where he received what would become a treasured copy of *A Game of Golf, A Book of Reminiscences*, by Francis Ouimet. Crenshaw brought the book to the Ryder Cup, where his team completed the greatest last day comeback in the event's history to defeat the European team. The climatic shot was a forty-five-foot putt by Justin Leonard on—what else—the 17th hole. After the ball went in, an emotional Crenshaw kissed the green surface and pointed in the direction of an old home a few hundred yards away on Clyde Street. "This is Francis Ouimet's hole, and we felt his presence," said Crenshaw. "The Country Club has certainly been kind to American golf."

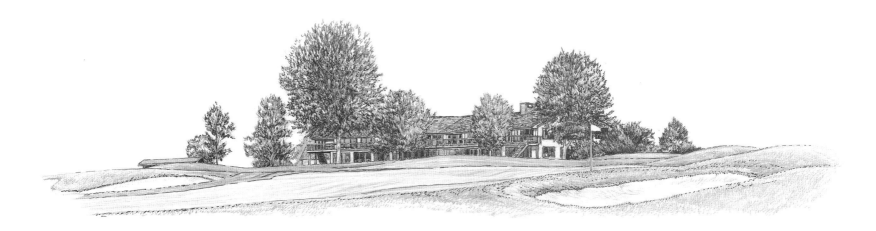

# HAZELTINE

No championship course has ever hatched fully grown. A golf course is a living organism that with time and the right kind of attention grows and evolves into something exemplary and beautiful. Some courses are late bloomers. Certainly the Hazeltine National Golf Club outside Minneapolis suffered from the ugly duckling syndrome. When it was built in 1963, it was with the stated aim of holding championships. But when the club's influential founders landed the 1970 US Open, the golf course's immaturity and awkwardness, along with some horrid weather, led to it becoming the most criticized Open site in history.

But since that painful week three decades ago, Hazeltine has blossomed. Major improvements were made almost immediately, and when the USGA gave the club another chance with the 1983 Senior Open, Hazeltine impressed enough to be awarded the 1991 US Open. Determined that an experience like 1970 would never occur again, the club launched an extensive five-year improvement program that was meticulously executed. The next time Hazeltine took center stage in the golf world, it was a swan.

Hazeltine always had the resources to become a great course. Minnesota offers ideal summer conditions for golf. The harsh winters are a blessing for tournaments held in June, because the courses have just emerged from a period of dormancy and regeneration. When the snow melts, the "Land of 10,000 Lakes" explodes into vistas of deep forest green and cobalt blue. On a bright day in late spring a golf course in Minnesota—a state

known for its progressive junior and women's golf programs—could pass for most people's conception of Camelot.

Hazeltine, in the farming community of Chaska about thirty miles west of Minneapolis, fits the profile. It is bordered by Hazeltine Lake and surrounded by lush rolling farmland. But before it was able to settle into its surroundings, Hazeltine got rushed into the lineup. The course's founder, Totten Heffelfinger, was a former USGA president who had considerable influence in the golf world and was determined to bring the US Open to Minnesota. The state had hosted the event only once, in 1930 at Interlachen, when Bobby Jones gained the third leg of what would become the Grand Slam.

To build his course, Heffelfinger brought in the well-regarded architect Robert Trent Jones, who had established his fame by toughening the Augusta National as well as Open standards like Oakland Hills, Baltusrol and Olympic. At Hazeltine, Jones made a concerted effort to built a big course that would withstand a future of more potent equipment and more powerful players, much as he had done in his draconian update of Oakland Hills before the 1951 US Open. In his original design, four par 5s measured close to 600 yards on a course stretching to a gargantuan 7,410 yards from the back tees.

Hazeltine had drawn no criticism playing more than 1,000 yards shorter when it hosted the US Women's Open four years before, although the image-conscious LPGA strongly discouraged negative comments about

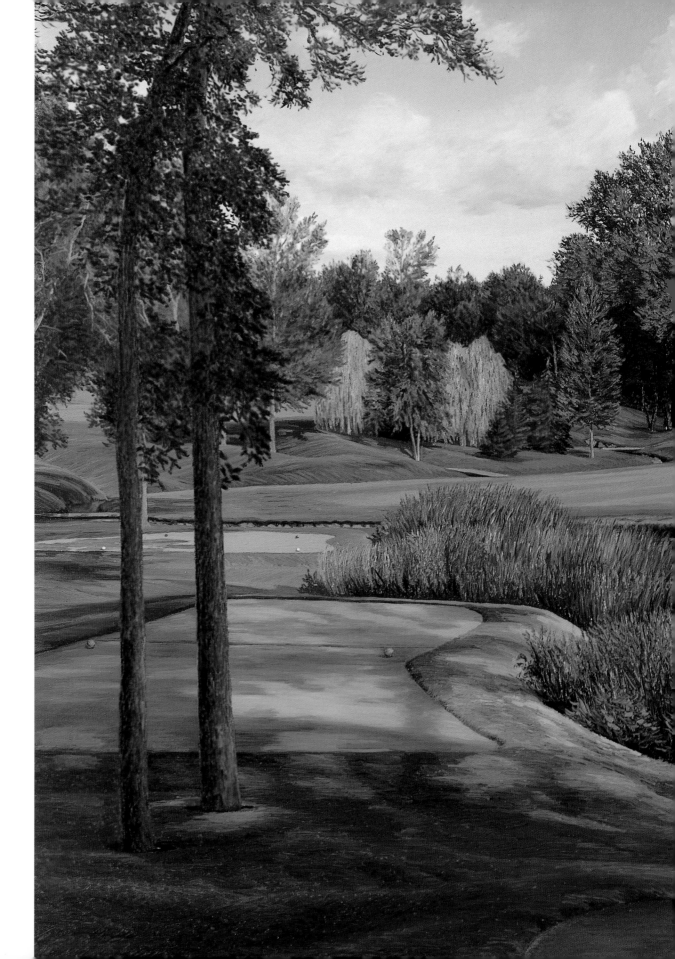

### HAZELTINE NATIONAL GOLF CLUB
### THE 16TH HOLE, 396 YARDS, PAR 4

*The 16th hole, at once beautiful and treacherous,*
*is guarded by mounds and a creek on the left, while the*
*green is nearly surrounded by Hazeltine Lake.*

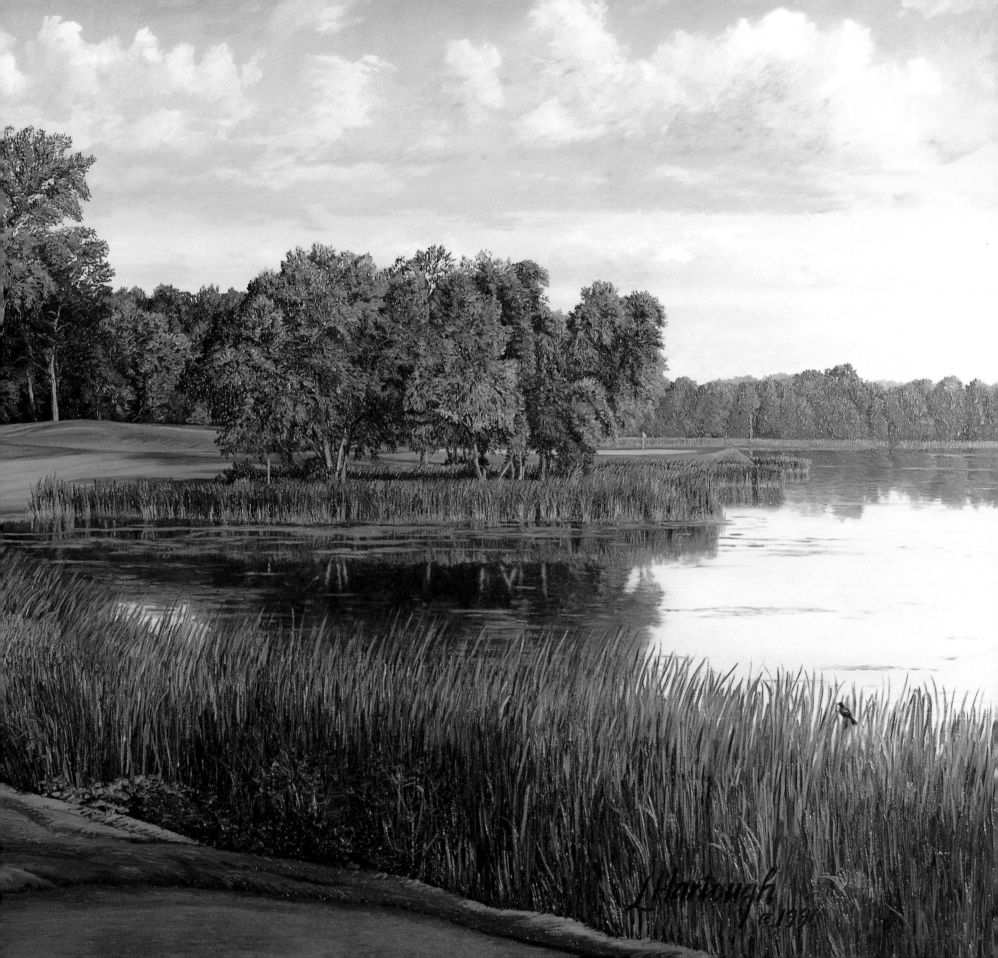

the host club. "We didn't complain about golf courses, we just played them," says Carol Mann, who finished second by a stroke to Sandra Spuzich's winning total of 10 over par 288. "We were playing in Patty Berg's home state, in a beautiful area, for the national championship. The course wasn't an issue."

But men professionals had a more secure platform than their female counterparts, and Hazeltine went under the microscope at the 1970 US Open. As soon as the practice rounds began, the locker room was buzzing. The chief criticism was over several tee shots in which the green was not visible, and over the unusually high number of doglegs, thirteen in all. "Jones has so many doglegs," said Bob Rosburg, "he must have laid it out in a kennel." Overall, Hazeltine was perceived as a course without "definition." Its trees were too small and the overall landscape was too raw and barren to provide the kind of "framing" of shots appropriate on an inland course holding the US Open. "The only target on the tee at 18 was the chimney on Tot Heffelfinger's house," said Jack Nicklaus, taking a shot at the founder. USGA official P.J. Boatwright summarized, "The plantings and so forth hadn't reached a maturity you associate with an Open course." In short, Hazeltine, only seven years old in a championship in which most of the host clubs had origins back to the 1920s, was in over its head.

To exacerbate the situation, forty-mile-per-hour gusts and fifty-degree temperatures made the first round a nightmare of windblown shots and rock hard greens. The average score was 79.1, the highest scoring Open round since 1958 and third highest since WWII. Tony Jacklin, the defending British Open champion, used his European familiarity with windy and cold conditions on difficult golf courses to improvise a 71 that was the day's lowest round. Jacklin also decided it would do no good to dislike the course. "Complaining about the golf course is a self-destructive exercise," Jacklin would say later. "The more others criticized Hazeltine the more I programmed myself to approve of it. Persuading yourself you like a course can be an important factor in winning." Jacklin put on a tour de force to become the first Englishman to win the US Open in fifty years. His total of seven under 281 was seven strokes the best, and made him the first player since Ben Hogan in 1953 to lead the championship outright after every round.

The rest of the field, meanwhile, had a bone to pick with Hazeltine, and eventual runner-up Dave Hill became their spokesman. A chainsmoking, high strung, opinionated, impulsive and very talented player, Hill said he hated Hazeltine even before he saw it because it had taken him an extra hour of aimless driving through farm country to find it. When he played his first practice round, he quit after the first nine. When he came back the next day to play the second nine, he quit at the turn again. He wanted to quit the championship period, but a friend he was staying with talked him out of it.

Hill shot 75 in the first round, and after a 69 in the second put him into second place he was called to the pressroom. Hill admits he'd had a few vodka and tonics on an empty stomach, and was in an expansive mood. When he was asked what he thought Hazeltine lacked, he piped, "eighty acres of corn and a few cows. They ruined a good farm when they built this course." For the rest of the championship, Hill was "mooed" by spectators. But a point had been made—Hazeltine had some major weaknesses. Boatwright in particular disliked the par-3 16th, which demanded a draw around tree branches that had some players calling it Jones' fourteenth dogleg, and the 17th, a claustrophobic par 4 bisected by a creek. He told Hazeltine's membership that if they ever wanted to hold another Open, those holes would have to go.

The message was not lost two decades later. Robert Trent Jones' son, Rees, took control of the redesign for the 1991 Open. He shortened most of the longest holes from the 1970 set up, created better sight lines for the drives, and straightened out several doglegs. Finally, the champion chairman, Reed Mackenzie and future club president Warren Rebholz converted the 17th to a par 3 and the 16th to a dramatic par 4 with a green perched on a narrow peninsula jutting into Hazeltine Lake. When Rees Jones dammed a swale to make a burn that meandered down the left side of the 16th fairway, Hazeltine finally had a hole to capture the imagination of the public and the players.

The redesign was an unqualified success, drawing praise from opposite ends of the 1970 spectrum. Even though much of his original

work was redone, Robert Trent Jones liked the changes. "It takes time and refinement to make a good golf course," he said. He was particularly partial to the 16th, allowing that if he had to save one item from his home in a fire, it would be Linda Hartough's painting of that hole. And when the Hazeltine membership graciously invited Dave Hill back as a non-participant to the 1991 championship he said he liked the new Hazeltine as well. "It's totally different," he said. "It has maturity and definition. I'm sure they will have a great Open."

Although it was marred by the death of a spectator from lightning in the first round, the 1991 championship was a success. The winner was Payne Stewart, although Scott Simpson had it in his grasp twice. In the fourth round, Simpson led by two as he drove from the 16th tee. But he pulled his ball into rough, couldn't reach green in two, and bogeyed. When he bogeyed the 18th as well, he fell into a tie with Stewart. In the 18-hole playoff, Simpson was again two strokes up with three to play. But on the 16th green, he missed a three-footer for a par after Stewart made a twenty-footer for birdie. Simpson then bogeyed the final two holes to lose 75 to 77. It was a sad ending for Simpson, but Hazeltine impressed. In 2002, it will host the PGA Championship. It has become what it was intended to be— an exemplary and beautiful championship course.

# LAUREL VALLEY

Laurel Valley Golf Club came to life in 1960, a time when many Pennsylvanians were awash with pride over the improbable but muscular victories of their sports heroes. In the World Series the Pirates of Pittsburgh had somehow toppled one of America's reigning dynasties, the New York Yankees, with Bill Mazeroski's unexpected home run in the bottom of the ninth inning in the seventh game. Earlier that year the Keystone State's favorite son, Arnold Palmer, rose to the pinnacle of golf by winning the US Open at Denver's Cherry Hills in a similar fashion. The strapping embodiment of Western Pennsylvania directness, Palmer drove the green at the par-4 first hole in the final round, birdied six of the first seven holes, shot a 65 to win by one and gave birth to an entire army of followers.

So 1960 was a fitting year to raise a modern golf monument, and to deliver a contemporary riposte to the old Oakmont Country Club, some fifty miles away and fifty-seven years older. If Oakmont was the powerful and unbending turn-of-the-century grandfather, then Laurel Valley, on the outskirts of Ligonier, Pennsylvania, would be the vibrant and powerful scion.

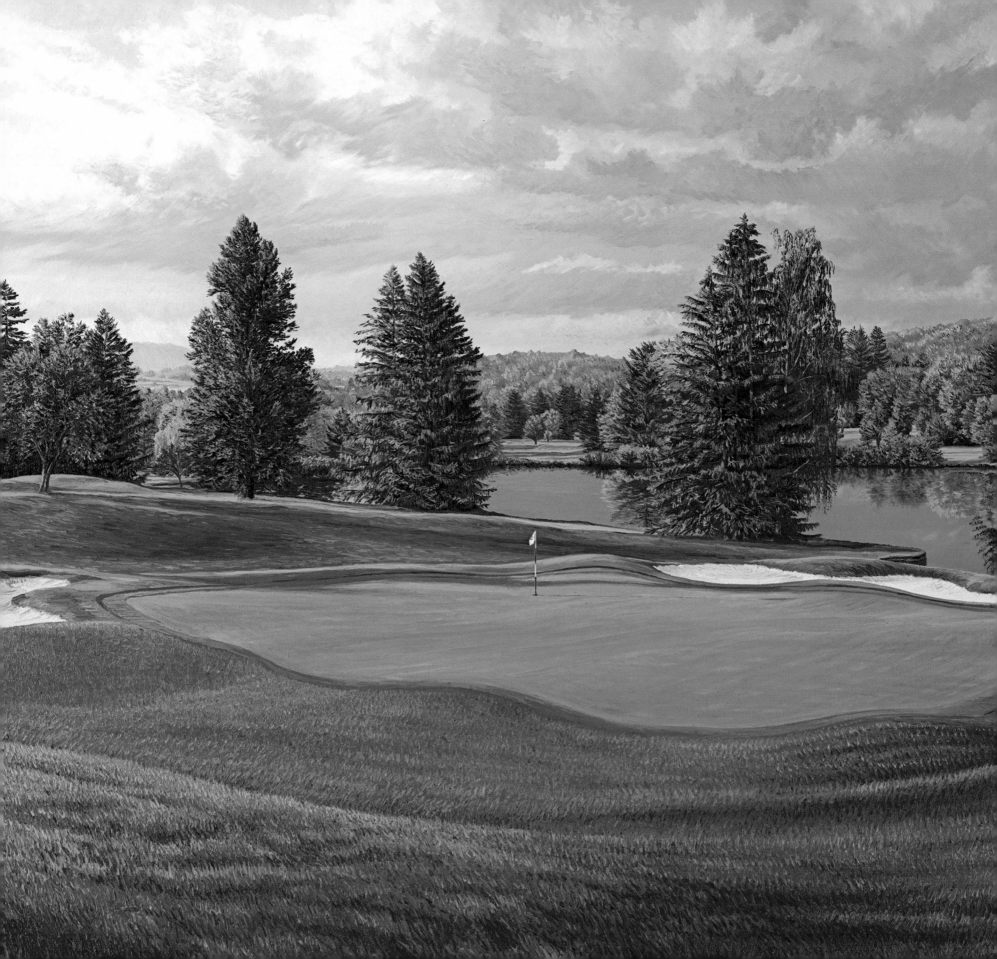

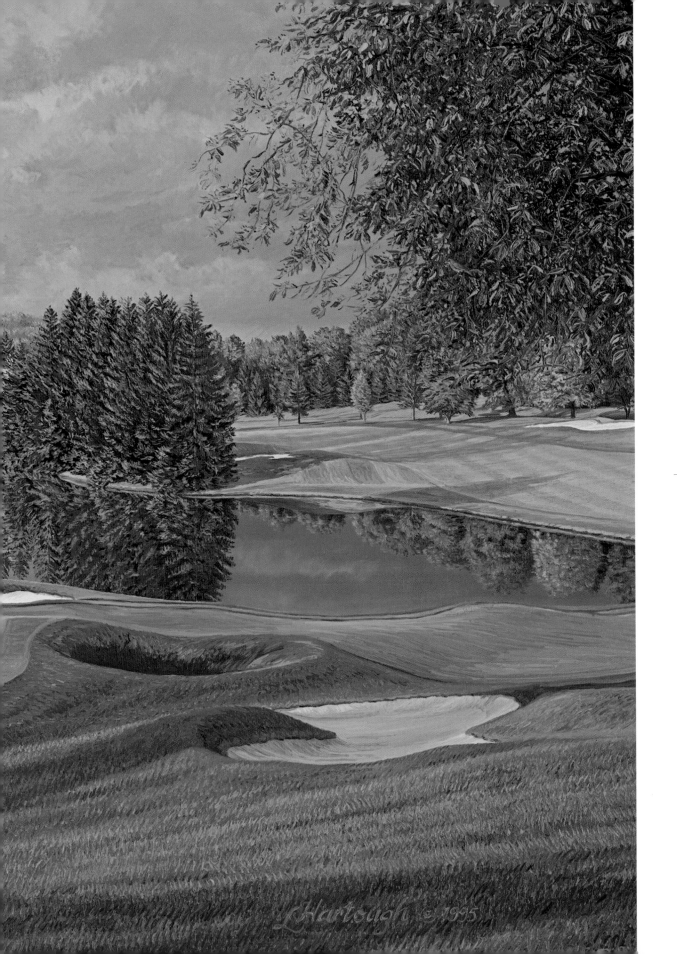

LAUREL VALLEY GOLF CLUB
THE 18TH HOLE, 506 YARDS, PAR 5

*Originally designed by Dick Wilson in the 1950s,
Arnold Palmer altered the 18th among other holes
in the 1980s, providing excellent spectator vantage
points during tournament play.*

37

The flowing 260-acre tract of rolling grassland and thick stands of pines, laurel and oak that lay between the Laurel and Chestnut Ridges of the Allegheny Mountains in western Pennsylvania struck the initial planners of Laurel Valley much in the same way that the topography of the old Berckman's nursery in Augusta struck Bobby Jones when he first saw it in 1932. The club was originally a private enclave and pheasant shooting preserve where owner Richard King Mellon entertained industrial barons Benjamin Fairless, the president of US Steel, and George H. Love, the president of Consolidation Coal and chairman of the board of Chrysler. Laurel Valley remains a refuge for financiers and CEOs, and like many clubs where real powerbrokers go to relax it has a quiet, understated atmosphere. It is a club, after all, where golf's all-time Everyman—Palmer—often hangs out.

When the original business visionaries behind the club expanded their gaze, they brought in course architect Dick Wilson considered, along with Robert Trent Jones, the top designer of his day. Wilson began his career under William Flynn, the creator of Shinnecock Hills, and made his name with a group of excellent courses in Florida, including Doral, Pine Tree and, later, Bay Hill. But Wilson also did superlative work in northern settings, notably at NCR in Dayton, Ohio and Deepdale in Long Island, along with his delicate redesigning at Merion and Winged Foot. Given Wilson's credentials, his comment when he first laid on eyes on the Laurel Valley property in 1958 was notable: "This is the most natural, beautiful site I've ever seen for a golf course."

In addition to its scenery and ideal topography, Laurel Valley had several other advantages, not the least of which was its proximity to Palmer's hometown of Latrobe, only ten miles away. Palmer and Laurel Valley have been enmeshed ever since his keen interest in the club became evident from the beginning when he made some suggestions about the design and agreed to be its touring professional. Some twenty-eight years after the club's opening, Palmer and his architectural partner Ed Seay would update the course, modify fifteen holes and completely redesign a sixteenth. Although a brawny 7,045 yards from the back tees, Laurel Valley is a strategist's course whose primary obstacles are distinctly expansive bunkers—a Wilson specialty—

hugging the front of large, elevated greens. It is a course that favors the modern game, rewarding players who can carry the ball high in the air and stop it quickly, but only those who position their drives on the correct side of the fairway. "Every time I looked up I saw enough sand to make me think I was in the Sahara," said Sam Snead, who at age fifty-three finished sixth at Laurel Valley at the first major event it held, the 1965 PGA Championship.

The young course had been awarded the major championship largely through Palmer's influence, and if there was ever a place The King would have chosen to win the PGA that somehow escaped him his entire career, Laurel Valley would have been it. Unfortunately, being the unofficial tournament host proved to be a major distraction for Palmer. "I wanted it to be picture perfect in every way," he wrote, "so, experiencing a kind of large scale host anxiety, I worked and worried myself into a frantic state of mind, checking and rechecking on every detail in the days leading up to the championship. Perhaps I should have gone fishing..."

Palmer, doomed from the start, eventually tied for 33rd. He incurred a two-stroke penalty on his very first hole when an overzealous group of marshals headed by Miles Span, a Palmer fan and acquaintance, removed the railing to a temporary footbridge so that Arnie could have an unimpeded swing with his wedge. Span's act improperly improved Palmer's line of play. From that point, Palmer wrote, "the wind went right out of my sails." At the news that their hero had opened with a one-over par 72 rather than a one-under 70 because of the penalty, the howls could be heard from Aliquippa to Harrisburg. Palmer may have been the focal point of the event, but the winner was Dave Marr. A native Texan, but New York transplant whose natural wit allowed him to glide easily in the highbrow culture and nightlife of Manhattan, Marr's reputation for being urbane often obscured the fact that his short-hitting but exceedingly stylish game could occasionally be world class. At Laurel Valley, Marr played the tournament of his life. On a course in which only four players broke par for the week, Marr shot four under par 280 to win by two, capping it off with a final round 71 in which he held off Jack Nicklaus head to head in the final pairing.

Going into the fourth round, the thirty-one-year-old Marr was real-

istic. "If Jack played his best, I knew I couldn't beat him," he said later. "To have a chance, I would have to play as well as I could and hope he stubbed his toe." Nicklaus did, mishitting a chip to bogey on the 11th hole while Marr birdied to regain his two-stroke lead. Marr needed the buffer, because on the 16th hole he missed a two-foot putt. (Later he would say that just before hitting the putt, his head was filled with his son's voice crying, "Daddy, be careful!") On the 18th, still leading by two, he got another fright. The par 5 for members played as a 460-yard par four for the pros. Marr's drive found the lone bunker on the left side of the fairway. Rather than attempt a carry of 230 yards over a lake to an elevated green, Marr laid up short with a 7-iron, then hit a 9-iron he would always call "my career shot" to within five feet of the hole. Still, victory wasn't assured until Nicklaus' chip shot from sixty feet rolled over the high side of the cup and stopped six inches away. "Damn if he hasn't made it," Marr thought as the ball approached the hole. After a deep sigh, Marr made his putt to win.

Both Palmer and Nicklaus exacted some revenge from Laurel Valley when they won the National Team Championship there, a best ball event, in 1970 and 1971. Commenting on the ferocity with which the two rivals competed in a common cause, Nicklaus said, "I don't know that we're actually trying to beat each other. We just don't want to be embarrassed."

At the 1975 Ryder Cup at Laurel Valley, Nicklaus, coming off one of the best years of his career was, if not embarrassed, at least humbled. Although the United States team, captained by Palmer, easily administered a 21-11 hiding to the team from Great Britain and Ireland, Nicklaus received a comeuppance from Brian Barnes, a pipe smoking, shorts-wearing Englishman with arms like a Liverpool stevedore and a bludgeoning swing to match. Barnes beat Nicklaus 4 and 2 in the morning, in a relaxed match in which they spoke about fishing. But with the team outcome decided, Palmer arranged for the two to meet again in the afternoon singles as a crowd pleasing finale. "Jack fixes me with a glare and says, 'You beat me once, but I'll be damned if you'll beat me twice,'" Barnes recounts. "My knees should have been shaking." Nicklaus birdied the first two holes, but Barnes remained on a roll, and won again, 2 and 1. "Jack was seething," said Barnes. "But great sportsman that he is, he put out his hand."

Laurel Valley's reputation as a position golf course was enhanced at the 1989 US Senior Open, where the straight-driving Orville Moody won. Old Sarge, a former career military man, outflanked the field as he had in winning the US Open at Champions in Houston twenty years before. At Laurel Valley, the course that The King helped create but couldn't conquer, strategy and sound play had again triumphed over the form charts.

# MEDINAH

The Medinah Country Club is the championship jewel of Chicago, its breadth and scale perfectly suited to the city with big shoulders. It has three 18-hole courses on 640 acres, including its own Monster of the Midway, the No. 3 Course. Medinah possesses all the best components of parkland golf: gently rolling land, huge oak trees and, on the No. 3 Course, four heroic forced carries over water. The three courses were designed by Tom Bendelow, who built more than 650 courses in the midwest in a thirty-five-year career that began in the early 1900s. In Bendelow's utilitarian style, No. 3 at Medinah is a relentless test of driving and iron play. And while it lacks unique aesthetic touches, Medinah's spacious environs and exceptional facilities make it a natural venue for golf's biggest events.

There is nothing utilitarian about Medinah's clubhouse. The club was founded in 1924 by Chicago's Shriners, a group originally known as "the nobles of the Ancient Arabic Order of Nobles of the Mystic Shrine of North America." The name Medinah derives from the ancient Islamic city where the prophet Mohammed lived and was buried, and the sign visitors pass as they leave the club reads, "Allah be with you." The Shriners are primarily a charitable organization that descend from the European Freemasons. In concert with that tradition, they built a clubhouse that is the most eclectic, ornate and stunning in all of golf.

Moorish in theme, Medinah's clubhouse is a one-of-a-kind spectacular, a medley of multi-toned brick, arched porticos, graceful minarets and green-tiled domes—with a facade accented in burnt orange and gold trim. After research in Europe and the Middle East, architect Richard Schmid designed the massive structure which blends Byzantine, Italianate, Oriental, and Louis XIV influences. For comparison, the 60,000 square foot interior is ten times larger than the clubhouse at the Augusta National, and it is full of palatial adornments like archways, detailed handpainted walls, and a sixty-foot high rotunda. Completed in 1925 for $870,000, its replacement cost today would be in excess of $30 million. The building's craftsmanship, grandeur and sheer audacity make it one of golf's great monuments.

There are no Moslem influences on the No. 3 Course, other than the name of its most perilous water hazard: Lake Kadijah (for the first wife of Mohammed). Built in 1928, and originally conceived as a shorter course for women, architect Tom Bendelow got more ambitious with the layout, which eventually grew to a 6,215-yard, par 71 that the membership instantly came to regard as its most challenging course.

But the first time a tournament was held on the course in the 1930 Medinah Open, the pros had their way, with Harry Cooper posting a 63 and Gene Sarazen a 65, unheard of scores in that era. The club decided to

revise the course, and in 1932, seven new holes were added and two others remodeled to produce a par 72 of 6,820 yards, making No. 3 one of the longest and most difficult courses in the country. When Cooper won the 1935 Medinah Open, it was with a one over par score of 289.

Medinah held the US Open for the first time on its silver anniversary in 1949. Ben Hogan was the defending champion, but missed the event because of injuries he suffered in a car accident early that year. The winner was Dr. Cary Middlecoff, a former dentist who took the first of two US Opens in a career that saw him win forty official tournaments. Middlecoff was a highly strung competitor with a quick temper. "I hate to admit this," he once said, "but I was playing so poorly when I was about to win my first Open, I was ready to quit and go back to pulling teeth." Five over par in the first round going into the very tight 316-yard, par-4 15th hole, he gambled with a driver off the tee and nearly reached the green. "I was steamed," he said, "but I chipped up and made three and that cooled me a little. I parred in for 75 when I was that close to getting mad and shooting 80." Middlecoff played the next two rounds in 67 and 69 to go three up on his closest pursuer, another player with a low boiling point, Clayton Heafner. The two were playing partners in the final round, which Middlecoff was glad for. "God, I loved Clayton," said Middlecoff. "He was caustic like me. I was the only guy he liked who went beyond high school." Both men struggled, Middlecoff barely holding off Heafner's 73 by parring the last seven holes for a 75. Sam Snead was tied for the lead after 12 holes of the final round, but bogied the par-3 17th and lost another Open by one shot.

The Open returned in 1975, and a championship that nobody could seize on Sunday was finally taken by Lou Graham in a playoff with John Mahaffey. Graham was a soft spoken Tennessean who had served as an honor guard at the Tomb of the Unknown Soldier during his Army days. Implacability served him well at Medinah, where the best 72-hole score of the week was three over par 287. "You've got to get those pars; you don't need that many birdies," said Graham. "I've never been one to shoot that much under par. When I walked to the first tee of an Open course, I liked it. I knew that every time I made par, I was beating more people than were beating me."

After two rounds, Graham was eleven strokes behind 25-year-old Tom Watson, who had started 67, 68 on the rain soaked course to tie the 36-hole Open record. When Watson stumbled to a 78, Frank Beard took a three-stroke lead into the fourth round, only to give it all back with a 40 on the front nine, setting the tone for a mistake-laden final nine. Ben Crenshaw was tied for the lead until he mishit a 2-iron shot on the 17th into Lake Kadijah. Bob Murphy bogeyed the final hole to finish a stroke behind, and Jack Nicklaus, who had won the Masters and was going for a second leg of the Grand Slam, bogeyed the 16th and 17th holes to finish two behind. Beard shot a 78 to lose by one. Even Graham bogeyed the tight 18th to fall into the playoff. But, making par his mantra, Graham defeated Mahaffey in the playoff 71 to 73.

When Medinah held the 1990 US Open, twenty-seven players were within four strokes of the lead going into the final round. One of them was two-time Open winner Hale Irwin, at forty-six considered well beyond his prime, and only in the field because of a special USGA exemption. But Irwin shot a five under par 31 on the back nine, capping it with a forty-five foot birdie putt on the 18th that inspired a raucous celebration in which he high-fived the gallery like a kid running his hand along a picket fence. Nick Faldo, desperately wanting to add the US Open to his collection of majors, narrowly missed a twelve-foot birdie putt on the 72nd that would have put him into a playoff. But Mike Donald, a journeyman who was having the tournament of his life, parred the 18th to tie Irwin. The playoff was a thriller, with Irwin two strokes behind when he hit a vintage 2-iron to six feet on the 16th. The birdie cut the lead to one, and when Donald bogeyed the 18th it set up the first sudden-death playoff in Open history. Seizing the day, Irwin birdied the 19th playoff hole to win.

Medinah's standing as one of the great theaters for championship golf was enhanced by its hosting of the 1999 PGA Championship, and it has already lined up the 2006 PGA and the 2011 Ryder Cup as it enters the new millennium. Indeed, the club that so singularly has its roots in the land of Mecca has become one of the mecca's of American golf.

MEDINAH COUNTRY CLUB
THE 13TH HOLE, NO. 3 COURSE
212 YARDS, PAR 3

*Medinah was Linda Hartough's first US Championship*
*course commission. The exacting 13th hole, with its*
*steep green slightly guarded by water and sand, presents*
*an unnerving challenge.*

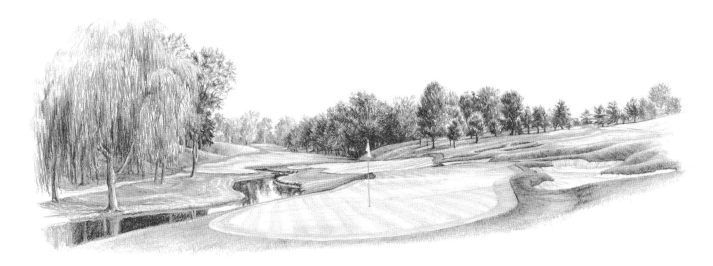

# MUIRFIELD VILLAGE

From the moment a visitor sets foot on the Muirfield Village Golf Club in Dublin, Ohio, he is of two minds. On one hand, this is Jack Nicklaus' place—in his home area, and the site of the PGA Tour event he founded, the Memorial Tournament. Nicklaus has a home near the 9th tee, his memorabilia is in the clubhouse, and there is even a life-size bronze statue of him in full follow-through gracing the main driveway. Since 1972, Nicklaus as course architect has poured everything he knows about golf and design into making this landscape of rolling fairways, thick groves of trees and ribbons of gurgling streams a special place in the world of golf. All those things make Muirfield Village a shrine.

On the other hand, the term doesn't really fit the surroundings. There is nothing stiff, formal, glamorous or pretentious about Muirfield Village. While it is private and exclusive, and the traditions of the game of golf are revered, the club's components in this suburb of Columbus, Ohio are straightforward in the way of middle America. Dublin is an upper middle class community, and the property is surrounded by comfortable but not opulent two-story homes. The sprawling clubhouse is impressive but less than grand, a modern geometric design in dark wood and gray stone where black tie would look out of place.

The centerpiece, the golf course, is striking in its grand scale, lush foliage, and immaculately manicured condition. But compared to the weathered look of America's classic old-line clubs, Muirfield Village has cleaner lines and is less "broken in." It is a place devoid of the quirky idiosyncrasies that lend charm to some older places. Rather it is forthright, efficient, well-planned and above all, down-to-earth. It's no coincidence that these are the dominant personality traits of Nicklaus himself. While he was compiling twenty major championship victories and the greatest record in the history of the game, Nicklaus left the flourishes—in his game, his dress or his manner—for others. Instead, he beat everyone with unmatched dedication and a laser-like intelligence that discerned and focused on what mattered most. Form has always followed function. Yes, Muirfield Village is Jack's place.

"The thing I take the greatest pride in as a designer is honesty," says Nicklaus, "not tricking up holes, trying to keep everything out in the open." With Nicklaus, and his courses, what you see is what you get. Which is precisely why touring professionals tend to have a deep affinity for Muirfield Village. Year in and year out, they rate it as one of their favorite tournaments. "If the courses are like this in heaven," said Jerry McGee, "I'm going to change my ways."

The club has the details right. The locker room is a split level, open-ceilinged, mezzanine design that is spacious yet private, a place for bull sessions or quiet preparation before a round. The practice range, wonderfully maintained, is shaped in a large half moon so that players can hit shots into

all wind directions. It is widely considered the best such facility in the game. The course is spectator-friendly, with plenty of walkways and amphitheaters to make the often rigorous job of following a golfer much easier, even amid the large galleries the golf-savvy Columbus area produces. Most of all, the players enjoy the golf course. A model of conditioning, its fairways are fast, firm carpets, its greens as uniform as pool table felt. "They've got them too good, almost," John Cook once said of the putting surfaces. In 1976, the tournament's inaugural year, Dan Jenkins wrote that spectators "would sooner have dropped cigarette butts on their babies' tummies," than on the golf course.

Muirfield Village's fairways tend to be wide, but extreme precision is demanded on the approach to get close to the hole. Because Nicklaus believes golf is much better game played slightly downhill, there are no blind shots and only a few where a player can't see the bottom of the pin with his approach. The course has almost perfect "site lines," a course architecture term for the way the design of a hole lines a golfer up and allows him to "see" the shot. Muirfield Village has plenty of tough holes—five of its par 4s are more than 440 yards long—but none have ever been attacked as unfair.

"My number one goal," Nicklaus writes, "in terms of creating individual shot values, is to make the player use his mind ahead of his muscles—to control his emotions sufficiently to really think through his options before drawing a club from the bag. Beyond that, I want to make well thought out shots look interesting and inviting, and I want the ball to be collected rather than repelled whenever it is properly played or only slightly missed." Nicklaus has sometimes been criticized for designing to the strengths of his own game by putting in too many left to right holes, but at Muirfield Village, only one more hole moves right than moves left. Resisting strict characterization, Nicklaus does allow that he favors a style of design somewhere between the heroic and the strategic. Especially on par 5s and par 3s, he likes to tempt the golfer with a shot over water. But there is always a less dangerous alternative that offers the opportunity for solid par. Consequently, all types of players have won at Muirfield Village. One of the most impressive performances ever on the course came when light-hitting Justin Leonard devastated his

opponents in the 1992 US Amateur. Says Nicklaus: "Golf to me is a game of precision more than power, and I think the course reflects that."

Muirfield Village came into being at a time when Nicklaus was starting to take a long view of his career. By 1973, he had won his fourteenth major championship, surpassing the total of his idol, Bobby Jones. Nicklaus had studied Jones since he was a boy, prompted by his father Charlie who had followed Jones during his victory at the 1926 US Open played at Scioto in Columbus, (which was also the course Nicklaus grew up on). Now, at about the same age as Jones was when he left active competition, Nicklaus began to think of leaving a permanent mark on the game.

In a way, he had been thinking of it since 1959 when he made his first Masters appearance and fell in love with what he saw. One night in the condo he was renting during the 1966 Masters, Nicklaus asked Ivor Young, a real estate developer from Columbus and long-time friend, to look for the site of a potential course around their home area. Later that year, Nicklaus won his first British Open at the links that would become his own course's namesake, Muirfield. By that time, Young had found a large parcel of land where Nicklaus had hunted rabbits and pheasants as a teenager. Course architect Pete Dye, who Nicklaus wanted to assess the land, told him "Curly," (his nickname for the then crew-cutted Nicklaus), "this is the best site I've ever seen that doesn't have mountains or the ocean—the best inland golf course site I've ever seen." With that, Nicklaus bought the land from retired Columbus bookstore owner Katherine Flowers.

With typical zeal, Nicklaus began to immerse himself in course architecture, consulting with Dye on Harbour Town. It was the beginning of a second career that to date has produced more than 130 courses; among them Muirfield Village will always be closest to his heart. First, Nicklaus wanted to give something back to Columbus, a sports-mad area that, without any professional teams, had only six Ohio State home football games a year to truly vent its fervor. The 1964 PGA at the Columbus Country Club had been a great success, and Nicklaus was sure the area would support an annual golf tournament. Architecturally, he wanted to build a course that had more character than many of the more modern courses on the PGA

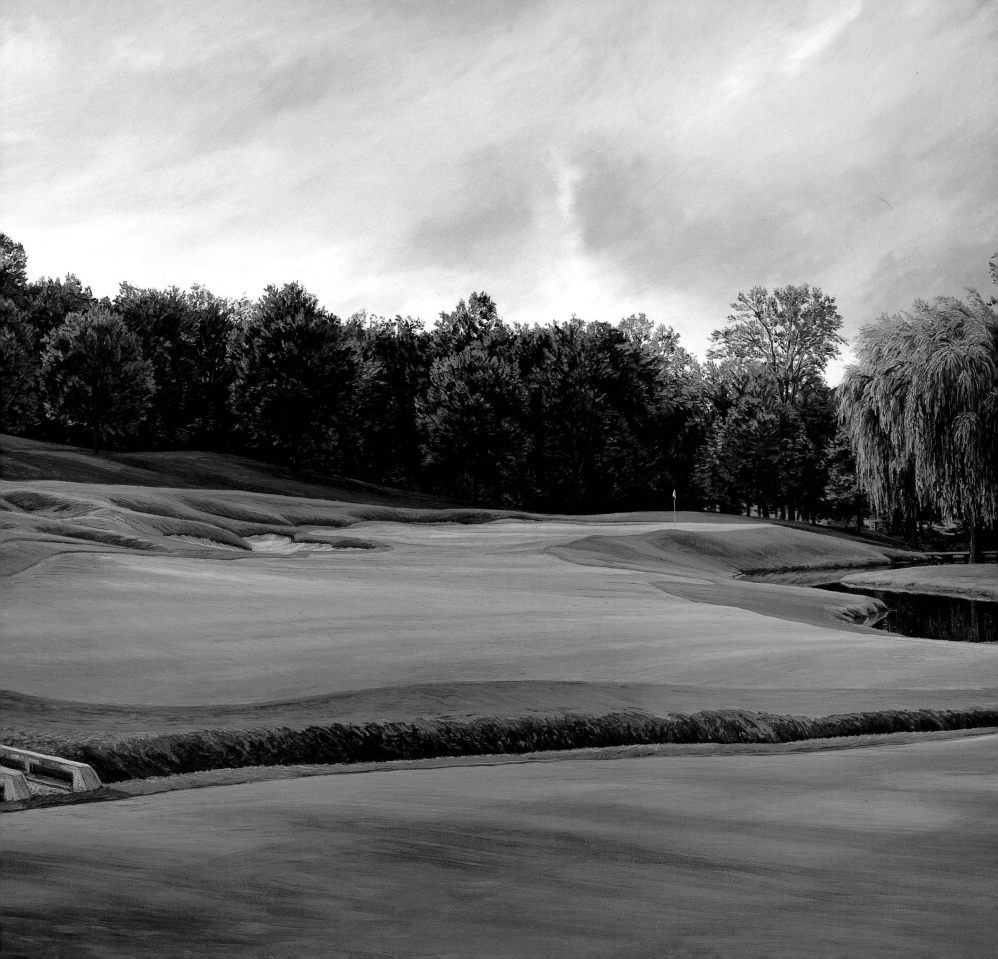

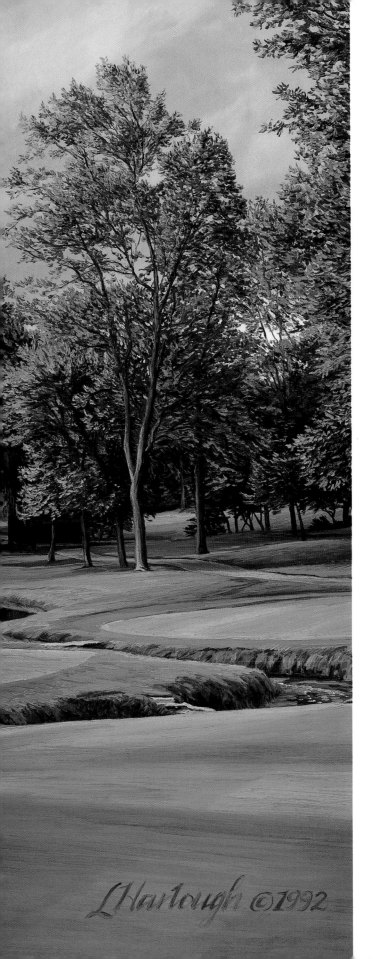

Tour, and that made a personal statement. "This course is really a conglomerate of what has happened to me in my life and what the game of golf has meant to me," he wrote of Muirfield Village. "I don't like the word monument. I would rather say this is my mark. You might call it a showplace of what the game of golf should be. It means more to me than my career."

It must have, because the unanticipated costs of the project nearly ruined him financially. "If you ever saw a project that came close to taking somebody down the tubes," he wrote, "this was pretty close to it. A lot of people wanted me to abandon the project before we got started, but I never thought of abandoning it. Never! What finally carried the day was blind, pigheaded, cloth-eared, head-in-the-sand Teutonic stubbornness, plus large amounts of thought, sweat, salesmanship, along with many sleepless nights." With architect Desmond Muirhead advising Nicklaus on environmental issues, and unhampered by the concerns of real estate developers or outside owners, Nicklaus followed his vision. "There were very few pieces of paper drawn on this property as compared with most course construction today," said Ed Etchells, Muirfield Village's first course superintendent. "Mostly, it was Jack's verbal instructions and waving of his arms. I would say it was 95 percent Nicklaus and 5 percent Muirhead."

With Muirfield Village near completion, Nicklaus wrote a letter to the PGA Tour in which he proposed his idea for the Memorial, which would annually honor a great player, alive or dead. The letter included Nicklaus' hope that Muirfield Village would someday hold a major championship. The course opened in May of 1974. One of the visitors was Masters' chairman Clifford Roberts who, after his stay, wrote a letter in which he told Nicklaus, "you have a chance to do here in five years what it took us forty years to accomplish in Augusta." The tournament began in 1976. The next

MUIRFIELD VILLAGE GOLF CLUB
THE 14TH HOLE, 363 YARDS, PAR 4

*Jack Nicklaus designed this ticklish dogleg right which
demands the most precise approach required on his course.*

year Nicklaus won, calling it the "biggest thrill of my golfing career. I didn't think I could do it in my own mind, it was something harder to do than I thought I had the ability to do." He would win again in 1984.

Since then, Muirfield has held other events, including the 1987 Ryder Cup, in which the European team, riding the collective talents of Seve Ballesteros, Sandy Lyle, Ian Woosnam, Bernhard Langer and Nick Faldo, won for the first time on American soil. Nicklaus captained the US side, and while disappointed with the result, was thrilled with the way Muirfield Village produced sensational golf.

Not that he has ever stopped refining his masterpiece. "I can still think of a hundred ways to improve it," he still says of his course. "The only way you ever get good at anything is to try to improve." Even after Muirfield Village gets a major championship, the founder's personality ensures that process will continue.

MUIRFIELD VILLAGE GOLF CLUB
THE 18TH HOLE, 437 YARDS, PAR 4

*A testing finisher amid an ampitheater built to contain the large galleries that attend the annual Memorial Tournament.*

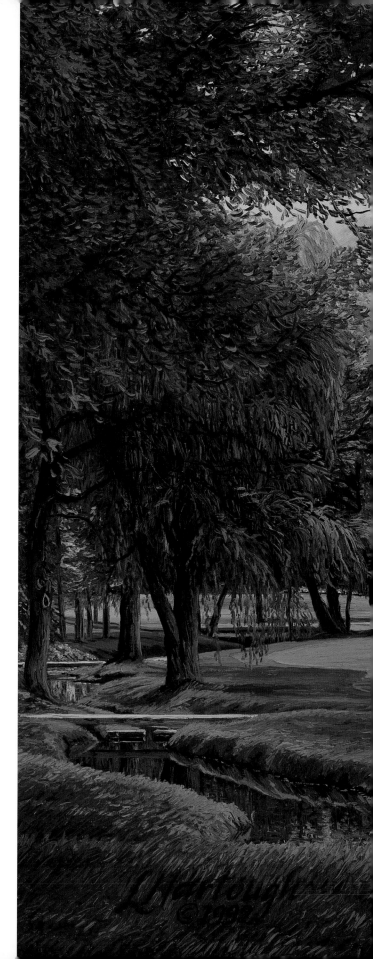

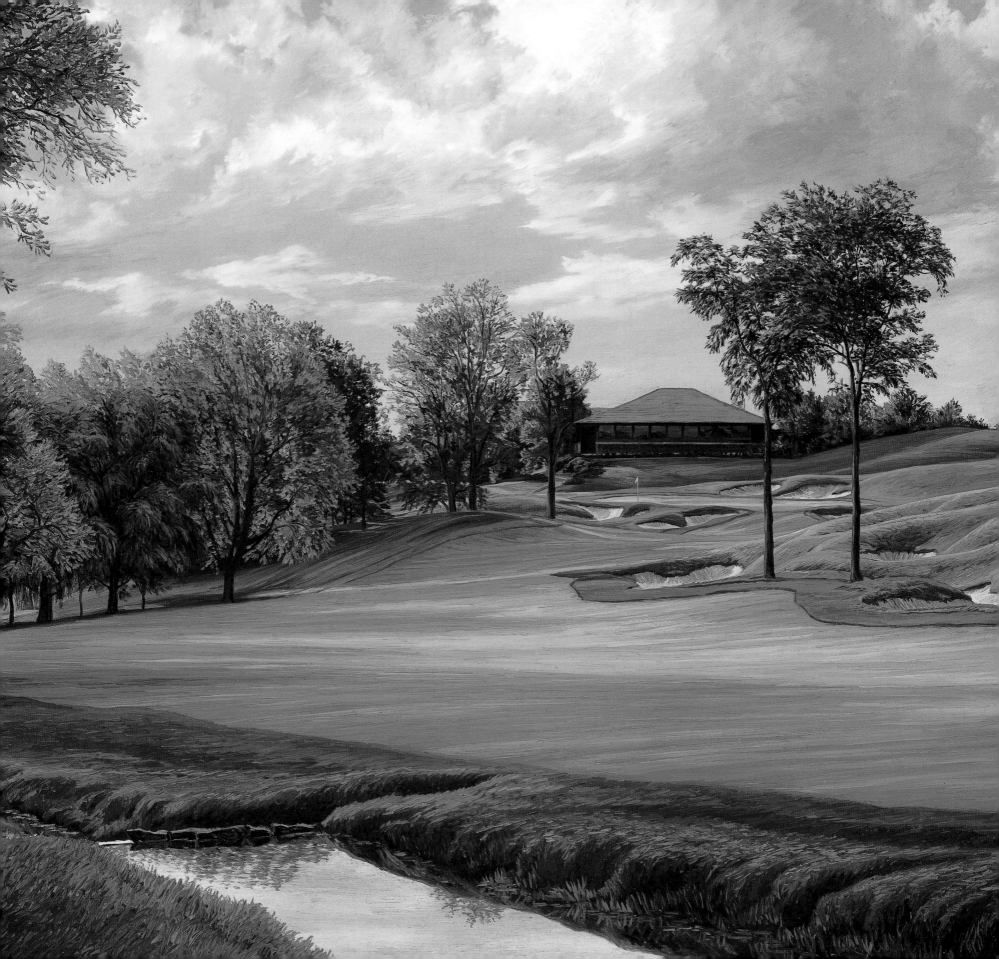

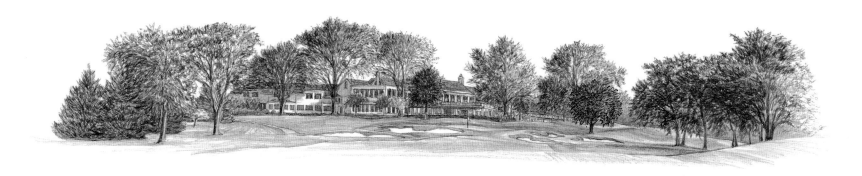

# OAKLAND HILLS

Perhaps the most famous thing ever said about a golf course came at the 1951 US Open when Ben Hogan trudged off the South Course of Oakland Hills Country Club and declared, "I am glad I brought this course, this monster, to its knees." It was a watershed moment for all involved. For Hogan, his second straight victory at the national Open assured his place in the pantheon. His airtight final round 67 remains the most mythologized eighteen holes in the game's history. Hogan's victory, and his famous words, also begot the rising influence of the course architect, a trend that would shape the face of golf in the latter half of the century. Before The Monster could be tamed it had to be created, and an ambitious and iconoclastic course designer named Robert Trent Jones rose to fame for his work at that 1951 Open. Above all, Hogan announced Oakland Hills as one of the sternest layouts in championship golf, and in the years since the club has jealously guarded its reputation while balancing an easy air of distinction and hospitality.

It is ironic that Oakland Hills will forever be known as The Monster, because the club's roots could not have been more pastoral. In 1916 two Detroit businessmen, Norval Hawkins and Joseph Mack, acquired 400 acres of farmland off Maple Road in the city of Birmingham, fifteen miles northwest of downtown Detroit. Hawkins and Mack shared a vision as well as a boss—Henry Ford. (Hawkins was Ford's first accountant and later Ford Motor Company's first sales manager, while Mack handled much of FMC's printing and advertising business.) The gently rolling hillside of Oakland County was dotted with crop squares and orchards, and both men wanted to create an idyllic community in the country. As both Hawkins and Mack were horse enthusiasts, they were initially more excited about the equestrian trails and polo field than the golf course that was to go along with their real estate venture. All that changed when they contacted Dr. Donald Ross, the renowned Scottish designer, who had ties to the area through his brother Alex, the head pro at Detroit Golf Club and 1907 US Open champion. Upon seeing the property for the first time, in the fall of 1916, Ross was moved to say, "The Lord intended this for a golf course."

Oakland Hills opened for play in July of 1918, but by then Ross' wasn't the only glittering name attached to the place. In May of that year Walter Hagen had been hired as the first head pro. The Haig, then twenty-seven, had already won a US Open in 1914, the first of the eleven major championships he would take during his Hall of Fame career. Though Hagen stayed on only a year, (resigning after his victory at the 1919 US Open), he brought a level of prestige and class to the fledgling club, even if he did have to run his pro shop out of a chicken coop while waiting for the clubhouse to be built. That clubhouse, which opened in August of 1921, would become the sprawling symbol of Oakland Hills, at least until Hogan's exploits.

The gorgeous Colonial styling was modeled on George Washington's Mount Vernon estate, and with its formal columns, outsized veranda and sparkling white exterior the Oakland Hills clubhouse was not only the class of the Detroit area but also one of the most distinctive in the nation. It didn't come cheap. At $650,000 the clubhouse cost nearly triple the original budget, but the 125 founding members did get something of a home away from home. The upstairs featured overnight accommodations for up to forty-eight

and, according to early club literature, members often stayed "for weeks at a time." This was in keeping with the inclusive vision of Hawkins and Mack, who wanted their members to luxuriate in the country setting rather than be flayed by a difficult course and then haste away home. The guestrooms have gradually been lost to expansion over the years, but Oakland Hills' clubhouse remains a comfortable place, lined with old black-and-white photos and invitingly oversized armchairs. It has a no-frills feeling to it, much like Detroit as a whole. In fact, the members are so lacking in pretense that many eschew the cachet of the South Course in favor of the more user-friendly North Course, which was also designed by Ross and opened for play in 1924.

By then the larger scaled South was establishing its reputation. The first tournament to be played on the course was the 1922 Western Open, then one of golf's most important events. Mike Brady, Oakland Hills' head pro, delighted the galleries by storming to victory. Hagen had recommended Brady for his post, after their spirited playoff at the 1919 US Open. In 1924 the US Open came to Oakland Hills for the first time, and Cyril Walker, a 118-pound Englishman, held off the great Bobby Jones by three strokes. Two more national championships followed, and both were won by players of note—Glenna Collett Vare at 1929 US Women's Amateur, and twenty-four-year-old Ralph Guldahl at the 1937 US Open, who shot a record 72-hole total of 281 to defeat Sam Snead by two strokes in the first of his back-to-back championships.

For the South Course to host four major tournaments in its first two decades was a testament to the strength of Ross' layout. Oakland Hills was laden with his classic design elements—large, artful bunkers; twisty, powerfully contoured fairways; and frightening, undulating greens that sloped severely from back to front and were more conducive to draining water in the winter than putts in the summer. It was to this canvas before the 1951 US Open that Robert Trent Jones added his own bold brushstrokes. It was Jones' opinion that "the game had out-run golf course architecture," and he took it upon himself to retrofit Oakland Hills. Jones' innovative approach was to have "two target areas, one for the fairway and one at the green, demanding double accuracy on the play of each and every hole. No mistake could be made without a just penalty." This was achieved by narrowing the already slender fairways with thick rough, adding a spate of new bunkers in the most inconvenient of places and reshaping the greens to allow for still more impenetrable pin placements. Ending with a par 70 that played a very long 6,927 yards, Jones' alterations created a course that tested the modern player like nothing before it ever had, beginning a trend that required more athletic swings and more sophisticated shot-making skills from the game's best.

Jones' work was featured in a *Life* magazine spread in the weeks before the Open, adding dramatic background to the events that followed. When the eminent golf writer Herbert Warren Wind followed with a celebratory article in the *New Yorker*, Jones' reputation soared. He soon became known as the "Open Doctor," and over the years was often imported by courses to strengthen their layouts prior to the national championship. All of this can be traced to the stir he caused at the 1951 US Open.

Hogan found he performed better when he approached golf courses coldly as an enemy, and when he lost the opening round battle to Oakland Hills with a 76 he seethed, telling his wife, Valerie, "That was the stupidest round of golf I've ever played in my life." But Hogan harnessed that fury to slowly but inexorably slay his dragon. He steadied with a 73 on Friday, and blazed the front nine Saturday morning round in a three-under 32. Still not totally in command, he struggled home for a 71, but Hogan was getting closer. He was only two strokes back of co-leaders Bobby Locke and Jimmy Demaret. Hogan's surge up the leaderboard had captured the attention of the gallery, which was estimated at 17,500, easily a one-day record for the sport at that time. Before going out in the afternoon, a quietly determined Hogan took a deep drag of a cigarette and in a hard whisper told USGA executive director Joe Dey, "I'm going to burn it up this afternoon." Well ahead of the final pairing, Hogan shot a flawless 35 on the front nine, creating a near stampede as fans rushed from the far corners of the course, magnetized by the emerging Hogan mystique. Gaining momentum, Hogan's 2-iron shot covered the flag from 200 yards out on the brutal 448-yard 10th

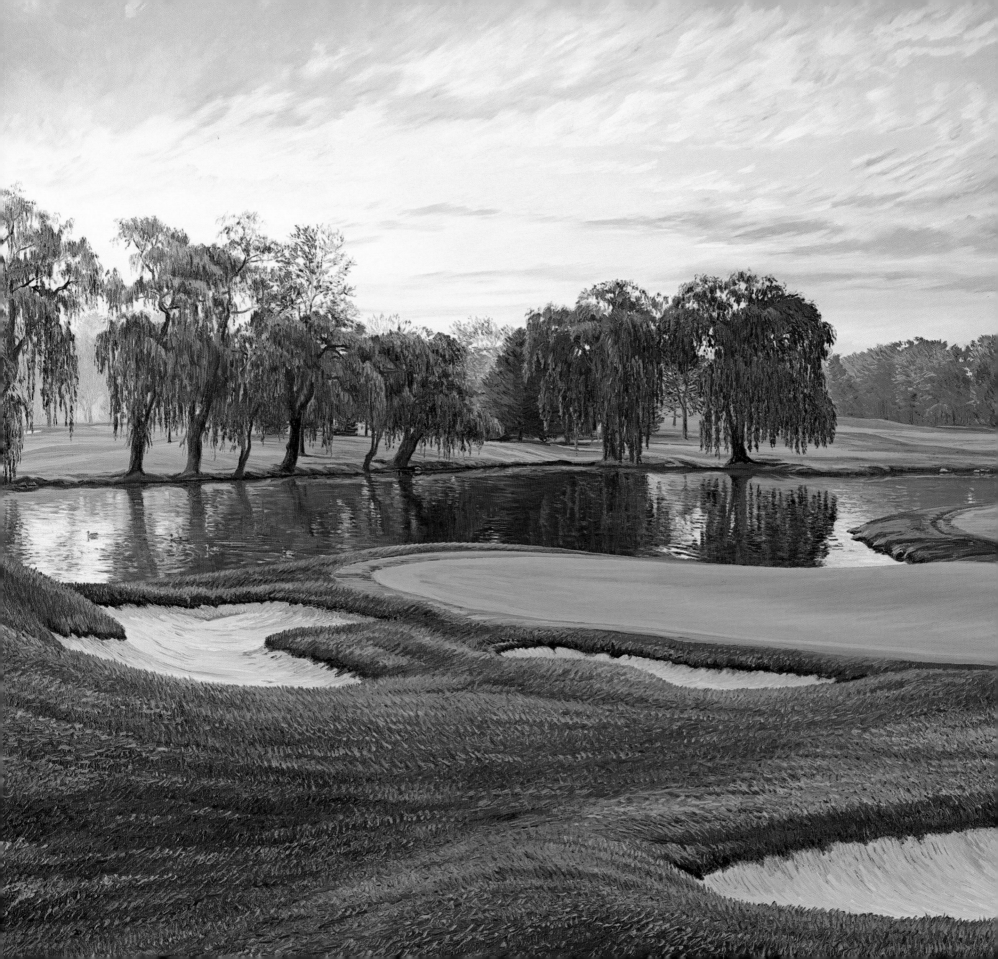

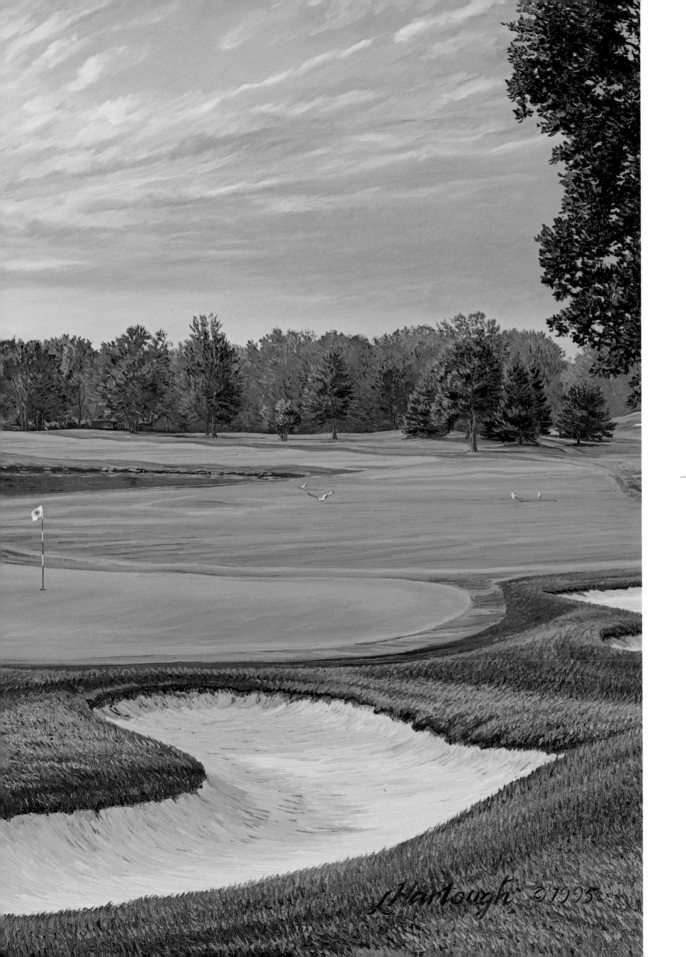

OAKLAND HILLS COUNTRY CLUB
THE 16TH HOLE, SOUTH COURSE
403 YARDS, PAR 4

*Robert Trent Jones revamped the 16th in 1951, reducing
the fairway down to less than thirty yards in the landing
area. Gary Player's famous all-or-nothing 9-iron over willow
and water here won him the 1972 PGA.*

53

hole for a kick-in birdie. Three more birdies would ensue, including a stylish one at the last that extinguished the hopes of any remaining challengers. Hogan finished two shots ahead of Clayton Heafner whose fourth round 69 was the only other subpar score of the week. "This is the greatest test of golf I have ever played, and the toughest course," Hogan said. "If there is any tougher, I don't want to play it." In later years he would call his final round the best of his career.

As much as the 1951 US Open meant to Hogan, it did even more for golf as a sport. The epic result was burned into the consciousness of fans across the nation, lifting the game to "a new peak in public interest," in the estimation of *Golf World* magazine. In the process, Oakland Hills became one of the most respected shrines in the game.

In the years since, Oakland Hills has hosted three more US Opens (a record of six total), two PGA Championships, and a pair of US Senior Opens. There have been many great moments—Gary Player's famous all-or-nothing 9-iron over water and a weeping willow on the classic 16th that won him the 1972 PGA and rousing playoff victories by Arnold Palmer at the 1981 Senior Open and Jack Nicklaus at the same championship in 1991. But no matter what the future brings, Oakland Hills will always be remembered for Hogan's monster performance, and as the course that inspired it.

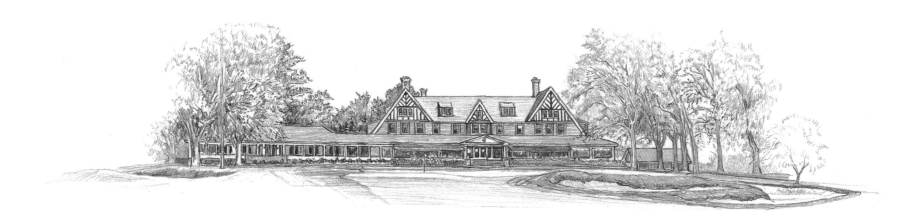

# OAKMONT

Oakmont is a living portrait of turn-of-the-century American optimism, a manifestation of the puffed-up belief that the best of the old world could be made bigger and better in the new. Built in 1903, Oakmont has remained remarkably unchanged for nearly a full century, forever marked by the ironclad determination of a Pittsburgh entrepreneur named Henry Fownes (pronounced "Phones") to build the toughest golf course in the world.

With the fastest greens and most severe bunkering to be found anywhere, Oakmont almost single-handedly represents the "penal" philosophy of golf architecture. Fownes had never built a course before Oakmont and never built another, but he had visited the classic courses of the British Isles, and he poured his autocratic Guilded Age mentality and unwavering beliefs about what golf should be into his masterpiece. "A poorly played shot," said Fownes, "should be a shot irrevocably lost." They were the words of an ideologue, but their spirit still lives at Oakmont, where the membership takes enormous pride in the knowledge that day in and day out, no golf course punishes mistakes more unsparingly and decisively.

Such a course, especially when it is meticulously maintained, is a magnet for championships, and Oakmont has held more than any other

American course—seven US Opens, three PGA Championships, one US Women's Open and four US Amateurs. Oakmont consistently required less doctoring than any other championship site; in fact, it has traditionally been made easier. Over the years, USGA officials slowed up Oakmont's lightning-fast greens, widened fairways, and smoothed the sand in its bunkers. "There's only one course I know of," Lee Trevino once said, "where you can step out and play the US Open right now. I mean today. And that's Oakmont."

Located on rolling land above the Allegheny River, fifteen miles northwest of Pittsburgh, Oakmont has a stark, brooding, rawboned atmosphere that announces the harsh test it will be. Despite being a prestigious club with a wealthy membership, Oakmont does not convey opulence. Its green, multi-gabled, Tudor-style clubhouse is modestly appointed and has a lived-in rather than grand aura. Much like Pittsburgh itself, Oakmont has a matter-of-fact, no-nonsense, unpretentious and muscular aspect that is also in concert with the personality of the favorite son of nearby Latrobe, Arnold Palmer.

Oakmont is not without its charms. Its 9th green is so immense that the top half, framed by the clubhouse, uniquely doubles as the practice green, creating an intimate atmosphere during competitions. A lone Victorian just to the right of the 18th green has been the home of its head pros for the last fifty years. And Oakmont is one of only two American courses, with Pinehurst being the other, that is on the National Register of Historic Places.

But Oakmont does not warm the heart. Since 1947, the Pennsylvania Turnpike has run almost exactly through the middle of it, dividing holes two through eight from the rest of the course. Although the course's trees are large and mature, they are not particularly colorful or varied and—except where they form a cooling canopy around the clubhouse—lack a majestic presence. Rather than closely framing the fairways, they are mostly set back slightly, allowing the course to retain the essence of the vast, exposed and near barren look Fownes desired. Oakmont is a course easily visualized in black and white, America's equivalent of that bleak, equally testing Scottish links, Carnoustie.

There were not a lot of gray areas in the way Fownes saw golf. An energetic model of the American Dream who made a fortune developing several Pittsburgh manufacturing businesses, Fownes, in 1896 at age thirty-nine, was told by doctors that he had arteriosclerosis and only a few years to live. The diagnosis proved to be incorrect, but the experience changed Fownes approach to life. He sold his small steel company to Andrew Carnegie, who then introduced him to golf. With the same will that had earned him a fortune, Fownes became an avid player who by 1907 had qualified for the US Amateur four times. He became obsessed with the idea of building his own course, and drew a detailed layout reflecting his stringent philosophy before he ever acquired any land. When he bought the rolling terrain on the Oakmont site, he cut down hundreds of oak trees to recreate the raw look he had admired in the links and moorland courses of Scotland and England. He then put 150 men and two dozen mule teams to work and within a year, had built a torture chamber—much longer than other courses of its day, with eight par 5s, one par 6, and total par of 80. It also had 350 bunkers—an average of nearly 20 per hole.

Even Fownes came to understand that his creation was too extreme, and with the help of his son, William, who won the US Amateur in 1910, revised the original course into almost exactly the same layout it remains today. The bunkers have gradually been reduced to 180, although until 1962 they were draconian. Because the clay-based subsoil and its lack of porous drainage precluded deep pot bunkers in the fairway, Fownes devised another way to guarantee that recovery from the sand could be nothing more than a short explosion back to the fairway. He built a special rake with a heavy weight across the head that left furrows two inches deep and two inches wide. "You could have combed North Africa with it," quipped Jimmy Demaret, "and Rommel wouldn't have got past Casablanca."

Fownes also insisted that his greens be as fast as possible. That meant cutting the grass blades at an almost impossibly low $3/32$ of an inch and further compressing them with a 1500-pound roller pushed by eight men. Former US Open winner Lew Worsham, who was the pro at Oakmont for thirty-two years, said, "This is a course where good putters worry about the second putt before they hit the first one."

## OAKMONT COUNTY CLUB
### THE 18TH HOLE, 456 YARDS, PAR 4

*By the time the golfer in a major championship at Oakmont reaches this 456-yard par 4, his game and psyche have undergone a complete examination. Oakmont has hosted seven US Opens.*

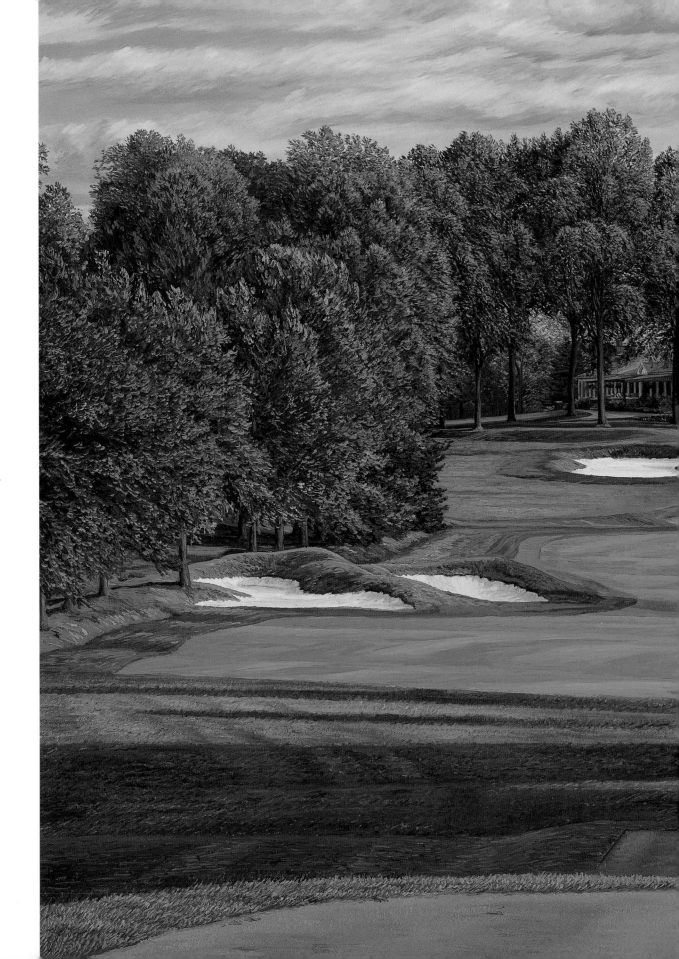

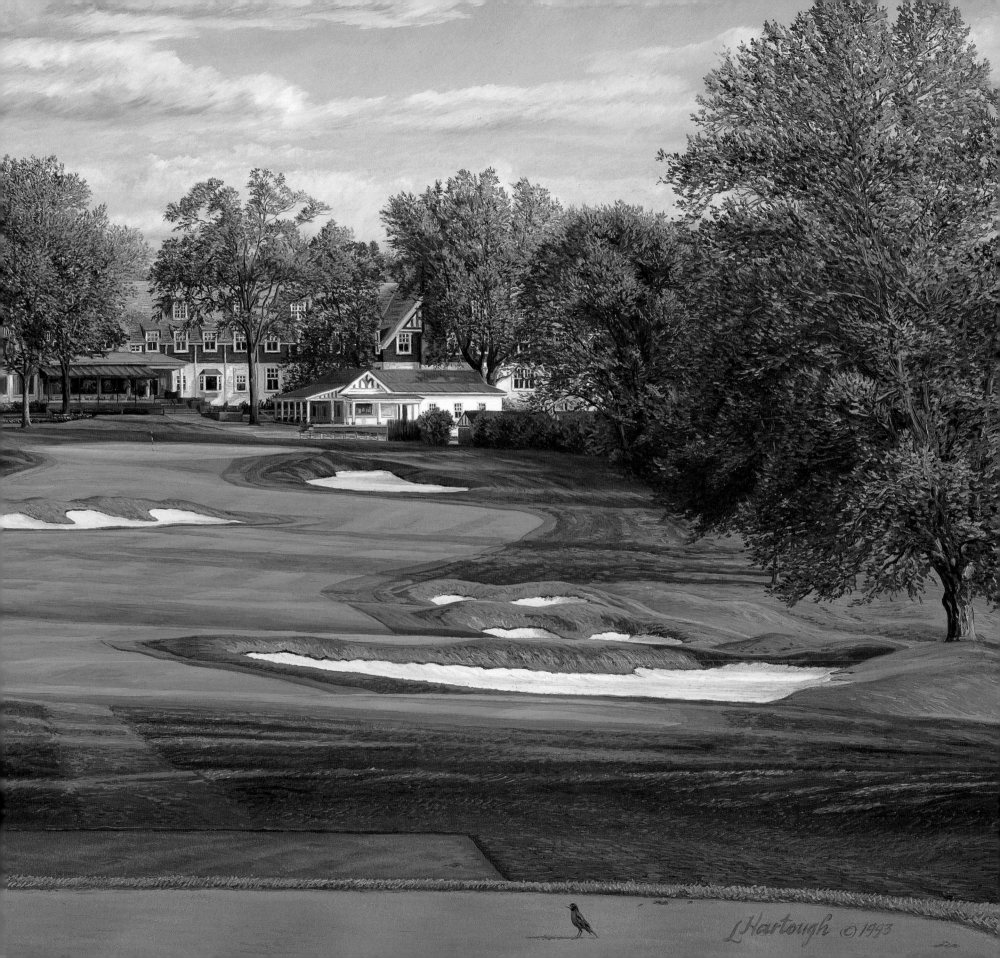

L Hartough ©1993

Oakmont begins with probably the hardest first hole in major championship competition, a par 4 of 468 yards with a downhill approach to a green built on a downhill grade. "The ball just keeps on going," says Ben Crenshaw. There is no let up. The second hole has a green so steeply pitched that putts from above the hole routinely roll off the green. On the third and fourth holes, the famous Church Pews bunker will capture hooked drives. Sixty yards long and up to forty yards wide, the bunker is traversed by eight grass-covered islands that are seventy-five feet wide and three feet tall. By the time the golfer in a major championship at Oakmont reaches the 456-yard, par-4 18th, his game and psyche have undergone a total examination.

Oakmont's US Opens in particular have been memorable. Tommy Armour won its first in 1927 in a playoff with Harry Cooper after they tied with a total of 13 over par 301, the highest score since 1913 and the last time the winner has been over 300. "I don't like it," said Armour, who birdied the 72nd hole by hitting a 3-iron to ten feet and making the putt. "You never simply played a shot at Oakmont, you manipulated it. And it was a great relief when the round was over."

In 1935, when local Pittsburgh pro Sam Parks used his familiarity with the course to win with 299, none of the twenty leaders bettered 75 in last round. When Sam Snead won the 1951 PGA, he joked that the dime he was using to mark his ball kept sliding off the greens. In the 1953 US Open at Oakmont, Ben Hogan produced an epic performance. On his way to winning all three major championships he played in that year, he led after every round at Oakmont and won by six strokes. It meant that Hogan had won four of the last five Opens he had played. Alas, he would not win another.

The 1962 Open was a watershed moment, when Palmer, then in the full flower of his career and playing before a heavily partisan and boisterous gallery, was tied in regulation and then beaten, in an 18-hole playoff, by twenty-two-year-old Jack Nicklaus. The biggest difference between the two players occurred on Oakmont's greens, where Palmer had thirteen three-putts and Nicklaus only one. "In those days I usually made the putts coming back," Palmer remembers. "At Oakmont I started missing them." In the playoff, Palmer almost mounted one of the magical charges for which he had

become known. Four strokes behind after six holes, Palmer cut the margin to one after the 12th. But the charge ended when Palmer three-putted the 13th, and he could sense there was uncommon steel in his young opponent.

"In the past, whenever I mounted a charge, I could almost feel that the player I was chasing was going to collapse and give ground," Palmer wrote in his autobiography. "But Jack Nicklaus was a different animal altogether, completely unlike anybody I'd ever chased. …I had never seen anyone who could stay focused the way he did—and I've never seen anyone with the same ability since."

At the 1973 Open, Oakmont made more history when Johnny Miller fired a championship record 63 in the final round to win by one. The impossibly low number seemed especially incongruous at Oakmont, but the greens were holding and slower due to rain during the week. Still, Miller was superb, hitting all eighteen holes in regulation figures, and even three-putting once. Ten of his iron approaches finished inside fifteen feet of the hole. The victory launched Miller into a brief but torrid prime that ended when he won the 1976 British Open.

As respected as it has always been, Oakmont has had few imitators and a diminishing influence in golf architecture. Indeed, its severity inversely spawned the "strategic" style of Donald Ross, Alister Mackenzie and A.W. Tillinghast that was more tolerant of the foibles of the average player, and more attuned to the varied skills of the best. But Oakmont endures, a singular shrine to a different time and an uncompromising vision.

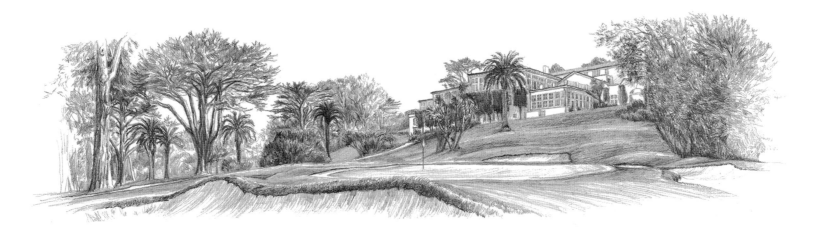

# THE OLYMPIC CLUB

Almost by definition, all of America's great championship venues are gardens of earthly delights. But hole-for-hole and amenity-for-amenity, the most comprehensively appointed is San Francisco's Olympic Club. Its three courses—the Lake, the Ocean and the par-3 Cliffs—sit on the rugged coastal edge of one of the world's great cities. It has a huge but harmonious red-tiled and cream-colored Spanish-style clubhouse that nestles beautifully into a hillside behind the Lake's 18th green. Six miles away, behind a classically pillared facade on Post Street in the elegant heart of San Francisco, Olympic's bustling six-story downtown athletic club is a center for exercise and fine dining. Finally, the club has a storied history of golf that includes four US Opens, two of which may be the most written and wondered about ever. When it comes to adding up its parts, Olympic totals a sum that is unsurpassed.

Of all of America's championship sites, The Olympic Club may be the all-around favorite. The United State Golf Association loves it for the competition it produces, its tight turf and ideal growing conditions, and the lack of summer thunderstorms that routinely wreak havoc at US Opens held in other parts of the country. Television loves Olympic for the deep hue of its emerald fairways, its world famous backdrops of shimmering hills and the Golden Gate Bridge, and the way its final round ends in prime time on the heavily populated East Coast. Spectators love it for its invigorating ocean air and the way its friendly confines provide perfect corners for viewing, not to mention the amphitheater behind the 18th that is the grandest in golf. And when the day's play is over, everyone loves San Francisco.

The player's love it, too, but in the way that children love a strict parent who has zero-tolerance for waywardness. The Lake Course's dense forest of some 30,000 firs, pines, oaks, cypress and eucalyptus hug the fairways so tightly that they form a virtual canopy over the tee boxes. Whoever said trees are 90 percent air never hit it crooked at Olympic, where the branches are likened to catcher's mitts. In one of American golf's greatest examples of architectural minimalism, Olympic's only other hazards are the severe bunkers that push up against the edges of its tiny and severely pitched greens. Out of bounds does not come into play, nor does water, and there is only one fairway bunker. Still, the Lake Course is a complete examination, demanding controlled driving, virtuosity with the irons, a nuanced short game and courage on the greens. It speaks volumes that Ben Hogan, who in his twelve US Open appearances between 1940 and 1956 won four times and never finished worse than sixth, called The Olympic Club his favorite Open course, and Byron Nelson, who spent a lot of time in San Francisco after he stopped competing regularly, said Olympic was his favorite place to play.

"It was the greatest training ground a golfer could have," said Johnny Miller, a San Francisco native who as a teenager had a junior membership at Olympic. "Just the purest, no-nonsense, hit-it-and-chase-it course in the

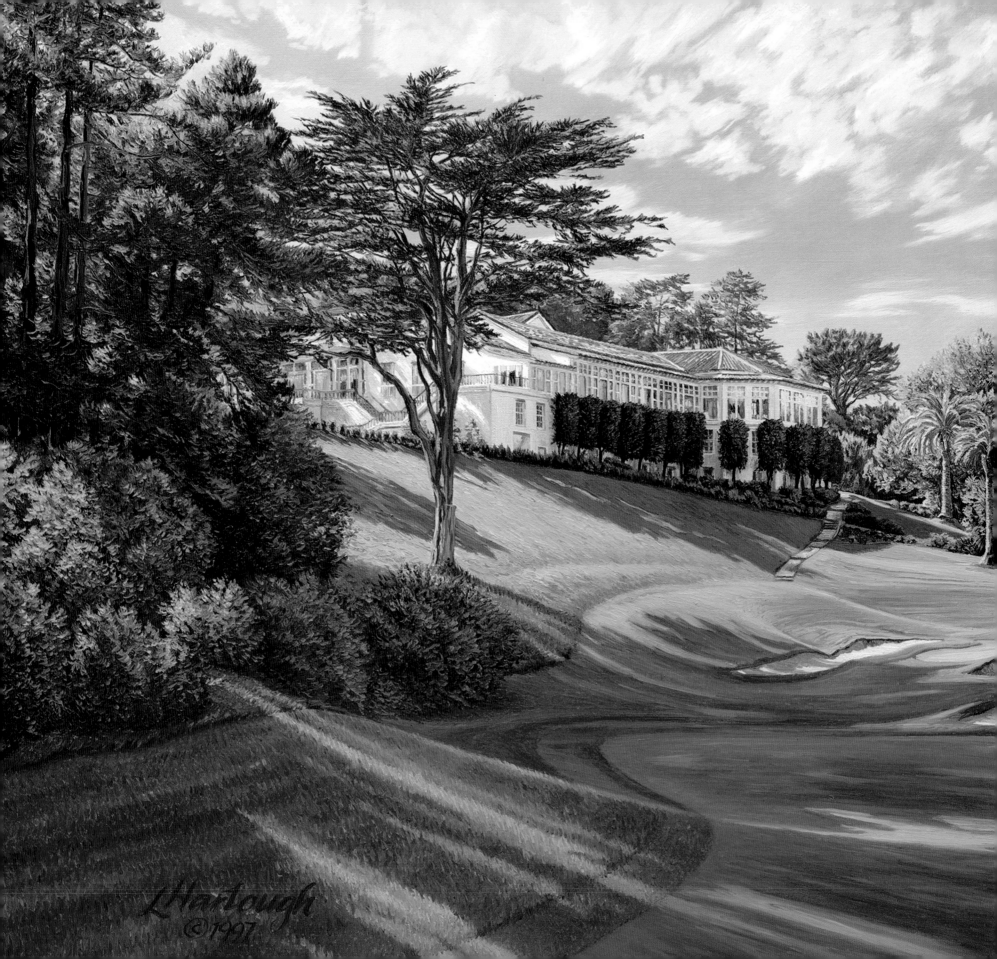

THE OLYMPIC CLUB
THE 18TH HOLE, LAKE COURSE
347 YARDS, PAR 4

*At only 347 yards, the 18th is deceptively difficult with one of the most treacherous greens in championship golf. It is also the greatest spectator hole.*

world." Olympic's strengths are a direct result of its location on San Francisco's western boundary, which in the 1920s was transformed from dunes into an enormous green belt that would also contain Golden Gate Park. "The sand dune owned by the Olympic Club," famed course architect Alister Mackenzie wrote during this period, "which although not as spectacular as that on the Monterey Peninsula, is the finest golfing territory I have seen in America."

It remains unquestionably special. Visually, the pervasive gray fog that regularly shrouds the landscape is both peaceful and foreboding. Physically, the air is invigorating, but the usual moisture drastically reduces the distance the ball travels, especially in the wind. For the Open, the par-70 Lake Course is laid out at only slightly over 6,700 yards on the card, but is generally conceded to be the longest playing course of that length anywhere. Built on a wavy hillside above Lake Merced, Olympic rarely offers a level fairway lie. And because the bent grass is generally damp, the golf ball tends to settle down in and close to the ground, producing what Miller calls "slime lies." The bunkers are filled with a heavy variety of sand that makes it difficult to apply backspin. Straight putts are rare on the greens, where the shifting land in this earthquake belt can make breaks change from month to month.

It's no surprise that Olympic has produced great players. San Francisco natives Miller, Bob Rosburg, and Ken Venturi all played Olympic regularly as teenagers, along with Harvie Ward, George Archer and Tony Lema—a group that collectively won two US Opens, two British Opens, two US Amateurs, a Masters and a PGA. Miller says the "reverse-banked" fairways, which cause the ball to bounce away from the direction the hole swings, ask a player to ideally produce a faded approach from a sidehill lie that favors a hook—and vice versa.

"The conditions give you a lot of tricky things you have to master, kind of force you to be good in every phase of the game or you can't really cope," says Miller. "Looking back, it was such an advantage for me. When I turned pro and would go to tournaments in deserts—with flat lies and the ball sitting up—it just seemed easy after growing up in the city."

And the city loved its golfers. When amateur golf was in its last heyday in the 1950s, San Francisco, boasting Ward and Venturi (who in 1954 took on Hogan and Nelson in a legendary best-ball match at Cypress Point, losing 1 up to a Nelson birdie on the 18th), was the American capital of the game. "It was the best city ever to be a good player in," remembers Ward. "It seemed like everybody played golf. You could walk into the best restaurants without a reservation and get sent right to head of the line."

Those days have ended as the public golf courses have become crowded and run down in San Francisco, but the Olympic Club has continued on its run of sustained glory. Founded in 1860, it was a force in international athletics, sending 22 of its members to the 1924 Olympics. "Gentleman Jim" Corbett boxed for the Olympic Club before defeating John L. Sullivan, Cornelius Warmerdam set world pole vaulting records while representing the Olympic Club, and Hank Luisetti who popularized the jump shot, played on the club's basketball team. At the dawn of the Roaring 20s, the thriving club bought the property of the old Lakeside Golf Club, and built two courses on it. When they were ravaged by earth slides that caused several spectacular holes on the Ocean course to be permanently lost, Sam Whiting, an Englishman who had been Lakeside's professional, did the redesign that has remained the essential layout. He also planted the trees on the essentially barren landscape that would become Olympic's signature feature. By 1954, the trees framed verdant corridors, and Robert Trent Jones toughened the course further in preparation for the 1955 US Open, Olympic's debut on the game's greatest stage.

It did not disappoint. The only other time the national championship had come to the West Coast, in 1948 at Riviera, Hogan had shattered the championship record. To insure that didn't happen again, the USGA installed Italian-rye rough, leaving it so high in places that it is still remembered as the most punishing in Open history.

Jack Fleck, an obscure 34-year-old pro from Davenport, Iowa, came to Olympic as one of only two men in the field playing a full line of Ben Hogan clubs. In fact, when Hogan himself arrived at the event, he delivered a wedge and sand wedge to complete Fleck's set. Hogan, forty-three, had

won four of the last five Opens he had played in, and was honed for a record fifth. In Sunday's afternoon round he crafted a careful 70 for a total of seven over par 287 that seemed to clinch it. When he finished, Gene Sarazen, the commentator for the first-ever live telecast of the Open, congratulated him on winning. Hogan demurred, but as he walked to the clubhouse, he approached Joe Dey, then the executive director of the USGA, and gave him his ball, saying, "Here Joe, this is for Golf House."

Fleck was on the back nine, needing a highly improbable closing 33 to tie, which became more improbable when he bogeyed the 14th hole. But he came back with a birdie on the short 15th, and managed pars on the very difficult 16th and 17th. On the 340-yard home hole, Fleck hit his 7-iron approach to eight feet, and made the putt. In the locker room, a bone weary Hogan who, since his accident in 1949, had to take long baths each morning to get enough circulation in his legs, dropped his head and cursed softly. "I was wishing he'd either make a 2 or a 4. I was wishing it was over—all over," he said. The next day, Fleck's "Open Coma" continued. Trailing by one on the 18th tee, Hogan slipped and pulled his drive badly into the overgrown rough, from where he took three more strokes before reaching the fairway. Fleck won, 69 to 72. A devastated Hogan announced he would play no more tournament golf, but the next time the Open came to Olympic in 1966, he was there, finishing 12th.

That year, the outcome was even harder to accept. Arnold Palmer, trying to regain the throne that Jack Nicklaus now held, played some of the best golf of his life for 63 holes, building a seven-stroke lead over playing partner Billy Casper. Walking off the 10th tee, Casper noted that Nicklaus was playing well and said, "I'm going to have to go just to finish second." Palmer replied, "Well, if I can help you, I will. Don't worry about it." He was referring to the strong play he was anticipating in order to break Hogan's scoring record of 276. "I thought maybe that would push Billy," Palmer explained later. "I never thought at that point that I might have been in danger of not winning. I put myself in a bad position with those words."

Suddenly the strokes started to melt away, in that nausea-inducing way that occurs too often in championship golf. On the 18th tee, Casper

was three under for the final nine, and Palmer was four over; they were tied. Then a visibly shaken Palmer hooked his 1-iron tee shot into the rough. "I doubt if I have ever felt as alone or as devastated on a golf course," he wrote in his memoir. He responded with a champion's heart, blasting a wedge with all his might to the back of the green, and then bravely holing a downhill six footer to get into a playoff. But the next day, Casper's steadiness proved too much, as Palmer lost an early three-stroke lead and was beaten, 69 to 73.

The upset became entrenched as a theme at Olympic when Scott Simpson out-dueled Tom Watson in 1987, but the finish was less startling in 1998, when Lee Janzen won his second Open, edging Payne Stewart. The Olympic Club has yet to produce an Open in which one of golf's giants emerges victorious, but that is about all it lacks. Until then, all of golf looks forward to the day when this magnificent club gets another opportunity to make history.

# PEBBLE BEACH

An American golf course could receive no higher tribute than to be chosen to usher in the new millennium as the site of the 2000 US Open, which will also mark the 100th edition of the national championship. Yet the honor won't significantly elevate the stature of Pebble Beach. Alone among this country's great courses, Pebble Beach transcends golf. It is closer to being considered one of the wonders of the world.

Molded against the same rocky shore near Monterey, California that Robert Louis Stevenson (a Scotsman who didn't play golf) once called "the most felicitous meeting of land and water that nature has composed," Pebble Beach is a universal exemplar of earthly beauty. Since the course began getting annual network television coverage in 1958 as the site of the Bing Crosby National Pro-Am, Stevenson's sentiments have become an international maxim, as evidenced by the amazing sum of more than $800 million the Japanese paid for the property in 1990. The property was resold in 1999 for $820 million.

Pebble Beach is a symbol of the good life, at the epicenter of a sensual feast that is California at its most abundant. The golf course and its environs are a gathering place for excess—cash, cashmere, and cachet abound among a jet set crowd that keeps The Lodge at Pebble Beach and the Inn at Spanish Bay, both five star resort hotels, filled. The pleasure principle rules, for Pebble Beach is the epicurean capital of America. San Francisco and its hedonistic heritage is only 120 miles to the north, the Esalen Institute—the cynosure of New Age indulgence—only an hour south amid the canyons of Big Sur, pointing the way down the coast to the "La La Land" of Los Angeles.

Pebble Beach long ago ceased to be the rustic enclave where artists and golfers moved freely and horse drawn carriages traversed the 17-Mile Drive. At its worst, the modern Pebble Beach experience gives the impression of a slick artificiality that is the inevitable result of a factory philosophy that processes big spenders like so much Velveeta. A stay in either hotel averages $400 per night, plus a $275 (!) green fee to play Pebble. But at its best, Pebble Beach is the Golden State at its most glistening. At Pebble Beach, on a brilliant day—or even a slightly overcast one—it's easy to understand how arch New Englander Ralph Waldo Emerson could write, "The attraction and superiority of California are in its days. It has better days, and more of them, than any other country." The founder of Pebble Beach, a human dynamo named Samuel Morse, was also onto something when he opined that "the effect of the Monterey Peninsula is to make one want to shout, to run rather than walk."

If you are a golfer at Pebble Beach, the excitement level is multiplied. There is little dispute that Pebble Beach is the most visually stunning course in the world. The most dramatic sight in the game comes from the apex of the 6th fairway, looking down along the coast to the three best and consecutive par 4s anywhere, the 8th, 9th and 10th, all framed against the curve of Carmel Bay and the mountains beyond. Pebble Beach's aura is also enhanced as a place where man is routinely humbled by nature. The Crosby,

(now the AT&T Pebble Beach National Pro-Am) has provided plenty of occasions when the weather was so fierce that the golf took on the aspect of a cosmic joke. At Pebble Beach, the wind can blow so hard that seagulls are reduced to walking, and wind coupled with driving rain, hail and even snow, can make controlling a golf ball nearly impossible. Thus the Pebble Beach legend is dotted with events like Arnold Palmer taking a sextuple bogey 9 in the foaming Pacific behind the 17th, or Sam Snead using a putter off the tee at the 120-yard downhill 7th to avoid leaving his ball at the mercy of a gale. It is Johnny Weismuller, after playing through a storm in 1960, saying, "I've never been so wet in my life." Or Jimmy Demaret, waking to a snow covered course in 1962, piping, "I knew I got loaded last night, but how did I wind up at Squaw Valley?" And the wind blew so hard in the final round of the 1992 US Open that it created what is commonly believed to be the most difficult scoring conditions in championship history.

Tales of heavy weather can distract from just how good a golf course Pebble Beach is. For all its breathtaking scenery, it also happens to be a marvel of course architecture, which makes it, to many, the greatest course in the world. And with the 5th hole changed in 1999 from an inland, uphill par 3 to a cliffside hole, Pebble is even better. It now has seven consecutive holes on the Pacific Ocean, the most thrilling and exacting stretch of seaside golf in the game. Meanwhile, the inland holes are nearly all models of aesthetic and strategic design. It's an unbeatable combination. "If I had only one more round of golf to play, I would choose to play it at Pebble Beach," said Jack Nicklaus, who has won a US Amateur and a US Open on the course. "I can't imagine anyone ever creating a finer all-around test of golf in a more sensational setting."

Officially named the Pebble Beach Golf Links, the course is not built on true linksland, but rather along the tops of rocky headlands above Carmel Bay. Fully half its holes hug the coast, and in a more heightened way than a Scottish or British seaside links. Compared to the muted tones at the links, at Pebble the water and sky are bluer, the grass greener and lusher, the waves crash harder and the birds and seals make more noise. In some ways, Pebble is Scottish golf on steroids, but the classic lines and intimate simplicity of design save it from garishness.

That such an ideal site was saved for golf was due almost exclusively to the efforts of Sam Morse. In 1914, the former captain of Yale's football team was working for the Southern Pacific Railroad, where he was assigned to sell the company's vast holdings on the Monterey Peninsula. But Morse loved the area, and instead began his own firm, the Del Monte Properties Company, by buying some of the land himself—7,000 acres along seven miles of coastline for $1.3 million. Believing that the area would benefit from a world-class golf course, Morse set aside his choicest property for that project. Rather than hiring a well-known architect to design and build the course, Morse instead entrusted the project to one of his real estate salesmen, Jack Neville. A top amateur golfer who would win the California State Amateur five times, Neville had never built a golf course before but, like George Crump at Pine Valley and Henry Fownes at Oakmont, he would prove himself a novice with a native genius.

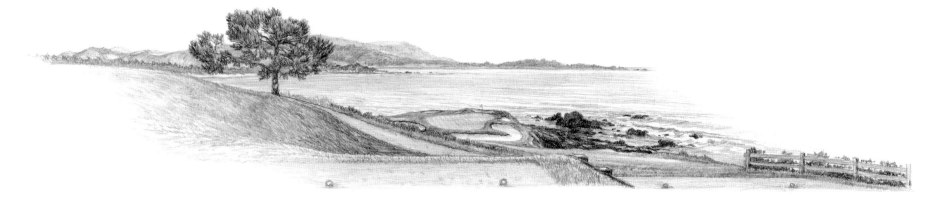

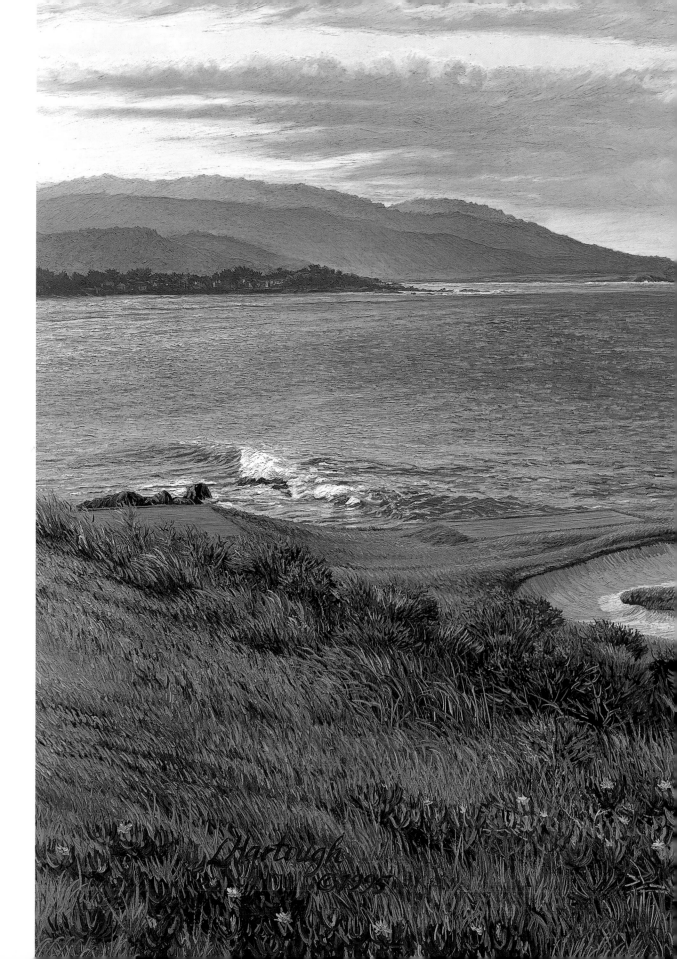

PEBBLE BEACH GOLF LINKS
THE 7TH HOLE, 107 YARDS, PAR 3

*The shortest hole in major championship golf,*
*the 7th is one of the most challenging and beautiful*
*par 3s ever built.*

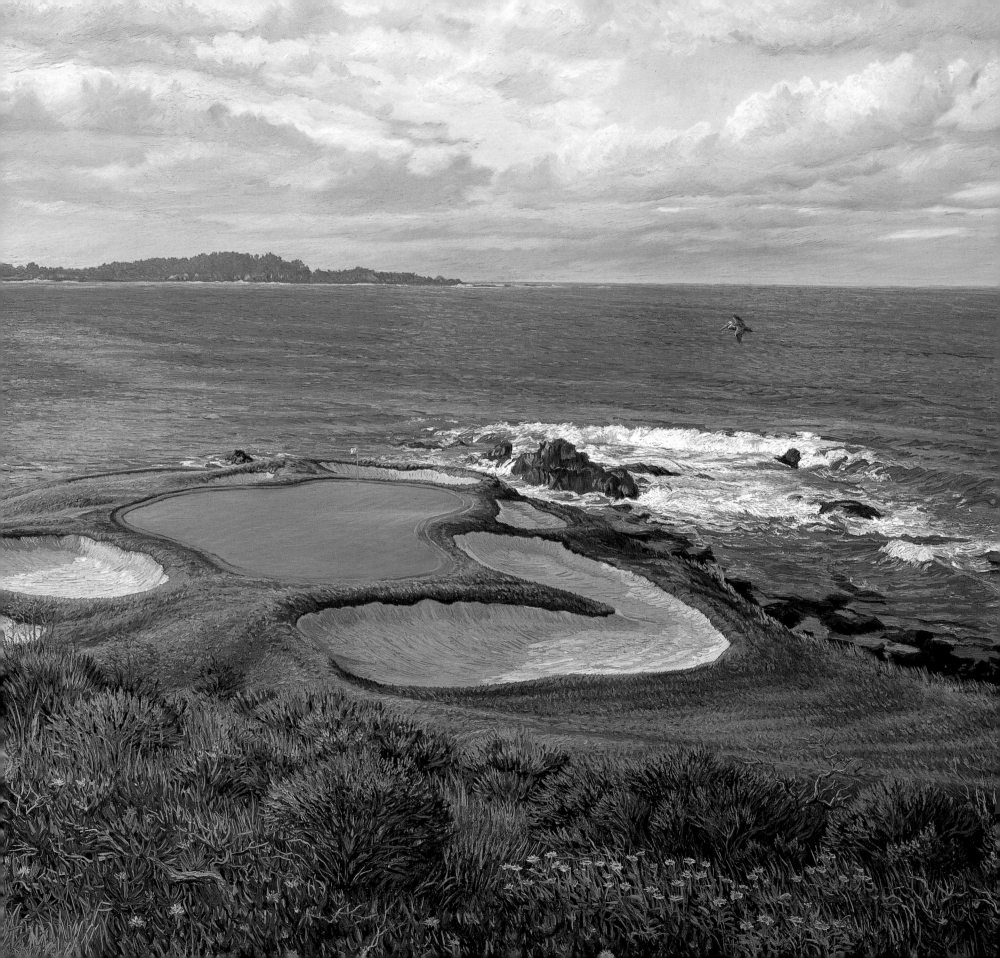

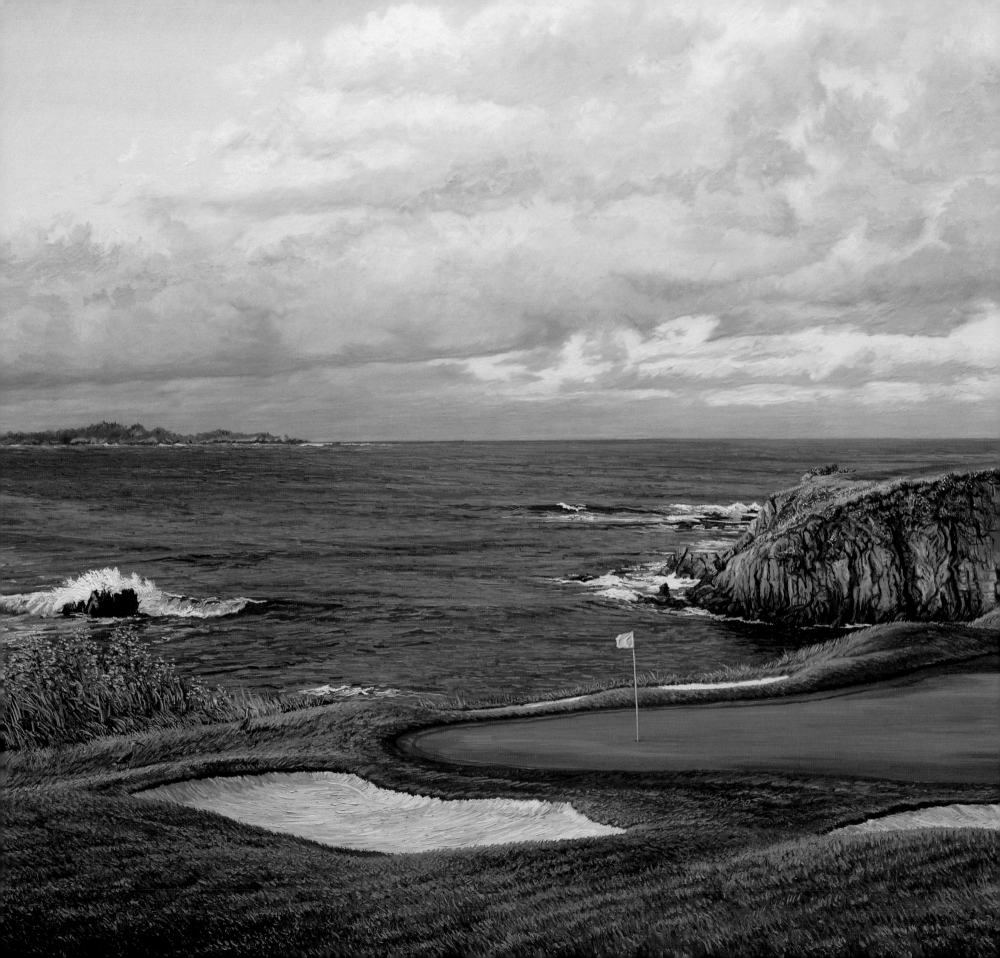

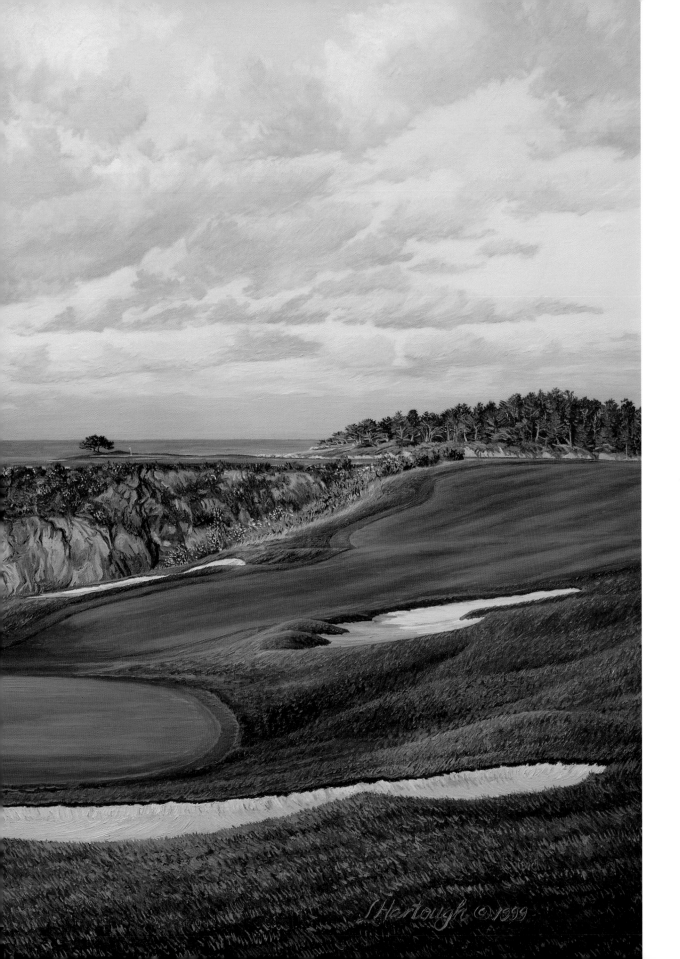

PEBBLE BEACH GOLF LINKS
THE 8TH HOLE, 431 YARDS, PAR 4

*Although only 431 yards long, the 8th begins with*
*a blind drive off a tee on the edge of a cliff, to the fairway*
*which is cut into by an elbow of the bay.*

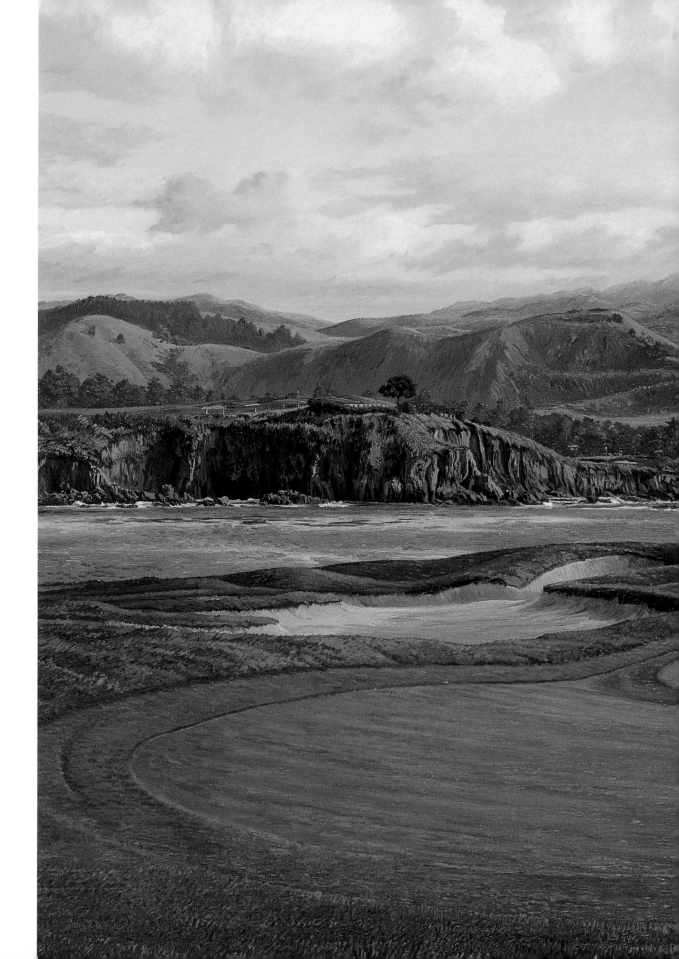

PEBBLE BEACH GOLF LINKS
THE 17TH HOLE, 209 YARDS, PAR 3

*The site of two of the greatest shots in US Open
history: Jack Nicklaus' pin-rattling 1-iron in 1972,
and Tom Watson's chip-in in 1982.*

70

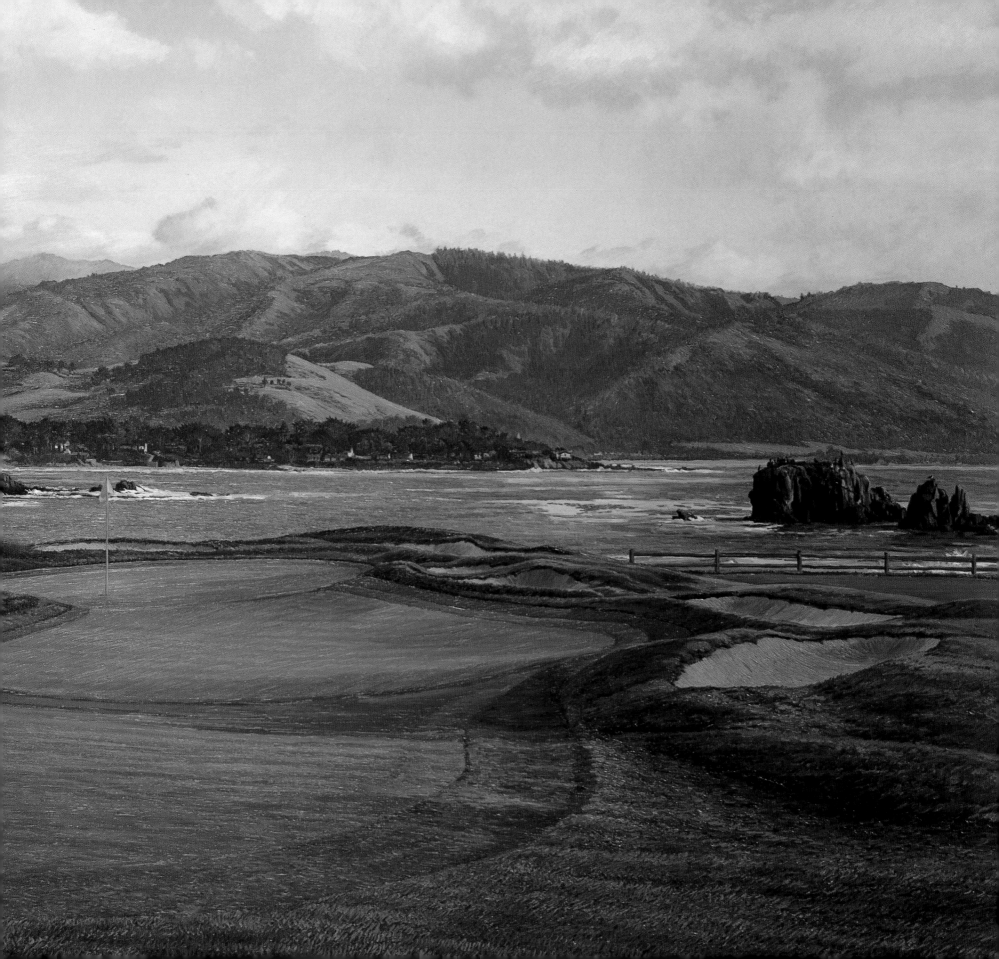

Neville and his friend Douglas Grant, also an outstanding California golfer who had visited and studied Britain's seaside links, came up with a "figure-8" routing that made the best use of the coastline. When Pebble Beach opened in 1919, it was immediately hailed as the most scenic golf course in the world.

Ten years later, in preparation for the 1929 US Amateur, Pebble Beach was remodeled and refined by H. Chandler Egan, the US Amateur champion of 1904 and 1905, into the layout it essentially remains today. Egan lengthened the course to very close to its present 6,809 yards, and improved several holes, including changing the 18th, originally a 379-yard par 4, into a heroic 540-yard par 5 that is widely regarded as the best finishing hole in the game.

As beautiful as it is, Pebble Beach's truest validation as a great golf course lies in the way it brings out the best in the best players in the biggest championships. It's been Pebble Beach's great fortune, but no coincidence, that Jack Nicklaus has played some of his most majestic golf there. Herbert Warren Wind once postulated that "the words Pebble Beach should be engraved on the heart of Jack Nicklaus."

Nicklaus first saw the course as a twenty-one year old at the 1961 Amateur. "I am not usually given to snap decision," he wrote, "but I fell in love with Pebble Beach from the moment I first played it in practice that year. …It is one of the supreme thinking man's courses in shot-making terms, and among the most testing I know of a man's grace under fire." Nicklaus went on to win in a dominating performance that the Amateur had not seen since Bobby Jones. Nicklaus never went beyond the 17th hole in any 18-hole match and won the thirty-six hole semi-final and final by the scores of 9 and 8 and 8 and 6. For the 112 holes he played, Nicklaus was an estimated 20 under par.

In 1972, the US Open came to Pebble Beach for the first time, and Pebble Beach became the first public facility ever to host the championship. Once again, Nicklaus came to the fore. With its greens particularly hard and fast, Pebble was diabolical. Said Billy Casper, "It was the first time you had to absolutely plan the perfect shot, shot after shot, then execute the perfect shot, then be lucky." Nicklaus, whose winning total was two over par 290, was the only player in the field to avoid shooting as high as 76 at least once. Before the final round, Nicklaus had a lingering nightmare in which he repeatedly came to the 17th tee with a three-stroke lead but still lost. "It was the worst dream I've ever had about golf—awful," he remembered. Yet on Sunday when he came to the 17th with a 3-stroke lead, he hit a 1-iron that hit flagstick and stopped six inches away. At the age of thirty-two, Nicklaus had his 13th major championship, equaling Jones' all-time total.

In 1982, Nicklaus was after an unprecedented fifth US Open title in what he reckoned would be his last best chance. After a careful 69 in the final round, it appeared he would get it, particularly when Tom Watson pulled his tee shot on the 17th into thick rough left of the hole and seemed certain to fall out of a tie for the lead. But Watson used to envision just such a situation as a student at Stanford, when he would rise well before dawn, make the hour and forty minute drive down to Pebble, and play 45 holes on one green fee on those occasions when the starter didn't let him on for free. Now on 17, Watson pulled out his sand wedge. "I had to hit a perfect shot just to get it anywhere near the hole," he said. "And right there in my mind I said, 'Well, the best thing I can do is hit the pin.' So when my caddy said get it close, I said, 'Close hell, I'm going to sink it.'" Struck with exquisite delicacy, the ball popped onto the green and hit the flagstick firmly before dropping into the hole. When he birdied the 18th, Watson won the championship that had eluded him by two strokes. Nicklaus was heartbroken, but he also understood the heart of a champion. "There is no question that it was one of the most sensational shots in the history of golf," he wrote. "I admit that it stunned me, but really it shouldn't have because I'd always known that what separates the great from the good players is their ability to visualize and will themselves into making superb shots when they most needed them." In the exquisite setting of Pebble Beach, historic shots seem to happen more often.

# PINE VALLEY

The world's greatest golf courses overload the senses, but no course overloads the psyche more than Pine Valley. The eye is filled with the stunning juxtaposition of dense forest and scrubby sand dunes surrounding islands of impeccably maintained grass, which, amid such a rugged mix, look as bright and polished as emeralds. Unfortunately, it is the trouble-laden periphery of this vista that usually captures and locks the golfer's attention at Pine Valley, inducing a fear that the merciless course seems to smell. Nowhere else in golf is the difference between an ordinary shot and a bad one so drastic—and nowhere else is the average golfer more likely to fall apart—than at Pine Valley.

It takes a strong game and stronger mind to overcome Pine Valley's intimidation, the kind of combination the young Arnold Palmer possessed in 1954. Palmer was the trophy-rich but cash-poor US Amateur champion who needed money fast to buy an engagement ring for Winifred Walzer. Feeling bulletproof, Palmer challenged the standing bet that no one could

break 80 at Pine Valley their first time, but Palmer added a twist. For every stroke under 70, Palmer would collect $100 from each of his three opponents, and for each stroke over 80, he would have to pay each of them $100. "In retrospect, it was pretty foolish," Palmer remembers, "I could have really lost my shirt." He was slightly unnerved by his first look at the course, amazed that it was both "manicured AND wild." Palmer survived a fright on the opening hole, where he had to make a thirty-footer for a bogey, but settled down to shoot a lucrative 67 that was enough to buy the ring for the woman known as "Winnie."

Palmer is the exception who proves the rule. Normal golfers who make their first appearance at this truly special place, (*Golf Digest* has chosen Pine Valley the best golf course in America every year since it began its rating system in 1966), almost always come undone. For the unskilled player, or even the fairly accomplished one who is given to spraying tee shots, Pine Valley is probably the most difficult course in the world. Set in the New Jersey Pine Barrens, about thirty miles southeast of Philadelphia, it is essentially one big sand trap dotted with islands of grass. Missing the islands means having to play from what Palmer called the wild part, where all the sand is left unraked, and where the foliage is often so dense that the option of two club-length relief from an unplayable lie is used less often than the more penal alternative of taking a penalty stroke and rehitting from the spot of the previous shot. Double digit scores are common, and first time visitors usually have at least one hole where they post an "X." It happened to Babe Ruth when he hooked his ball into bushes to the right of the monstrous 15th, took a few futile chops and got disoriented. Told by his partners to just try to get the ball back in play, Ruth yelled back from the jungle, "Forget the fairway. Where's the golf course?"

There is a school of thought that maintains Pine Valley is not that hard for a good player. After all, the fairways are wide, the length of the course is not overwhelming and the greens, while difficult, are among the smoothest in the world. During the Walker Cup matches in 1985 several players from America and Great Britain finished their matches under par. "Just stay away from the disaster shot," is the general counsel. But that's just the point.

What the good player has to deal with at Pine Valley is an unrelenting mind game. Knowing that a bad shot can ruin a round makes it that much harder to avoid one. The difference between playing Pine Valley and playing another course is like walking across a plank that is a foot off the ground, versus one that is suspended between two buildings one hundred feet high.

Pine Valley works on the golfer subliminally. There is a catalogue of stories that play off the difficulty of the course, like the one about the British Walker Cupper who stepped onto the tee of the 2nd hole, an astonishing par 4 which traverses a throat-tightening alley of fairway to a green perched above a moat of wasteland. "I say," he asked, "do you chaps play this hole, or just photograph it?" And then there are the names of some of the bunkers, like the sprawling Hell's Half-Acre on the par-5 7th, or the deep pot bunker in front of the short 10th that in polite company is known as the Devil's Aperture. Because disaster lurks everywhere, the golfer comes to feel that disaster, somewhere, is inevitable. "Just as prisoners break down at the sight of the torturer oiling his thumb screws and testing his electrodes," wrote Peter Dobereiner, "so the golfer who runs the gauntlet at Pine Valley loses his nerve just waiting for the moment when he hits a loose shot and runs up a score of double figures." What had been wide fairways become claustrophobic. The swing becomes tense and uncoordinated, and suddenly, the ball can go anywhere. "Pine Valley—just the sound of it can make you shank," wrote Dan Jenkins. "Pine Valley tests the mind as well as the stroke," says Bill Campbell, one of the great amateurs of American golf. "You must think

THE 10TH HOLE

well, and you can never make the mental mistake of trying to steer the long shot." But almost everyone does, and suffers accordingly.

Pine Valley is the epitome of target golf, its islands of grass forming a kind of connect-the-dots, point-to-point game plan for the golfer. Many of today's most controversial and difficult layouts—the "Stadium" courses at Sawgrass and PGA West, the spectacular first five holes at Spyglass Hill, or any of the courses where waste areas and water are prominent, owe a debt to Pine Valley. It was and remains a revolutionary golf course.

Because the landscape allows only minimal spectating, Pine Valley has never held a major championship and likely never will. It has only been on public view at the Walker Cups of 1936 and 1985—both won by the US team—and for a Shell's Wonderful World of Golf match in 1961 between Byron Nelson and Gene Littler that was won by Nelson. Still, Pine Valley has had as much influence on American golf as any championship golf course.

In 1912, when a group of rich Philadelphia businessmen decided they wanted to found a golf course they could play year-round, George Crump, a hotelier among them, was charged with finding the land. An avid outdoorsman, Crump went to a area where he often hunted in the Pine Barrens and found the kind of sandy soil that would drain during the wet winter and was close enough to the sea to possess a fairly mild climate. The syndicate bought 184 acres for less than $10,000 in 1913. (The club now owns 660 acres which have become incorporated as a borough of New Jersey.) Crump, a passionate golfer who had finished runner-up in the 1912 Philadelphia Amateur, sold his hotel and devoted the rest of his life to the golf course, eventually spending more than $250,000 of his fortune. Crump moved to the site, and lived like a hermit in a tent for six months and later in a small bungalow. He learned the land intimately by tramping through it with his hunting dogs. Crump had no golf course design experience, but he had some strong opinions, and had visited and studied the British Isles courses. He disliked holes running parallel to each other, holes where other holes were visible, and more than two holes running in same direction. As he considered what to do with his land, he listened to the advice of several top architects, including A.W. Tillinghast, William Flynn, and especially H.S. Colt, the

designer of Sunningdale in England and the final major remodeler of Muirfield in Scotland. Colt helped with the routing for Pine Valley, which ingeniously accomplished Crumps ideals and has remained intact to this day.

Using primitive earth moving equipment over the rugged terrain made construction a monumental project, and before Pine Valley was finished, some 22,000 trees had been cut down. In 1918, Crump died suddenly at age forty-six with only fourteen holes completed. Hugh Wilson, the architect of nearby Merion, was called in to finish the last four holes, 12 through 15. Colt revised the diabolical 5th hole. The course was completed in 1921.

Pine Valley is a masterpiece. Robert Trent Jones reckons there are ten great holes, five outstanding ones, two good ones and only one that is ordinary, the short, dogleg-left par-4 12th. For memorability, one of the hallmarks of a great golf course, Pine Valley is unsurpassed. Pine Valley may no longer be the hardest course in the game. The modern game and its equipment have made the course's length of less than 6,800 yards, short by championship standards, (Walker Cup competitors were hitting iron tee shots off several of the long holes), while several of the course's emulators have surpassed its model in difficulty. But Pine Valley remains an ultimate golf experience.

After entering the property, the visitor comes in over a driveway that crosses a lake and climbs to the understated white and green clubhouse. The grounds have a spartan theme, as if all extraneous activity were merely preparation for battle with the course. Even the ten-hole short course, a fascinating creation by Tom Fazio and Ernie Ransome, replicates the approach shots to come on eight of the holes on the big course. As he readies for the start of his round, the golfer becomes aware that the atmosphere is subtly charged. There is a crispness of movement by the employees, a quiet intensity rather than loud conversation among the other golfers, and a persistent dryness in the mouth. Even before a casual round, the golfer knows he will be tested in a unique and all too revealing way at Pine Valley. It may no longer be the hardest golf course in the world, but there is a fine and more enduring argument that it is the best.

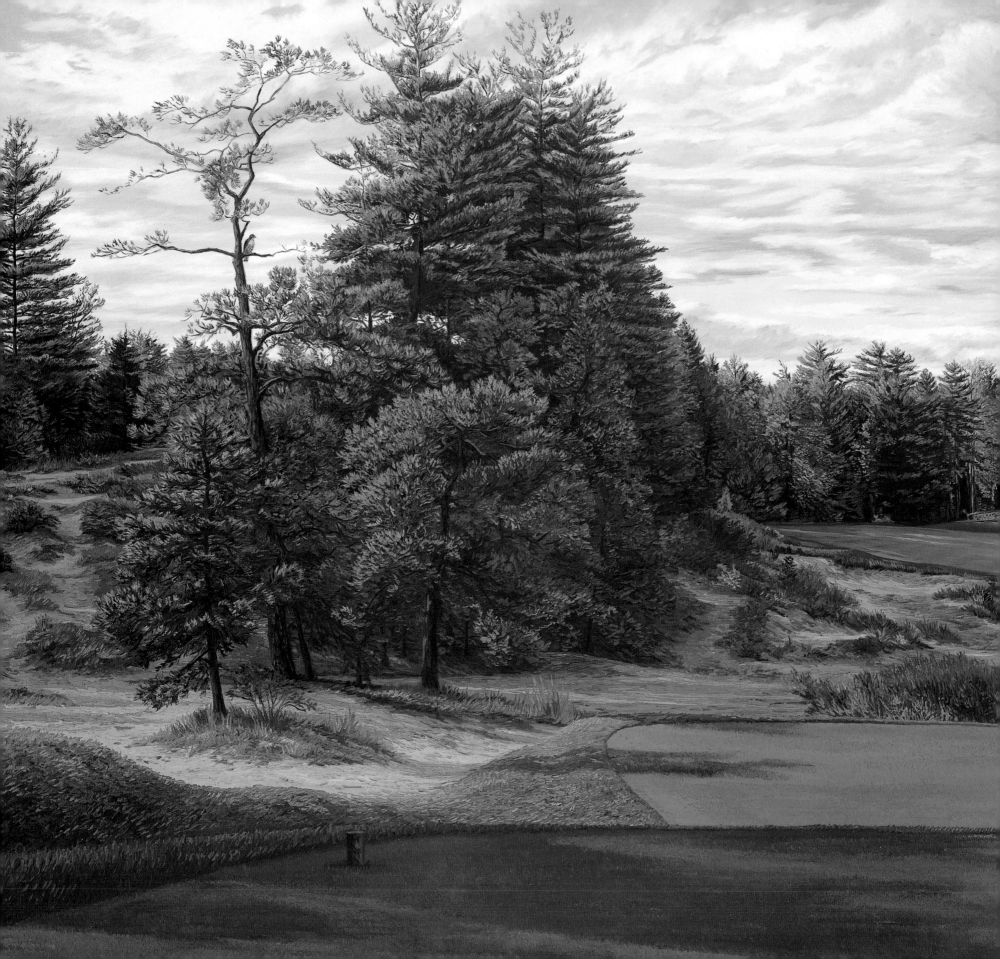

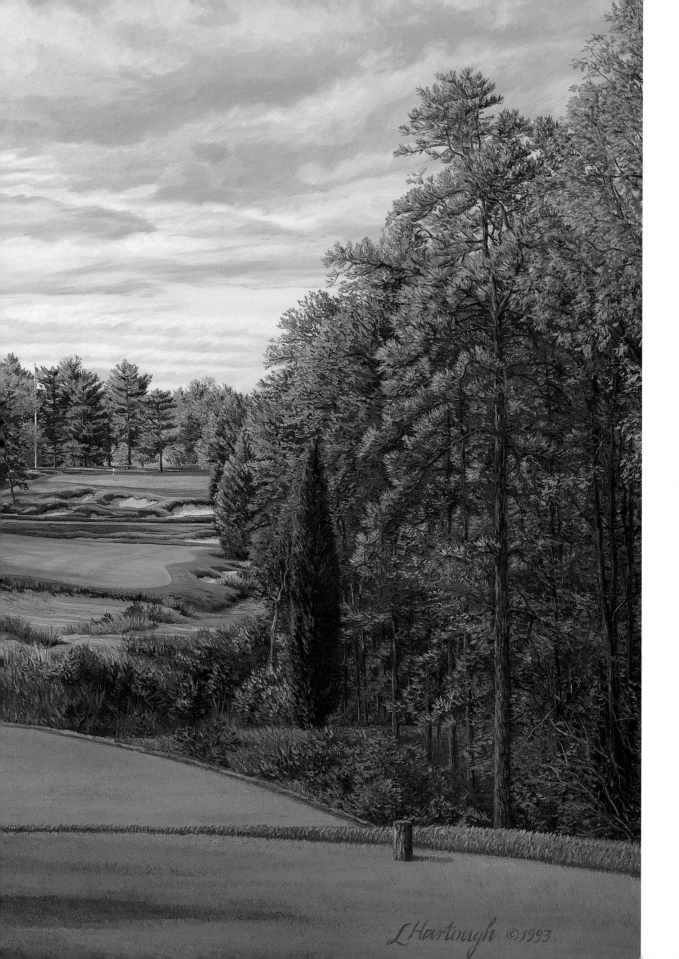

L.Hartough ©1993

### PINE VALLEY GOLF CLUB
### THE 18TH HOLE, 428 YARDS, PAR 4

*Consistently ranked the number one golf course in the world, Pine Valley has never held a major championship and likely never will due to its limitations on spectating.*

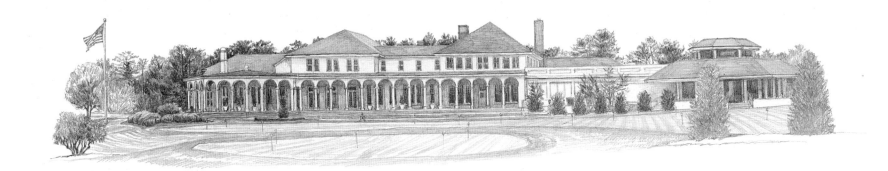

# PINEHURST

In the pithy shorthand of the game, Pinehurst is pure. In all of American golf, no place possesses more ideal components for a perfect day. The idyll begins the moment you wake up, clearheaded and refreshed from the cool and clean nighttime air that first brought visitors to this remote part of North Carolina, sixty-five miles south of Raleigh, in 1885. The lure of a robust Southern breakfast leads you on a brisk walk past the cottages, gardens and gracious people of the leafy New England-style village, designed at the turn of the century by the builder of Manhattan's Central Park, Frederick Law Olmsted. Entering the sweeping Mediterranean-style clubhouse with its terraced porches behind Tuscan columns, you breath in mahogany and history in a main hallway lined with photos of competitors dating back to six-time British Open champion Harry Vardon's legendary Pinehurst pilgrimage in 1900.

After collecting yourself atop Manica Hill, the first practice facility built in America and once described by Tommy Armour as "to golf what Kitty Hawk is to flying," you follow your caddy to the first tee of Pinehurst No. 2, the crown jewel among the resort's eight courses. No. 2 is extremely difficult, but it is also a course that unfolds so seamlessly that your excitement is tempered by an easy tranquility that caused Johnny Miller to reckon that "it's hard to get mad when you play Pinehurst." At dinner and well after, you will continue to discuss the mystique of this masterpiece. At Pinehurst, according to the late Charles Price, a longtime resident, "nobody talks about anything but golf, not politics, not religion, not even sex."

No, there is nothing quite like Pinehurst. As a mecca, it is often compared to St. Andrews, and indeed golf and the spirit of the game are everywhere. But Pinehurst also has its own distinct feel, one that its most habitual pilgrims are acutely attuned to but struggle to define. "There's something about Pinehurst," says former Wake Forest golf coach Jesse Haddock, who took his teams there hundreds of times beginning in the 1960s. "There's an aura or something that gets to all five senses." Bill Campbell, a former USGA president and a four-time winner of the North and South Amateur, which has been held continuously at Pinehurst since 1901, says, "Pinehurst is more than good golf courses. It is a state of mind and a feeling for the game—its aesthetics, courtesies and emotions." The definitive statement on the subject belongs to Armour, a blunt Scot who felt an undeniable ancestral tug at Pinehurst. "The man who doesn't feel emotionally stirred when he golfs at Pinehurst beneath those clear blue skies and with the pine fragrance in his nostrils," he said, "is one who should be ruled out of golf for life."

Pinehurst, and particularly its No. 2 course, is a unique blend of links and inland golf. Its gently rolling land has a sandy base, the result of distinct geological reaction to an ocean recession from a long-ago ice age. Located 100 miles from the Atlantic in an area known as the Sandhills, Pinehurst's turf is remarkably like the wonderfully firm and tightly woven variety found on the seaside links of the British Isles. At the same time, the groves of Carolina pines beautifully isolate the holes from each other in the tradition of America's classic parkland courses. "Ray Charles could have built a course at Pinehurst," architect Pete Dye once scoffed in reference to the ideal conditions for golf. But Dye is also one of the most devoted disciples

of the genius of architect Donald Ross and what he accomplished on No. 2, proudly admitting, "I've looked at that thing 'til I'm blind."

Despite such a felicitous setting, golf and Pinehurst came together by accident. James W. Tufts, a pharmacist and non-golfer from Boston who had made a fortune manufacturing the marble soda fountain that was so popular in drug stores, became interested in founding a winter resort area that catered to people with respiratory problems and chest ailments. He visited the Sandhills and, after finding respite from his own health problems there, purchased 5000 sandy and agriculturally worthless acres at the price of $1 an acre in 1885.

Meanwhile, Ross was growing up in his hometown of Dornoch, Scotland, playing golf and learning to be a carpenter. But when it was decided by the townspeople that Dornoch needed its own greenkeeper and pro, Ross went to St. Andrews to apprentice under Old Tom Morris, and then returned to tend his beloved home course in 1893. It was during this period that Ross befriended Harvard professor Robert Wilson, an avid golfer who visited Dornoch every summer. Wilson advised Ross to come to America, where golf was beginning to take hold. When Ross finally did come in 1899 at the age of 26, Wilson got him the job as professional at the Oakley C.C. in Watertown, Massachusetts, where Ross built the course. Soon after, Ross became acquainted with Tufts, who now had a nine-hole golf course laid out at Pinehurst to accommodate the increasing number of resort guests who had been bringing their golf clubs and bothering the cows in the dairy field. Tufts hired Ross to be the professional at Pinehurst, where he would stay in the job until his death in 1948.

Between 1901 and 1919, Ross used a mule and a drag pan system to build Pinehurst No. 1, No. 2, No. 3, and No. 4. Ross' goal was to create courses that every class of player could enjoy, so he favored wide driving areas and modest bunkering. "There should always be two ways to play a hole," he wrote, "one for the physically strong player and one for the man not so strong." Ross' courses possess balance, harmony and above all, a challenge for the good player. "Every stroke must be made with a full concentration and attention necessary to good golf," he wrote. "My aim is to bring out of the player the best golf that is in him." No. 2 may not be topographically dramatic or visually spectacular, but it is very stimulating when the golfer has a club in his hand, contemplating a shot. In fact, the better the player, chances are the better he will like Pinehurst. The best player of all, Jack Nicklaus, who grew up playing Scioto, a Ross design in Columbus, Ohio, calls No. 2 his favorite course from a design standpoint. He once said, "Other architects may lead a player to negative thinking on-course, but his courses led to positive thinking." Vardon's exhibition tour, in which he displayed a level of golf never before seen in America, brought positive exposure to Pinehurst, and the resort became a leader in the game's first great national boom. Pilgrims would play Pinehurst's courses, then go back to their home areas and eagerly start their own clubs, often calling on Donald Ross to build the course. Ultimately, Ross and his team completed more than 600 courses in the United States.

No. 2 became Ross' obsession when Bobby Jones chose Alister Mackenzie rather than Ross to be his co-designer for Augusta National. Wounded by what he perceived as a snub, Ross spent the last two decades of his life improving No. 2, determined to make it the greatest course in America. The key step was to finally replace Pinehurst's sand greens with grass greens. In 1934, after years of trying, Ross found a strain of Bermuda that would survive in the hot climate. Whereas Pinehurst's sand greens had to be flat, the grass allowed Ross to build green complexes defined by humps, hollows, swales and runoffs, much like Dornoch and St. Andrews. The undulations would have presented impossible drainage problems on anything but a natural, sandy soil, which few American courses have. Freed to carry out changes he had long visualized, Ross poured all his knowledge into renovating No. 2, making it the most challenging chipping course in the world.

"This mounding makes possible an infinite variety of nasty short shots that no other form of hazard can call for," wrote Ross. "Competitors whose second shots have wandered a bit will be disturbed by these innocent appearing slopes and by the shot they will have to invent to recover."

Architect Bill Coore, a native of nearby Thomasville who played at Wake Forest, expands on the problem of missing a green with an approach

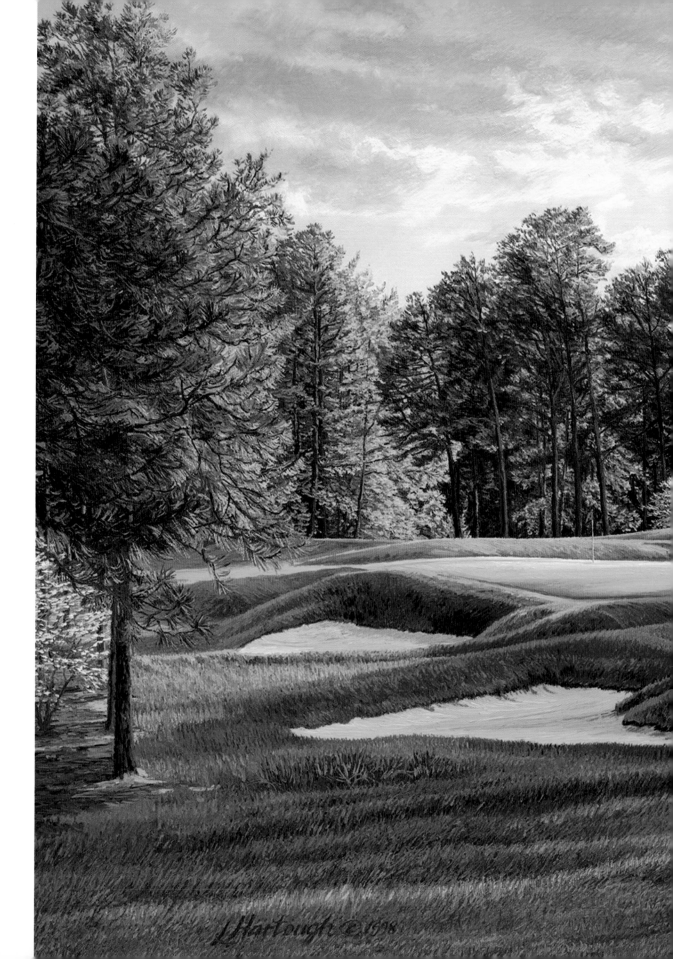

PINEHURST RESORT & COUNTRY CLUB
THE 5TH HOLE, PINEHURST NO. 2
482 YARDS, PAR 4

*A masterpiece of design by Donald Ross, the 5th at*
*Pinehurst No. 2 is the most difficult hole at Pinehurst,*
*both long and extremely severe around the green.*

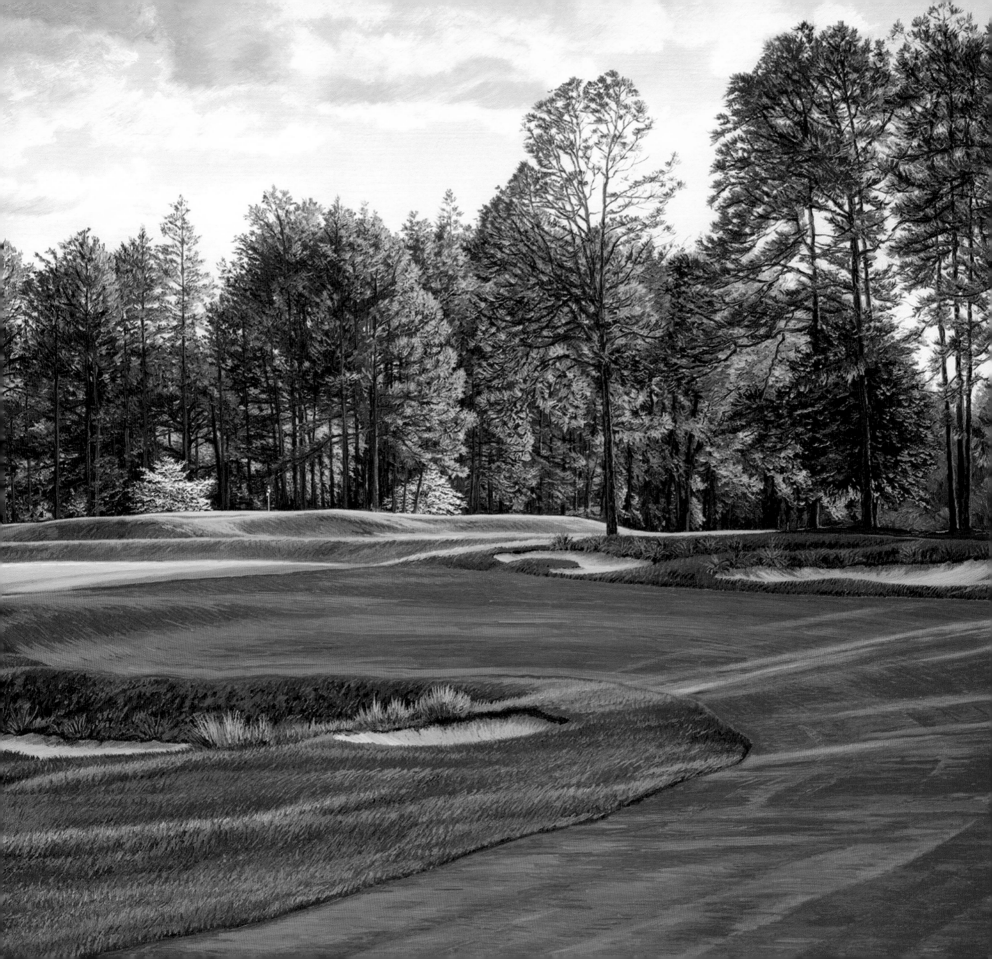

at No. 2. "People don't realize, the more options you give a good player, the harder it is to play a shot," Coore says. "So he makes a decision, and as he's standing over the shot, he's thinking, 'Am I doing the right thing?' The element of doubt is the only way par will stand up to the best players." The delicacy needed around the greens is No. 2's most distinctive quality, and it contributes to an overall feel of subtlety. Other than the 5th, one of the truly great par 4s in all of golf, none of No. 2's holes stand out as tremendously difficult. It is relatively easy for the average golfer to avoid disastrous scores on No. 2, for there is little out-of-bounds, no water hazards, and only light rough amid the generously open areas between the fairway and the pines. But the genius of No. 2 lies in how it exacts its toll. "The golf course takes strokes away in almost half shots, very gently," says Coore. "It lulls you into mistakes as opposed to bludgeoning you with them. Its greatness eludes people at first unless they're well-versed in golf course design."

Because of its geographic remoteness, Pinehurst has held few major championships. While the North and South Amateur has been won by players ranging from Francis Ouimet to Jack Nicklaus to Corey Pavin, and the North and South Open, which was last played in 1951, boasted champions from Ross himself to Ben Hogan, Byron Nelson and Sam Snead, the only major championships Pinehurst has hosted were the 1936 PGA, the 1962 US Amateur, and the 1989 Women's Amateur. But a long campaign by the game's wise heads was rewarded when the USGA chose Pinehurst as the site of the 1999 US Open. The championship was an unqualified success, with Payne Stewart holing a thrilling fifteen foot putt on the final hole to win by one stroke with a total of one under par 279.

Still, Pinehurst is more suited as a sanctuary than as a bustling venue. "Pinehurst's greatest attribute is its friendliness and calm," wrote author and resident John P. Marquand. "Peace never wholly leaves Pinehurst." Coore puts in the golfer's shorthand when he says, simply, "It feels so good out there playing." Either way, Pinehurst is pure.

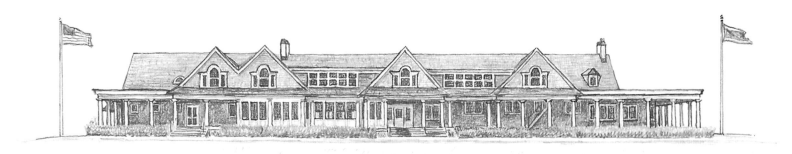

# SHINNECOCK HILLS

Among America's great championship courses, the truest heir to the classic British links is Shinnecock Hills Golf Club in Southampton, New York. Built on a thin stretch of land thirty-five miles from the eastern tip of Long Island, between the Atlantic Ocean to the south and Great Peconic Bay to the north, Shinnecock has all the elements of a seaside links even though it technically isn't one. Its turf and grasses are of a more inland nature, but in its spirit and distinctive look, Shinnecock emanates directly from the cradle of the game. Viewed from the long veranda of the rambling, circa-1892 clubhouse that overlooks the expanse of its property, Shinnecock possesses a vast openness. Its low hills are covered by a shaggy, multi-hued carpet of fairway and native grasses, with only occasional stands of small pines and blackberry bushes rising up to further accent the beautifully blended green and amber color scheme that gives the course its golden patina. The untamed links-like ambiance is reinforced by the brownish scrubland and large,

woolly-edged bunkers. The wind is constant, causing the shaggier grasses to ripple in waves, and the air to be heavy with an invigorating moisture from the nearby ocean.

Two adjoining courses, the National Golf Links and Maidstone, are architectural gems with similar properties, making the fashionable Hamptons American golf's paean to Scotland. The sense of the game's origins is so pervasive that USGA President William J. Williams began the 1986 US Open with a clearly understood bit of misdirection. "On behalf of the United States Golf Association," said Williams, "I would like to welcome you to Great Britain, for the first playing of the British Open in the United States."

In the same way as a seaside links, Shinnecock is thrilling to play. Although its rough is thick and punishing, the uncluttered design allows the player to feel there is space to hit the ball and freedom to maneuver it. Its fairways bend artistically with the shape of the land, giving the entire course a sense of natural flow. With its elevation changes, uneven lies, fast running turf and constant wind, Shinnecock incites exciting, creative and daring golf shots. "I love this course," says Lee Trevino, one of the great shot-makers in the history of the game. "It doesn't favor one kind of player. You can go high, go low, hook, fade, do what you want. I wish all our courses were like this." Although its first golf course was built before the turn of the century, the present Shinnecock Hills is a masterpiece by William Flynn, who helped create such classics as Merion, The Country Club, Cherry Hills and Cascades. Flynn was hired at the end of the 1920s when the original course was split by an extension of the Sunrise Highway. When he completed his work in 1931, Flynn knew he had produced a course that was both artful and architecturally sound.

As much as any championship course in America, Shinnecock gives the golfer options. Its greens are open in the front, so that the player has the opportunity to run the ball into the target—a necessity in heavy wind. At the same time, several of its greens are set on small hills and protected by bunkers cut close and deep into the slopes. Shinnecock's bunkers are indeed punishing, but their placement and aesthetic qualities also help frame shots beautifully. As Ben Hogan said in praise of Shinnecock: "You know exactly where to shoot and distance is easy to read."

Flynn established an ingenious blend of holes that alternate between emphasizing finesse and power. With six par 4s of more than 445 yards, Shinnecock tests perhaps the truest indicator of skill—the ability to hit long iron approaches to well guarded greens. Two leading examples are the 9th and 18th, both of which rise dramatically to the clubhouse. Such holes give Shinnecock an unmistakably muscular and near-epic majesty that makes it an unsurpassed arena for the best players in the game. "If I ran golf," says Johnny Miller, "the US Open would alternate between two courses— Pebble Beach and Shinnecock Hills. Shinnecock is just that good."

As one of the USGA's five founding original clubs—with Chicago, St. Andrews of New York, The Country Club, and Newport—Shinnecock Hills had an auspicious start when it held the second US Open and the second US Amateur in 1896. Then it fell out of the mainstream of championship sites, hosting only the 1900 US Women's Amateur, the 1967 Senior Amateur, and the 1977 Walker Cup. As the US Open became a major sporting event, Shinnecock was generally considered to have two insurmountable logistical problems. Although it is only two hours from New York City by car, Shinnecock's remote and confined location seemed a recipe for traffic nightmares. Secondly, Shinnecock is essentially a summer club, with play beginning in early May and ending in November. With no year-round staff or permanent residents, Shinnecock could not provide the volunteer support necessary to plan and put on a big event. But USGA insiders loved Shinnecock, and became determined to bring the 1986 US Open there. It rented Shinnecock and for the first time used its own employees to run every organizational aspect of the championship. Despite predictions of doom, this labor of love turned out to be a resounding triumph.

The golf world was reintroduced to Shinnecock in an opening round played on one of the stormiest days in Open history, with rain pelting the course, temperatures falling into the 50s and wind gusts in the thirty mile-per-hour range. No one broke par, and the average score was 77.8, the highest since a similar first round at Hazeltine in 1970. From there, good weather saw the course play at its breezy, fast running best, and the best shot-makers rose

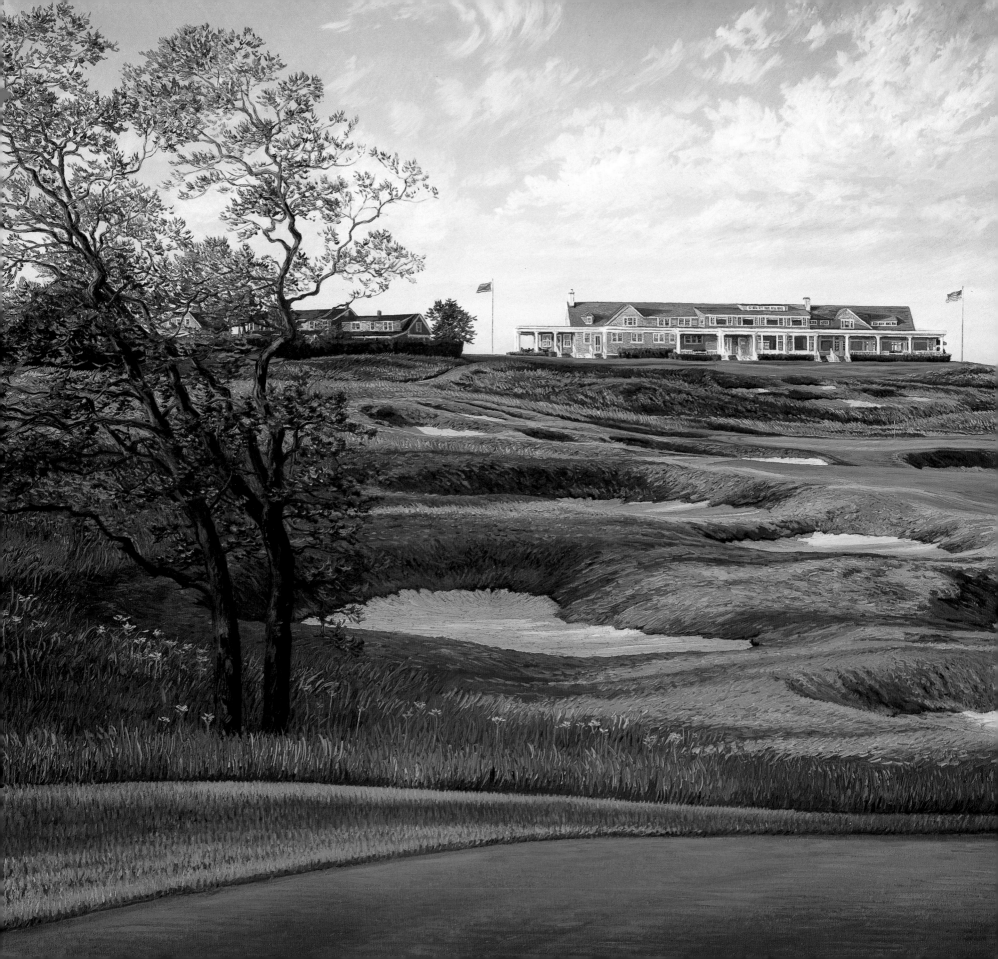

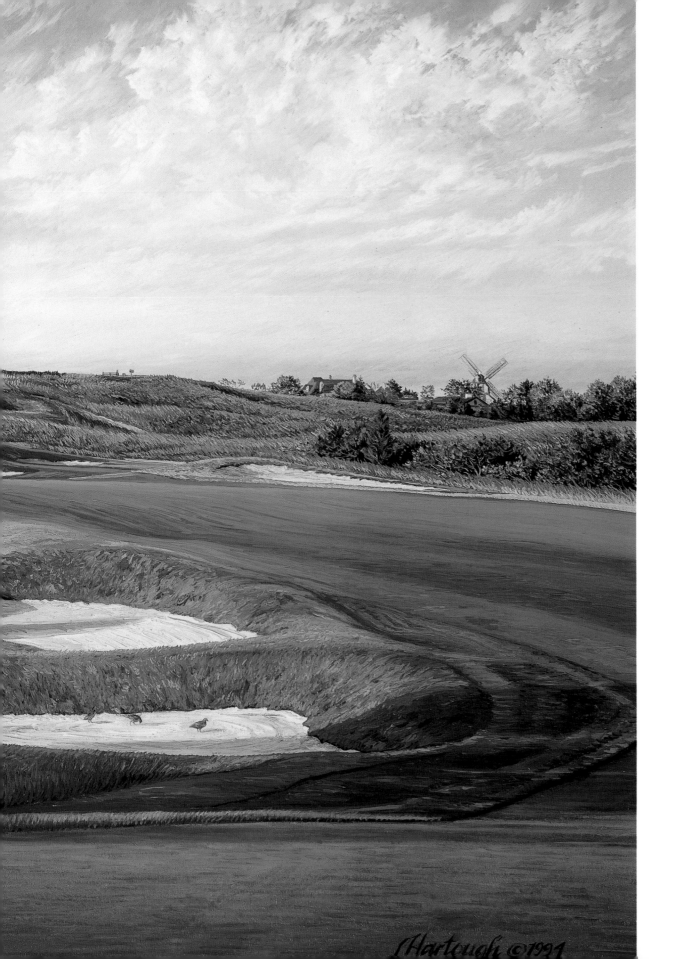

## SHINNECOCK HILLS GOLF CLUB
### THE 16TH HOLE, 544 YARDS, PAR 5

*Shinnecock Hills, reminiscent of a traditional links course, was one of the USGA's original five member clubs. The US Open was played here in 1896, and again in 1986 and 1995.*

to the top of the leaderboard. At one point on Sunday afternoon, nine players were tied for the lead, including Trevino, Lanny Wadkins, Ben Crenshaw, Hal Sutton, Raymond Floyd, Payne Stewart, Greg Norman and Bob Tway—major championship winners all. Finally, Floyd emerged with a bogey-free 66 for a 72-hole total of one under 279. His demeanor was so focused it gained it's own name—The Stare. "I've seen him win without it," said his wife Maria, "but I've never seen him lose with it." The Floyds are now members of Shinnecock.

The 1986 Open was so successful that it made Shinnecock the obvious choice to host the centenary Open in 1995. Corey Pavin, a specialist at shaping shots, won the championship. Pavin closed out his two-stroke victory with a classic shot on the uphill, 455-yard 18th hole. Countering a strong left to right crosswind, Pavin hit a low, drawing 4-wood from 230 yards away that bounced three times before reaching the green and rolling out to within six feet of the hole.

Pavin's was only the latest chapter in Shinnecock's long history. The club's genesis came in the winter of 1890 when tycoon William K. Vanderbilt was vacationing with friends near Biarritz in southwestern France where the Scottish professional Willie Dunn was designing a course. Dunn gave Vanderbilt's group an expert demonstration on a 125-yard par 3, hitting all his shots onto the green, and a few close to the hole. Fascinated, Vanderbilt said, "Gentlemen, this beats rifle shooting. It is a game I think might go in our country." When he returned to America, he and other wealthy men helped organize Shinnecock. Another Scottish pro, Willie Davis, (employed at the Royal Montreal Golf Club, which became the first golf club on this side of the Atlantic in 1873), was hired to lay out twelve holes adjacent to the Shinnecock Indian Reservation.

Forty-four men and ten women had purchased one to ten shares in the club at $100 a share. A nine hole women's course was also built. After finishing his duties in France, Dunn came to Shinnecock to incorporate the two courses into one 18-hole course. The club was incorporated in September of 1891, making it the first official golf club in the United States. It wasn't the first golf course in America, but as Herbert Warren Wind wrote, the country "for the first time had a golf course that looked like a golf course." Shinnecock instantly became the finest golf facility in the country, with members taking to the course wearing red coats with monogrammed brass buttons, along with knickers or white flannels. Amid the gaiety of the 1890s, Shinnecock became Long Island's favorite playground for the rich, and the first club to have a waiting list.

The club also enlisted Stanford White, the famed architect of the original and ornate Madison Square Garden as well as Pennsylvania Station, to build a clubhouse expressly for golf, the first ever in America. Wrote Alistair Cooke, "White regarded it as one of several experiments he had made in giving some substance and dignity to a native American form: the shingled country house." The clubhouse gained added distinction after 1906, when White, in one of the most celebrated murder cases of the century, was shot and killed by Henry K. Thaw, the wealthy husband of Evelyn Nesbitt, White's mistress. The club is so proud of the structure, all renovations have been strictly in concert with White's design, to the point that it has declined to install either central heat or air conditioning.

Although popular with the rich, Shinnecock, during the championship in 1896, also became known for celebrating the social underdog. One of the thirty-five competitors was John Shippen, a black man whose father was a Presbyterian minister at the reservation. Another player was Oscar Bunn, a full-blooded Shinnecock Indian. The day before the 36-hole event began, a number of professionals signed a petition stating they wouldn't play in the championship with Shippen and Bunn. USGA President Theodore Havermeyer, however, was decisive, telling the petitioners, "We will play the Open with you, or without you." None withdrew. When Shippen, who had worked on the labor crew that built the course, shot 78 in first round, he was only two strokes out of the lead. He remained in contention until the 13th hole of the final round, when he couldn't extricate himself from sand and made an 11. Shippen shot 81 to finish tied for sixth, seven strokes behind James Foulis, and won ten dollars. It was the beginning of Shinnecock Hills as a special place destined to hold special championships.

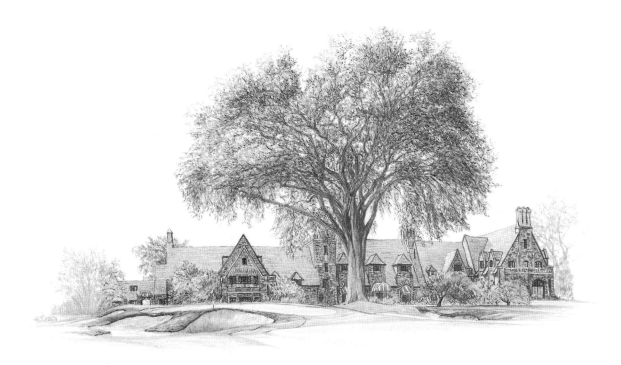

# WINGED FOOT

There's an unmistakable energy at Winged Foot Golf Club in otherwise sleepy Mamaroneck, New York. Some of it comes from the humming vortex of Manhattan, just 35 minutes down I-95. Part of it is due to the palpable eagerness with which the golf-loving membership—which numbers more than 1000—daily takes on the club's two artfully shaped and ultra-demanding courses, the West and the East. But there's also a surge that emanates from the sepia-toned photos of champions in the wood paneled clubhouse, as well as lively lore filled with names like Jones, Armour, Hogan and Harmon that holds men rapt amid slamming metal doors in the vast two story locker room. All of it, along with the bronze statue of a roaring lion that graces the front portico of the dazzling clubhouse, announces Winged Foot as one of golf's great battlegrounds. As the late Dave Marr, who served as an assistant professional at the club, once said, "Winged Foot is to golf what Yankee Stadium is to baseball."

Like the House that Ruth built, Winged Foot is big time. Set in a rugged geological region known as the Manhattan Prong, the courses were carved from heavily wooded foothills full of jagged outcroppings of glacial stone, impressing on the golfer a hard-edged feel even as it wends its way through bucolic groves of trees. Jagged, but precisely carved rock is also the motif of the clubhouse, a multi-gabled marvel of grey, brown and salmon pink stone and slate that is English Scholastic in style and worthy of a country home for Britain's royal family. The classic profile of the clubhouse beautifully frames the approach shots to the green, especially on the 9th and 18th of the West Course.

In this setting, essentially unchanged since the 1920s, grand things have happened. What is widely considered the greatest putt in the game's history was made at Winged Foot's West Course on the 72nd hole of the 1929 US Open by Bobby Jones. Jackie Pung suffered the saddest loss ever at the 1957 US Women's Open on the East Course when her winning total was disallowed because she had signed an incorrect scorecard. The 1974 US Open at Winged Foot, which Hale Irwin won at seven over par, was probably the most severe set-up ever perpetrated by the USGA. In 1984, the grandest gesture in Open history occurred when Fuzzy Zoeller, from the fairway of the 72nd hole, waved a white towel at Greg Norman, who had

just sunk a forty-five foot putt that Zoeller thought had beaten him. That event was also where USGA president Frank "Sandy" Tatum delivered a perfect aphorism to define the ruling body's philosophy toward its championship: "We're not trying to humiliate the greatest players in the world," said Tatum. "We're trying to identify them." And when Davis Love III won the 1997 PGA on the West Course, his 66 was not only the greatest finishing round by a winner of that major championship, it was accentuated by a rainbow that appeared on cue as he birdied the 72nd hole.

Winged Foot is a place where lessons are learned, even by the greatest. At the 1959 US Open, after nineteen-year-old Jack Nicklaus shot two 77s to miss the cut, it was abruptly brought home to him that he was not nearly as good as he had previously thought. Comparing his effort to that of veteran playing partners Gene Littler and Doug Ford, he realized "that when it came to the management side of the game, the head stuff, I still wasn't really a contender. I decided then and there that I had better set about truly learning the arts of what the South African champion, Bobby Locke, so aptly called, "playing badly well." Nicklaus soon mastered the art so well it became his greatest strength.

And in 1974, twenty-three-year-old Tom Watson was sitting disconsolately before his locker after blowing a two stroke 54-hole lead with a final round 79, when he was approached by Byron Nelson. "We went off into a corner," Watson later wrote, "and Byron told me that almost every golfer he knew had, at some time in his career, suffered exactly what I had just experienced. The pressure had gotten to them and they'd started swinging poorly." As Nelson softly counseled him, it began a relationship that Watson says was crucial to his development as a champion.

WINGED FOOT GOLF CLUB
THE 10TH HOLE, WEST COURSE
191 YARDS, PAR 3

*Course designer A. W. Tillinghast considered Winged Foot his greatest achievement. He was especially proud of the 10th which he named "The Pulpit" and considered the finest par 3 he ever built.*

88

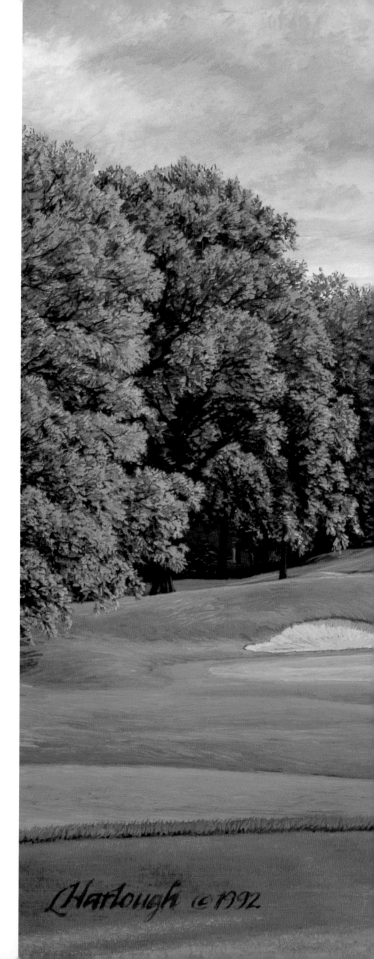

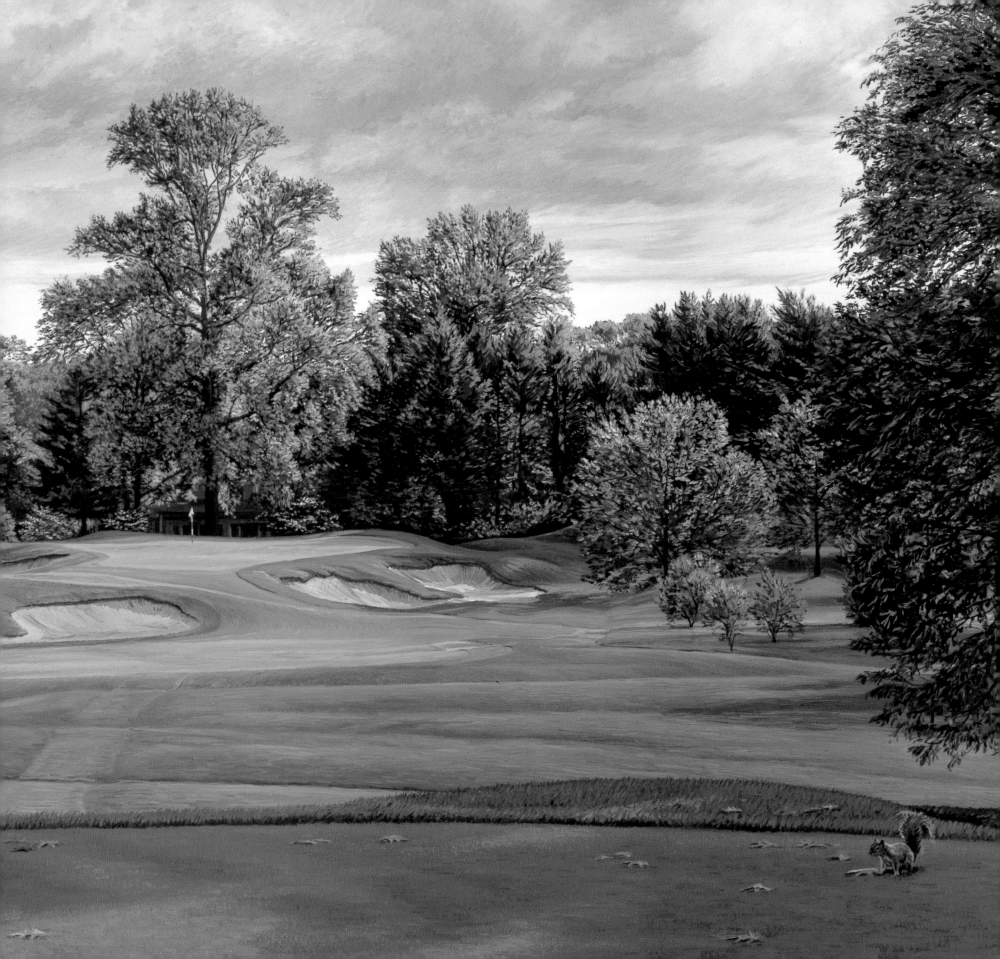

The man who built this immense stage was, fittingly, the most theatrical of all of the game's great architects, A.W. Tillinghast. Born in 1874, Tillinghast was the son of a Philadelphia rubber tycoon whose most popular product was a waterproof suit for ministers who baptized by immersion. "Tillie" as he was known, was a classic example of a spoiled rich kid. Playboy, raconteur, gambler and drinker were all terms that described him, but so did genius. The first, and perhaps only, celebrity golf architect, the flamboyant Tillinghast reached the peak of his popularity in the Roaring 20s, when he wrote a syndicated column, was a patron of Broadway plays, and held court in Manhattan hot spots with personalities ranging from Jack Dempsey to Leon Trotsky.

But it was when Tillinghast turned his intelligence and passion to golf that he truly left his mark. A crack amateur who finished 25th in the 1910 US Open, Tillinghast had studied the great courses of Scotland in his youth and even played with and picked the brain of Old Tom Morris. At age thirty-two, with no experience, but with an artistic eye and the confidence bred by a life-long sense of entitlement, he accepted an offer from a friend to build a golf course, Shawnee C.C., in Pennsylvania. It was hailed a success, and he followed it with a true masterpiece at the San Francisco Golf Club. He went on to create Baltusrol, Ridgewood, and Five Farms, establishing himself as a pillar, along with Donald Ross and Alister Mackenzie, of the "Golden Age" of golf architecture. But the Depression ended Tillinghast's lavish life. For a while, he consulted on courses for the PGA of America, but eventually could not sustain himself. He left golf and moved to Beverly Hills where he opened an antique shop that failed, and lived his final years with a daughter in Toledo, where he died in 1942.

When "Tillie the Terror" was asked to do Winged Foot in 1922 by the New York Athletic Club, he was at the height of his power. The club's mandate was to "build us a man-sized course," and for the grand sum of $12,800, he did. Like other masterpieces from the era, Winged Foot was essentially handwrought by moving and shaping dirt using a horse and pan. Bunkering was perhaps Tillinghast's greatest skill—"their shapes should be irregular, and the mound work ruggedly natural," he wrote—and his green-side bunkers are at once punishing and beautifully composed to define the target. Tillinghast believed "a controlled shot to a closely guarded green is the surest test of any man's game." Winged Foot is the epitome of that challenge.

Tillinghast was deeply satisfied by Winged Foot, his greatest achievement. "As the various holes came to life," he wrote, "they were a sturdy breed. The contouring of the greens places a premium on the placement of the drives, but never is there the necessity of facing a prodigious carry of the sink-or-swim sort. It is only the knowledge that the next shot must be played with rifle accuracy that brings the realization that the drive must be placed. The holes are like men, all rather similar from foot to neck, but with the greens showing the same varying characters as human faces." Tillinghast was especially proud of the 10th on the West Course, which he named "The Pulpit" and considered the finest par 3 he ever built.

Winged Foot was first thrust under the spotlight at the 1929 US Open. Bobby Jones led by four strokes going into the last round, and had widened the gap when he played the 8th, a long par 4. A fairly simple greenside sand shot became a disaster when Jones went from bunker to bunker and back again and made a triple bogey 7. "Once having seen how easily it could be done," Jones wrote, "I became afraid of every second shot, afraid of going into another bunker. I tried to steer them all, and I got the usual reward for my pains. …The first disaster was one of these things that can happen anytime you lower your guard. The balance of the round was an agony of anxiety." Jones made another triple bogey 7 on the 15th, and then three putted from twenty feet on the 16th, meaning he would need two pars on the difficult par-4 closing holes just to tie Al Espinosa. Gathering himself, Jones parred the 17th, but on the 18th pulled his approach slightly into a difficult lie in heavy grass and chipped short to twelve feet. Now he had a left to right downhill putt that he had to make or be guilty of the worst collapse of his career. Under the greatest pressure imaginable, Jones drew back Calamity Jane and struck the ball perfectly, causing it to die in the center of the hole. The next day, he beat Al Espinosa by 23 shots. Grantland Rice called Jones' effort on the 72nd "golf's greatest putt." He and O.B. Keeler both felt that if Jones had missed, the emotional weight of his collapse would have made

accomplishing the Grand Slam in 1930 impossible. Jones himself was less interested in what caused him to make the putt than what caused him to lose his lead. "Whatever lack others may have seen in me," he wrote, "the one I felt most was the absolute inability to continue smoothly and with authority to wrap up a championship after I had won command of it. …(At Winged Foot) I should have won by at least six strokes."

The championship was an auspicious debut for Winged Foot, and in the four subsequent times it held the Open, it has always proven a rigorous test. That wasn't surprising to Winged Foot members, a high proportion of who are single-digit handicaps who are particularly adept at the sand shot. Some of those skills have been imparted by a long line of distinguished professionals including Craig Wood, Claude Harmon and Tom Nieporte, and including assistants like Jackie Burke, Dave Marr, Mike Souchak and Al Mengert. Also holding court for many years on the practice and the grill-room was Tommy Armour, who made Winged Foot his home eight months of the year.

In such an environment, the golfing spirit is rich. It was at Winged Foot that the "Mulligan" originated due to longtime member David Mulligan's habit of following a mishit opening tee shot with a silent plea for a "take-over" shot. And Winged Foot members responded with heart and generosity when Pung's winning total of 298 over the East Course was disallowed because, while the final round total of 72 on her scorecard was correct, it also showed a 5 on the fourth hole rather than the 6 she had scored. In an effort to comfort Pung, Winged Foot's members immediately took up a collection that would total $3000, significantly more than the $1,800 Betsy Rawls collected for winning. It proved that not only is there tremendous energy at Winged Foot, it is the positive kind.

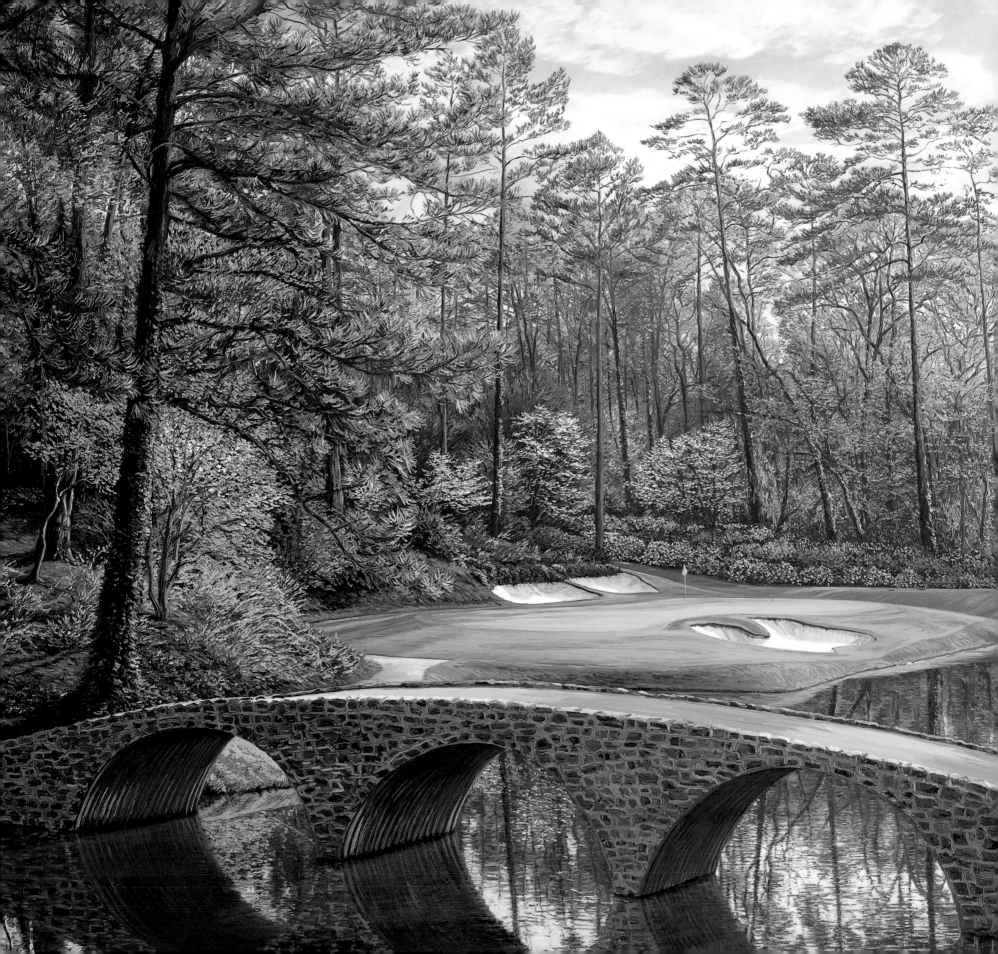

# THE AUGUSTA NATIONAL GOLF CLUB

## THE MASTERS TOURNAMENT

THE 12TH HOLE, "GOLDEN BELL"
155 YARDS, PAR 3

*With its swirling winds, narrow green and exacting
carry over Rae's Creek, this difficult hole has determined
the outcome of many Masters tournaments.*

CLUBHOUSE

ew men have ever had as much taken from them as Bobby Jones, if only for the simple reason that few men have ever received so many gifts. The most graceful, the most admired and the most accessible of all golf's champions lived the last two decades of his life crippled by an incurable, degenerative nerve disease, which first robbed him of his matchless ability to swing a club and then, all too soon, of his ability to walk. Jones never complained, saying only that "We all must play the ball as it lies." But in those moments when he felt his resolve flagging, Jones would ask to be wheeled to the spot where he first saw the breathtaking panorama of what would become his most enduring legacy: the Augusta National Golf Club.

"I shall never forget my first visit to the property," Jones wrote in his 1960 memoir, *Golf Is My Game*, recounting the magical moment in 1931, the year after he had ended his competitive career with perhaps the most singular achievement in the history of golf: the Grand Slam.

*The long lane of magnolias through which we approached was beautiful. The old manor house with its cupola and walls of masonry two feet thick was charming. The rare trees and shrubs of the old nursery were enchanting. But when I walked out on the grass terrace under the big trees behind the house and looked down the property, the experience was unforgettable. It seemed that this land had been lying here for years waiting for someone to lay a golf course upon it. Indeed, it even looked as though it already were a golf course, and I am sure that one standing today where I stood on this first visit, on the terrace overlooking the practice putting green, sees the property almost exactly as I saw it then. The grass of the fairways and the greens is greener, of course, and some of the pines are a bit larger, but the broad expanse of the main body of the property lay at my feet then just as it does now.*

The passage underlines the Augusta National's power of renewal, along with the strong sense that its founder was both its first and most poignant beneficiary. As Jones was in a position to understand better than anyone else, the ultimate appeal of America's most famous golf course, for all its trappings of wealth and influence, emanates from something much more pure, a rare kind of aesthetic splendor that makes anyone—golfer or non-golfer—feel that life is that much more worth living.

While it serves its elite membership in utmost privacy, the Augusta National's greatest value to the culture at large is as a unique personality. No other institution in America announces spring as emphatically as the Masters,

the only major championship in golf that returns to the same site each year. So forceful is Augusta's telegenic explosion of azaleas, dogwoods and unmitigated greenness on the collective unconscious that, at least for a few days in early April, otherwise arcane terms—Rae's Creek, the Crow's Nest, the Green Jacket, and Amen Corner—make up a shared refrain in a national ode to spring. An important part of this annual germination is that it marks the start of the big-time golf season. For the last 60 years, the Augusta National is where the game's elite get serious in the battle for supremacy, traditionally in neat units of three (Hogan-Snead-Nelson, Palmer-Player-Nicklaus, Ballestros-Norman-Faldo). Year after year, especially on a back nine as perilous as it is stunning, the Augusta National produces the best showdowns in golf.

The Masters' history is full of firsts. After Snead and Hogan waged an epic playoff in 1954, the Masters by consensus became the first and only tournament not aligned with an official ruling body to earn the title of major championship. It became the first golf club to be uniquely associated with the US presidency when Dwight D. Eisenhower became a member and frequent visitor during his two terms in office. The Augusta National is where Arnie's Army was born, where mounding was invented to improve spectator viewing, where the modern scoreboard was developed, and where leaderboards were first installed throughout the course. It is where Nicklaus first and finally gained the gallery's love, and where Tom Watson became the first to truly take the Golden Bear off the game's throne. Augusta is also where Woods stopped the world like no golfer—with the possible exception of Bobby Jones—had ever done before.

In American golf, the Augusta National was also a beginning. Built in 1932, it is not the oldest course, and there are others as venerated. But it is a course that went its own way in revolutionary design to ultimately become the course with which America is most identified. It looks like America as most of its citizens would like to see it, with its trees, ponds, bridges and quaint architecture suggesting the idyll of the classic small town. To the rest of the world, the Augusta National is what an American course should look like. Ironically, despite its influence, no other course looks quite like Augusta. Like any true original, it can't be duplicated.

Though it is in general like a majority of the more than 16,000 golf courses in the country that lie inland, a photograph or a painting of Augusta is instantly recognized for its distinct medley of light, shadow, color, space and balance. The view from beside the 13th green, perhaps the most beautiful in all of golf, reveals Georgia pines, white dogwoods, red azaleas, ivory sand, and the brown stonework of the Hogan and Nelson bridges. Augusta's grass seems to be a shade of green all its own, not as dark as that found in more northern environs, but deeper and richer than the strains from the rest of the south and Florida. Its stands of pines, while full and graceful, do not seem crowded, somehow allowing each tree its own identity and space. The overall feel is one of fresh fecundity. Above all, Augusta lives and breathes.

As influential as Augusta has been, it is really the spawn of golf's true beginning at St. Andrews. The Old Course was both a spiritual sanctuary and fountain of golf knowledge to Augusta's founder, Bobby Jones, and to its architect, Dr. Alister Mackenzie. Said Jones, "If I had to select one course upon which to play the match of my life, I should have selected the Old Course." Like the Old Course, Augusta is big and broad in its proportions and landscape. Its wide fairways look like they can't be missed, its huge greens seemingly easy targets. And at Augusta, the dearth of bunkers—only 45—adds to the spacious feel. But at both courses, there is an ideal route for the top-caliber golfer that requires precision and judgement. What makes the golf exciting, however, is that those who stray from the path are given the room and the opportunity to right themselves if they have sufficient nerve and skill to pull off something extraordinary. Augusta, even more than St. Andrews, is an arena for virtuosity. Without rough or exceptionally narrow confines, it is a place where the greatest players can do extreme things to a golf ball.

The examples are many, but the left-handed Phil Mickelson struck one at the 1996 event that stands out as an ultimate Masters shot. After pushing his drive badly under the trees to the left of the fairway on the 435-yard par 4, 9th hole, and with about 180 yards left to the green, Mickelson hit his driver off dirt and pine straw and fashioned a low, screaming seventy-yard slice that ran up the hill to the green about eighteen feet from the cup.

## THE 6TH HOLE, "JUNIPER"
### 190 YARDS, PAR 3

*An innocent-looking hole from the tee, its green is
one of the most fiendish on the course.*

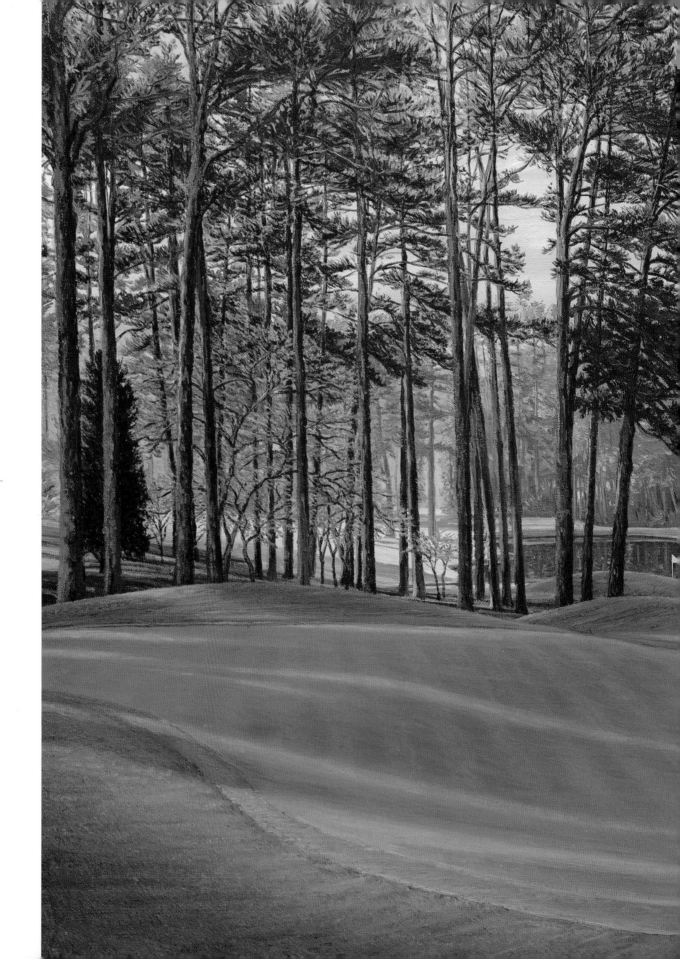

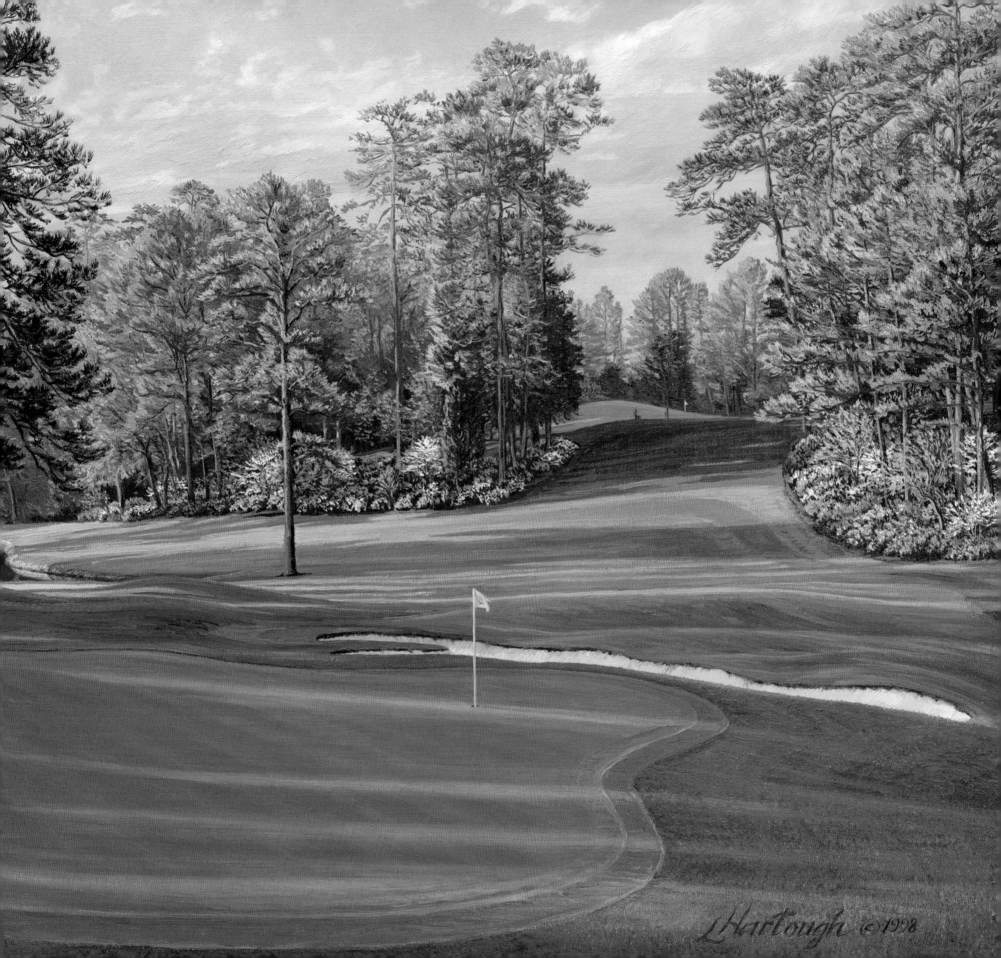

Hartough ©1998

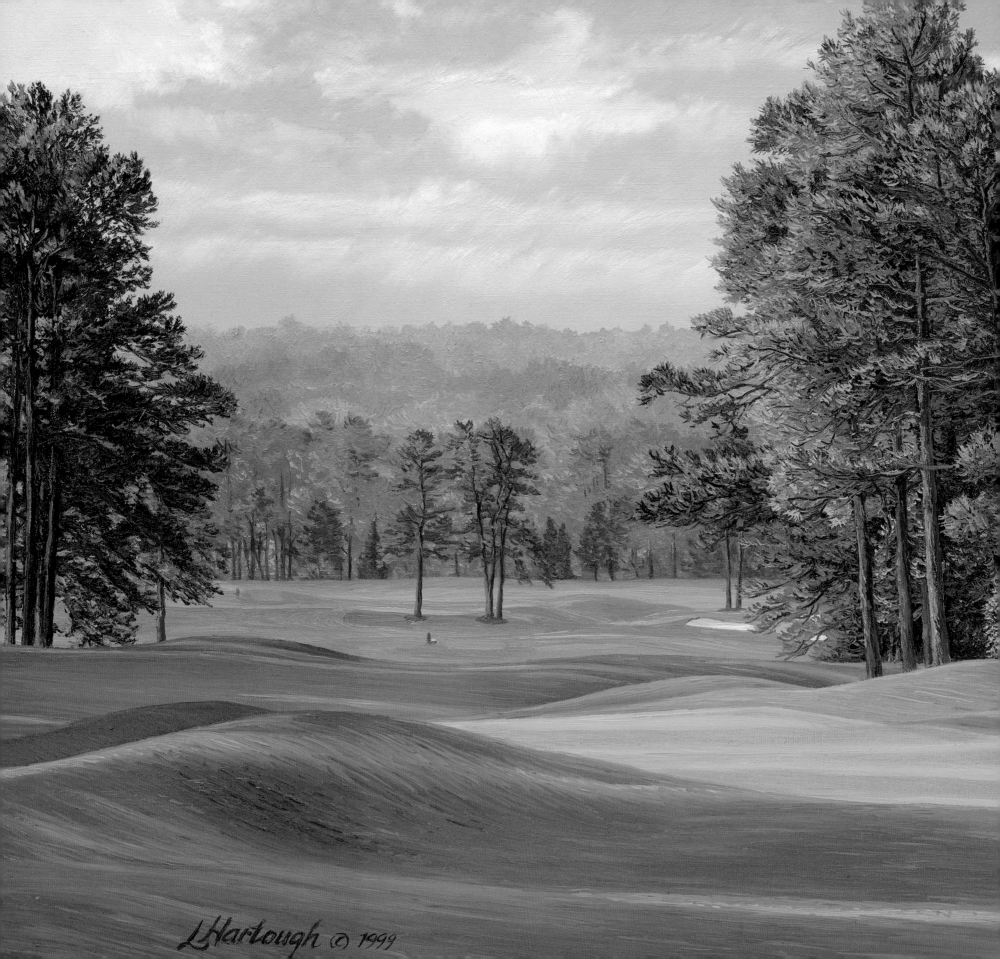

L Harlough © 1999

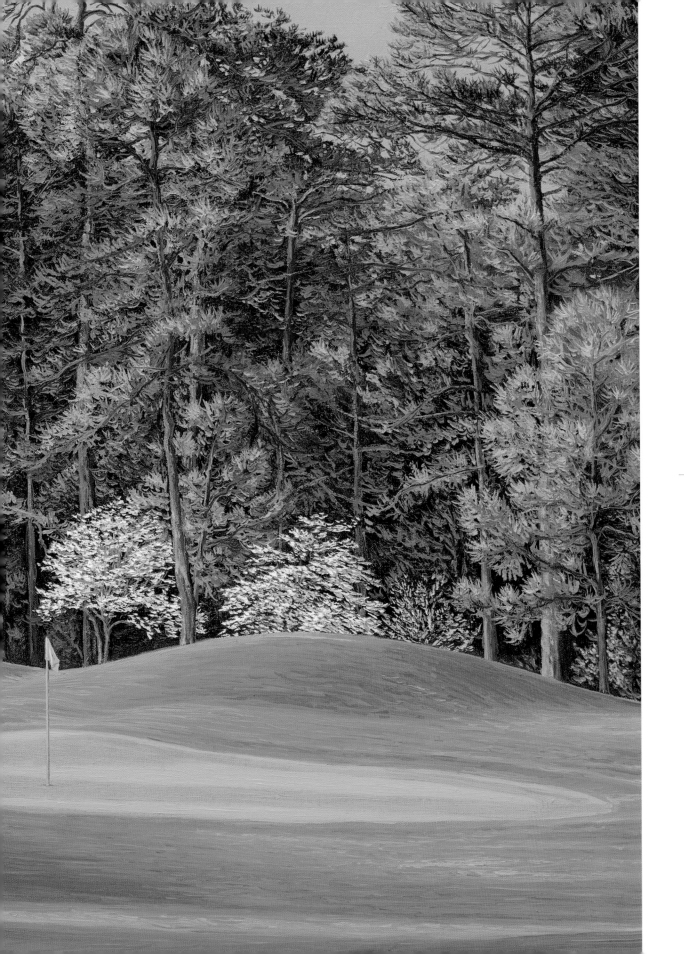

THE 8TH HOLE, "YELLOW JASMINE"
530 YARDS, PAR 5

*A hole that promises birdies and even eagles, although
the unique mounding around the green causes a surprising
number of bogeys.*

99

For all its difficulty, Mickelson was able to pull off the shot because of the turf and space that Augusta provides. It is thrilling golf.

It's no wonder that Augusta holds a special place in the hearts and minds of the game's best. "I don't want to sound overly sentimental about it," three-time Masters winner Sam Snead once said, "but with the course looking the way it does, and the spirit of Bobby Jones running around, sometimes it feels as through the Masters is played on hallowed ground."

The mystique has an equal hold on the average golfer, who typically wants to play Augusta more than any other course. It's a mystique loaded with substance, and it indeed begins with Jones. It is impossible to underestimate the effect of Jones' association with the allure of the club. In its most basic terms, when the Augusta National was founded in 1932, it was perceived as the product of the greatest, most intelligent, most artistic golfer who had ever lived, pouring everything he knew about the game into one place.

Jones' appeal was universal and, even in the Golden Age of Sport, transcended that of a famous athlete. Wrote Herbert Warren Wind, "Of all the people I have met in sports—or out—Jones came the closest to being what we call a great man. Like Winston Churchill, he had the quality of being at the same time much larger than life and exceedingly human." The son of a lawyer, Jones had earned a degree in mechanical engineering from Georgia Tech and another in English literature at Harvard. While he was still a competitor, he attended Emory Law School for a year before taking—and passing—the Georgia bar exam. Jones would write three books, two autobiographies and a golf instructional, and he wrote as well as or better about the game than anyone ever has. His description of contending in the final stages of a championship—"One always feels that one is running from something without knowing what or where it is"—has never been improved upon.

Jones was gracious and handsome, and his integrity was unquestioned. When he called a one-stroke penalty on himself in the first round of the 1925 US Open after seeing his ball move fractionally as he addressed it, Jones got into a thirty-six hole playoff against Willie Macfarlane, which he lost. When it was brought up that the penalty had proved the difference between victory and defeat, Jones would take no special credit for observing the rule. "You might as well praise a man for not robbing a bank," he said.

10TH TEE

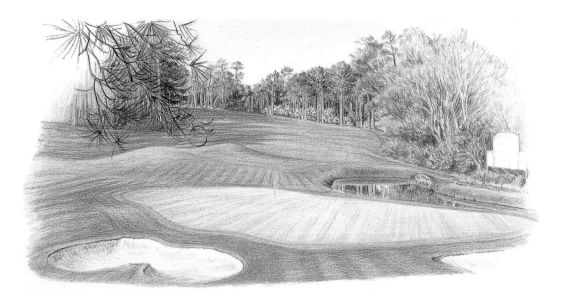

THE 11TH HOLE

Jones' competitive record was incredible. Though even in his prime he never devoted more than five months a year to serious golf, in the final eight years of his career, from 1923 to 1930, he won thirteen of the twenty major championships he played in, including four US Opens, five US Amateurs, three British Opens, and one British Amateur. Only Jack Nicklaus has won more majors. In eleven of the last twelve Open championships in which he played—nine US Opens and three British—Jones finished first or second. In 1930, he accomplished perhaps the most singular achievement in the history of golf, winning the US Amateur, US Open, British Amateur, and British Open in one year. With that, he retired from active competition at age twenty-eight, except for playing yearly in the Masters until 1948.

At the age of forty-eight, Jones would be crippled with syringomyelia, an extremely rare disease of the central nervous system. In the last decade of his life, Jones was an invalid confined to a wheelchair. He died in 1971 at age sixty-nine in his birthplace of Atlanta. "As a young man, he was able to stand up to just about the best that life can offer, which is not easy, and later he stood up with equal grace to just about the worst," wrote Wind. "Perhaps it is best simply to say that just as there was a touch of

poetry to his golf, so there was always a certain, definite magic about the man himself."

As Jones began to ponder what he would do after his competitive days, his most compelling wish was to found his own golf course. He envisioned a course that brought out all the skill and imagination a good player could muster, and yet one that could be played comfortably and enjoyably by the more casual golfer. He wanted it private, a place where in retirement he could be himself with friends, without the oppressive crush of fame. He wanted his course to be in his home state of Georgia, on rolling terrain, with good turf conditions. He also wanted to build a true championship course that could host great events, a commodity lacking in the South at the time. And to satisfy his keen aesthetic sense, he wanted it to be beautiful.

In the fall of 1930, his friend Clifford Roberts, a New York investment banker, suggested that Augusta, a genteel mill and resort town on the Savannah River, would be a logical place to build a golf course. Jones had played exhibitions at the Augusta Country Club and Forest Hills, and liked the area. Because it was close to sea level, nearly 1,000 feet lower than Atlanta, Augusta had a longer warm season than his hometown. With Jones' assent,

THE 10TH HOLE, "CAMELLIA"
485 YARDS, PAR 4

*From tee to flagstick, the elevation drops a gradual
ninety feet as one approaches the Cathedral of Pines
surrounding the green.*

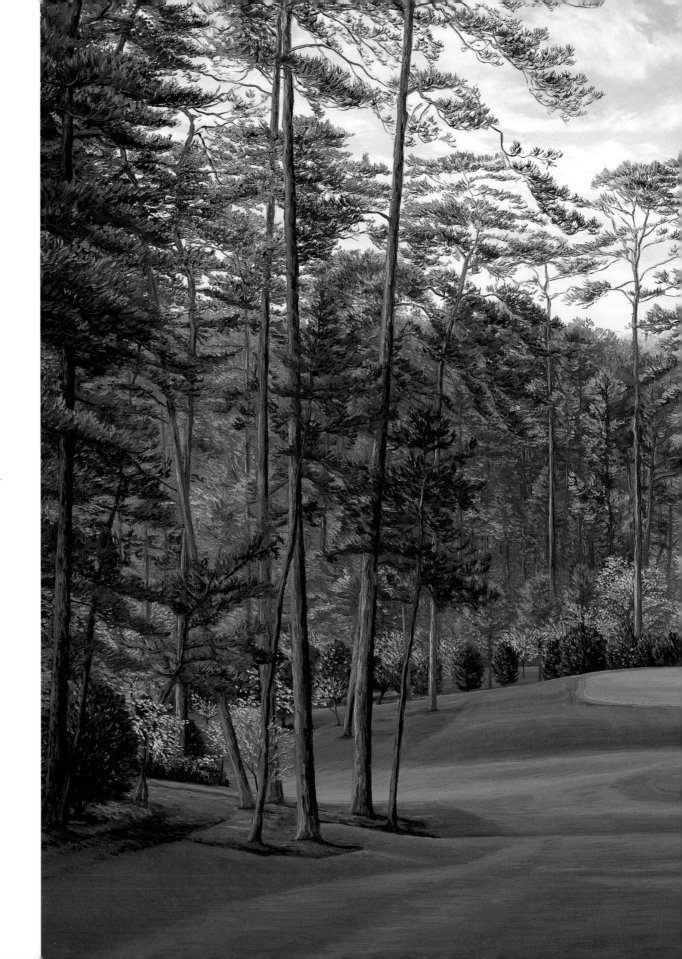

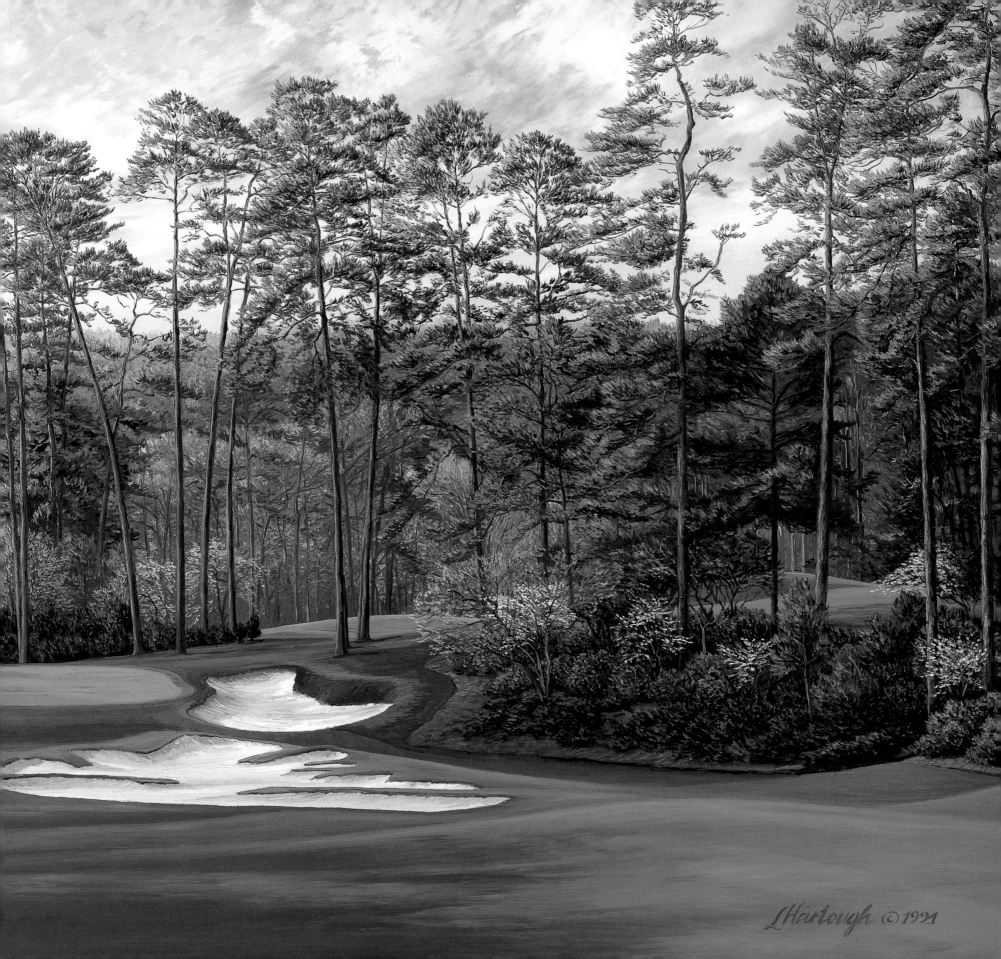

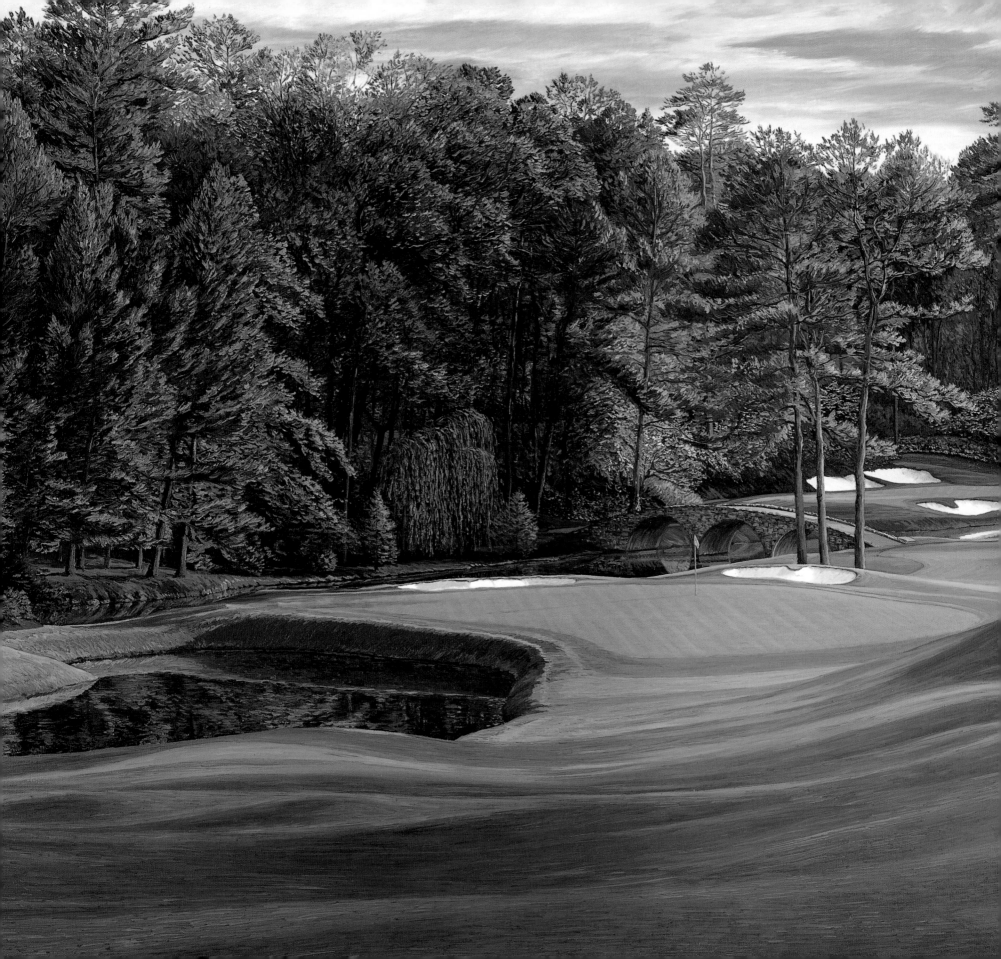

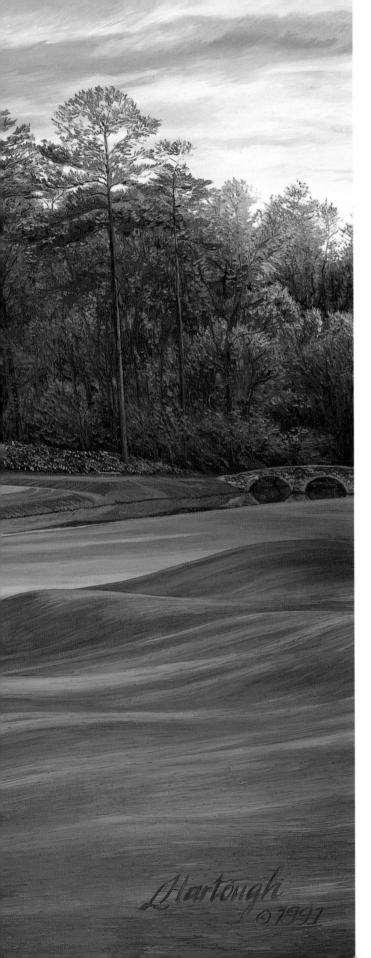

Hartough
© 1991

Roberts set about finding the financing to buy the former Fruitlands Nursery, a 365-acre parcel of land. On a hill at the top of the property was an antebellum manor house that would serve as the golf club's clubhouse. It was when Jones first stood outside that structure in 1931 that he knew he had found something special.

Jones chose Dr. Alister Mackenzie to design and build the course. The two probably would not have met had Jones not been beaten in the first round of the 1929 US Amateur at Pebble Beach by Johnny Goodman, still one of the great match play upsets in the history of golf. When Jones stayed around the Monterey Peninsula for several days after being eliminated, he played Cypress Point, Mackenzie's most spectacular course, and another of the architect's masterpieces, Pasatiempo, in nearby Santa Cruz. Jones loved both, and talked extensively with Mackenzie about his design ideas during and after the rounds. The two agreed on large principals, the most important being that a course be built to provide the most enjoyment for the greatest number.

Mackenzie's architectural eye had been made more acute by his experience in World War I as a specialist in camouflage for England's Royal Engineers. He would later observe that course design, like camouflage, depended on utilizing natural features to their fullest extent and creating artificial features that closely imitated nature. After doing the routing for Augusta National in 1931 and 1932, he called the project "my best opportunity, and, I believe, my finest achievement." It was no mean statement

THE 11TH HOLE, "WHITE DOGWOOD"
455 YARDS, PAR 4

*In 1957, Herbert Warren Wind coined the term "Amen Corner" to describe this view of the 11th, 12th and start of the 13th holes.*

105

from the creator of Cypress Point, Royal Melbourne and Crystal Downs.

Mackenzie codified his beliefs into thirteen commandments that became standards of course architecture. He incorporated all of them at Augusta, and notably:

- The course should have beautiful surroundings, and all the artificial features should have so natural an appearance that a stranger is unable to distinguish them from nature itself.
- There should be a complete absence of the annoyance and irritation caused by the necessity of searching for lost balls.
- The course should be so interesting that even the plus man (top amateur or pro) is constantly stimulated to improve his game in attempting shots he has hitherto been unable to play.
- The course should be arranged so that the long handicap player, or even the absolute beginner, should be able to enjoy his round in spite of the fact that he is piling up a big score.

Jones was impressed with Mackenzie's strategic and aesthetic sense, observing that he had a gift for knowing where to "cut a vista through the woods so as to expose an unusually beautiful view." Such vistas are a hallmark of Augusta. So is the location's legacy as a horticultural paradise. Each hole has been named after a species of flora that had grown in the nursery, from Tea Olive on the 1st hole, to Flowering Crab Apple on the 4th, to Holly on the 18th.

THE 13TH HOLE, "AZALEA"
465 YARDS, PAR 5

*A medley of beauty, strategic complexity and drama,*
*the 13th parallels Rae's Creek, which crosses in front*
*just before the large green.*

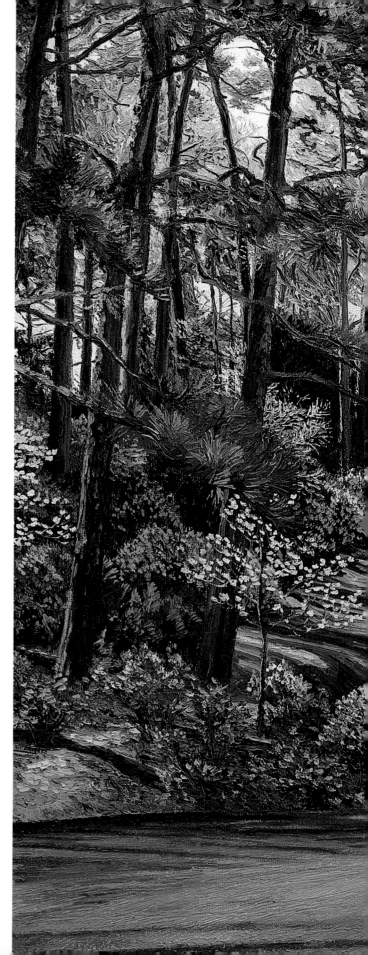

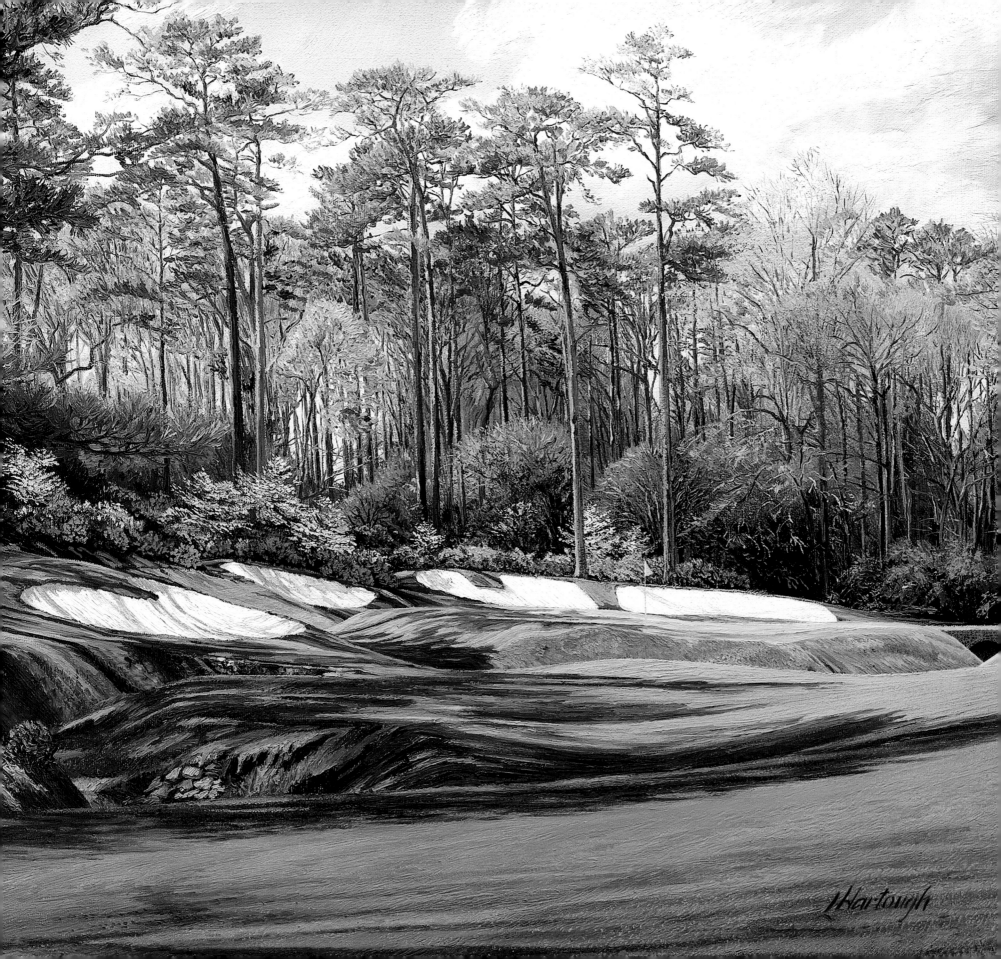

What was new about Augusta was a move away from penal to strategic design. Throughout the 1920s, America's best courses had relied on fairway hazards and rough to provide difficulty. Jones preferred to "reward the good shot by making the second shot simpler in proportion to the excellence of the first. …The elimination of purely punitive hazards provides an opportunity for the player to retrieve his situation by an exceptional second shot."

This philosophy made Augusta perhaps the easiest championship course in the world on which to find a wayward ball. And by having fewer bunkers and more contours on the green, the course was made more challenging for the professional, who has more trouble with difficult greens than with sand, and easier for the average player, whose problems are generally the opposite. Augusta's greens are collectively the most varied and unusual putting surfaces in the world, and no one has ever won the Masters without showing them the utmost respect.

It's arguable that Augusta does not have a weak hole. It's more certain that it has the most breathtaking stretch of holes in golf, beginning with the par-4 10th and ending with the par-5 13th. The 10th and 11th are both par 4s of grand scale, while the diabolical par-3 12th, with its swirling winds, narrow green and exacting carry over Rae's Creek, has been called by Nicklaus the most dangerous hole in tournament golf. The 13th is the best short par 5 in the game, a medley of beauty, strategic complexity, and drama. The final three holes in this series make up Amen Corner, a moniker invented by Wind after the 1958 Masters. Quite often, it's where the Masters is won or lost.

When Augusta's founders began to contemplate a tournament on their new course, they originally hoped it would be the US Open. But the Open's early summer date came at a time when Augusta's climate was both extremely hot and hard on its grasses, a fact that has traditionally kept the Open above the Mason-Dixon line. Instead, it was decided that the club would hold its own tournament, originally named the Augusta National Invitational Tournament. Within two years, however, the name had been changed to the Masters, one Jones objected to. "I must admit it was born of a touch of immodesty," he said.

The originator of the name was Roberts, the cofounder of the club, who remained at the helm of its daily operations until his death in 1977. Roberts is generally considered the most effective tournament administrator the game has ever seen, combining dedication, an eye for detail, vision, and

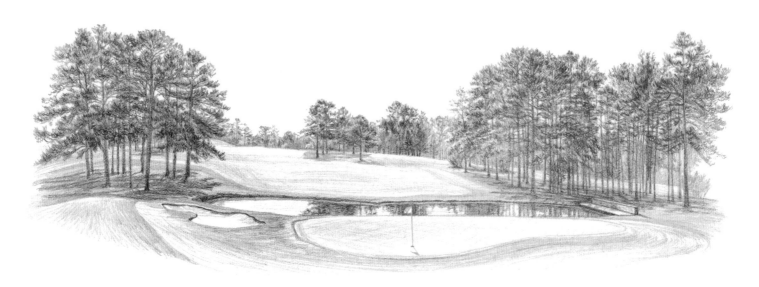

15TH HOLE

an iron will. Most of the tournament's innovations, as well as the way it has been exquisitely televised, have to do with Roberts' leadership. Almost immediately, golf at the Masters became known for its tendency toward the spectacular. Although it began as an intimate affair, big things started happening early on, beginning with Gene Sarazen's famous 4-wood for a two on the par-5 15th, a stunning double eagle that instantly took him from three strokes behind Craig Wood into a tie. Sarazen won the next day in a playoff.

The tournament also became known for huge stroke swings, especially late in the final round, resulting in the annual Masters' chestnut: "The tournament doesn't start until the back nine on Sunday." Following Sarazen's example, Byron Nelson provided a thrilling climax in 1937. Trailing Ralph Guldahl by four strokes, he watched from the 12th tee as Guldahl dunked his ball into Rae's Creek and made a double-bogey five. Guldahl went into the water again to bogey the par-5 13th. Nelson then birdied the 12th and eagled the 13th to pick up six strokes and go on to win. "I know the first time I won the Masters, I just felt like I had springs in me," he would reminisce. "I hardly didn't feel like I was walking." In his historic playoff for the 1942 tournament against lifelong rival Ben Hogan, Nelson was behind early but birdied the 11th, 12th and 13th to win by one.

Arnold Palmer's assault on the national consciousness began and reached it apex at Augusta, and his final-day play at Amen Corner figured prominently. In 1958, he won a crucial rules dispute at the 12th, and then eagled the 13th to win. In 1959, he was leading when he triple-bogeyed the 12th and lost by two. It would set a pattern that lasted until 1964, with Palmer winning in all the even-numbered years, and coming excruciatingly close in the others. He loved the Augusta National from the moment he first came through the gates in 1955. "This has got to be it, Babe," he told his new bride, Winnie, driving down Magnolia Lane in a coral pink Ford. "I felt a powerful thrill and unexpected kinship with the place," Palmer wrote in his recent memoir, *A Golfer's Life*. "Perhaps there are moments in life when we can feel destiny's invisible hand brushing our shoulder. I always felt something powerful in Augusta, and I knew my time would come."

Augusta was also where Nicklaus would truly establish his domi-

GENE SARAZEN

nance. He won for the first time in 1963 at age twenty-three, and in 1965 he set the tournament record at 271 to win by nine. Afterward, Bobby Jones said that Nicklaus had played a brand of golf "with which I'm not familiar." Nicklaus would go on to win six green jackets in all, some of them providing the most classic moments in Masters history. His final-day duel with Johnny Miller and Tom Weiskopf in 1975 is considered the greatest showdown in the tournament's history, while his victory at age forty-six in 1986, when he came from six shots behind to close with a 65, is considered the greatest Masters, period.

The Masters has also been the site of some of the saddest losses the game has ever seen. In 1968, Roberto de Vicenzo, upset at a final-hole bogey, signed for a score a stroke higher than what he had actually shot, and had to accept second place rather than a playoff with Bob Goalby. In 1979, Ed Sneed was leading by three shots when he bogeyed the final three holes to fall into a playoff that was won by Fuzzy Zoeller. And in 1996, Greg Norman, who had already suffered several near misses at Augusta, squandered a six-shot lead on

Sunday to lose to Nick Faldo. But regardless of the outcome, what the Augusta National does better than any other venue in golf is separate genius from the merely talented. It is *the* place in golf for the game's greatest players to display virtuosity. Since the 1930s, the game's all-time best—Nelson, Snead, Hogan, Palmer, Player, and Nicklaus—all showed their absolute best at Augusta and, in later years, so did Ballesteros and Faldo. Finally, in 1997, twenty-one-year-old Tiger Woods unleashed a colossal blend of immense power and deft putting that shattered the tournament record with a score of 270. He won by twelve strokes, another record. Because of Woods' age, his utter domination of the golf course and the margin of victory, the fact that Woods' father is Afro-American, and because it announced the arrival of a superstar, it was the most significant Masters ever.

Although the Masters has made year-to-year alterations on the golf course to refine its challenge and keep up with the advances in equipment and the always-improving level of play, Woods' victory triggered major design changes at the Augusta National. Prior to the 1999 tournament, the 2nd and 17th holes were lengthened, while the 15th and 17th holes were made more narrow. Most significantly, uniform rough was allowed for the first time to border the wide fairways. Augusta remains a course where power is rewarded, but it will now have to be applied with more control.

While much has changed, what remains most noteworthy about Augusta is its continuity. So many of its features and rituals seem locked in time. It will always be a place for beauty, for quality golf, for history, and

THE 15TH HOLE, "FIRETHORN"
500 YARDS, PAR 5

*Gene Sarazen scored a historic double eagle on this hole during the 1935 Masters, a feat no golfer has duplicated. He went on to win the tournament.*

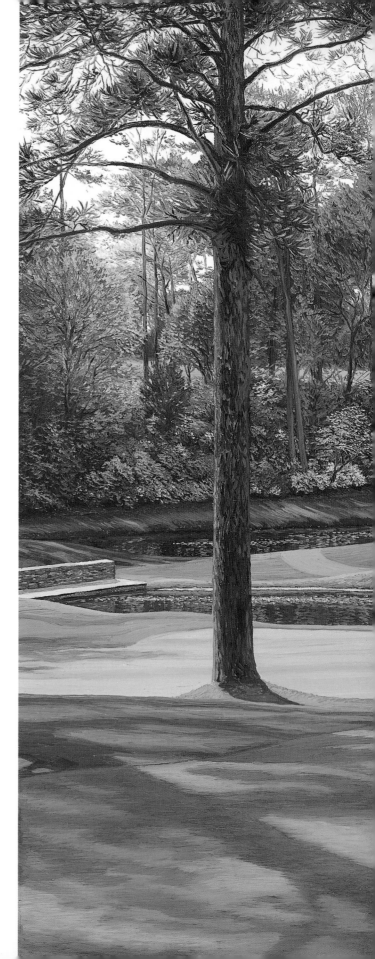

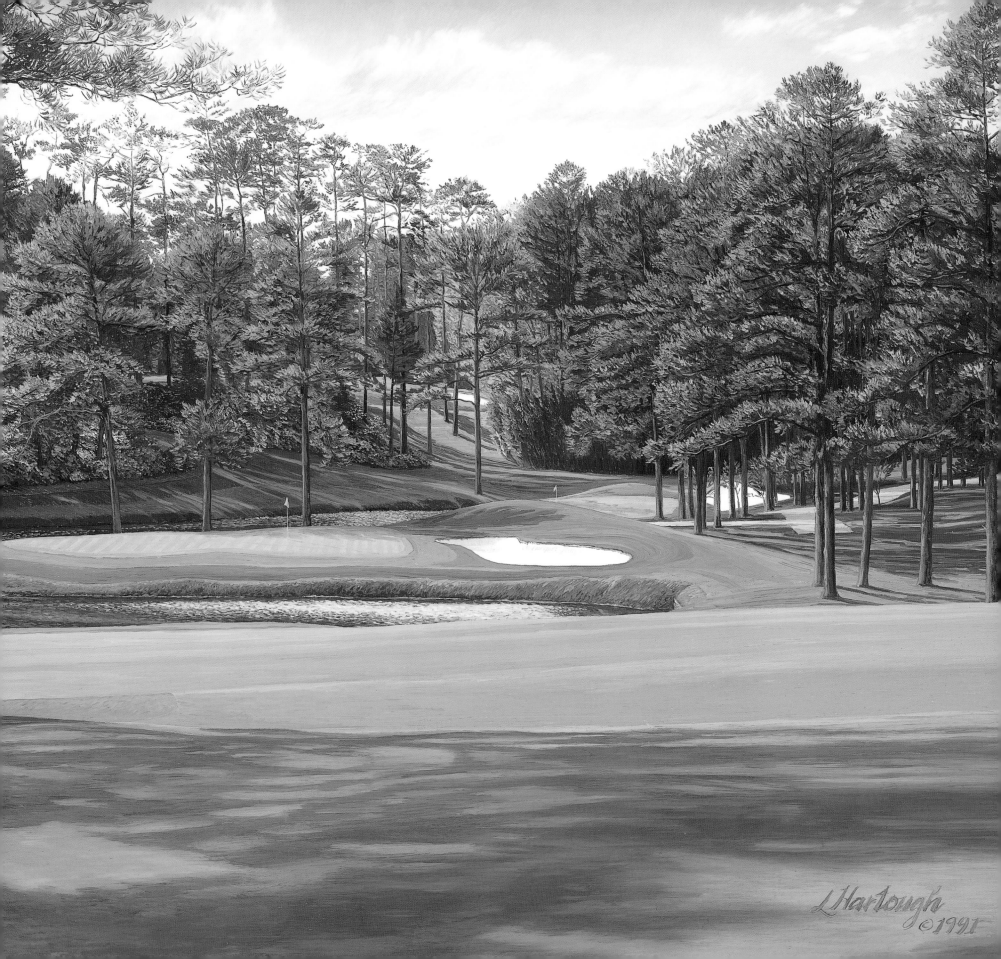

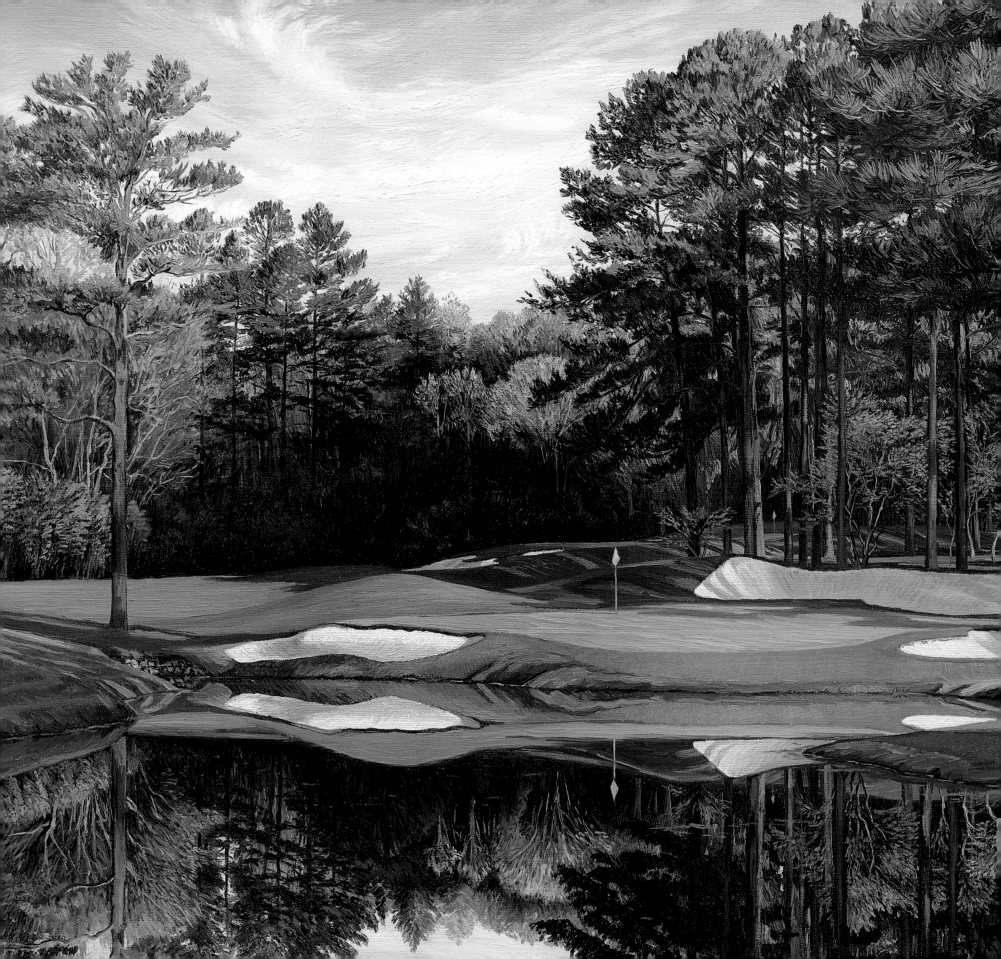

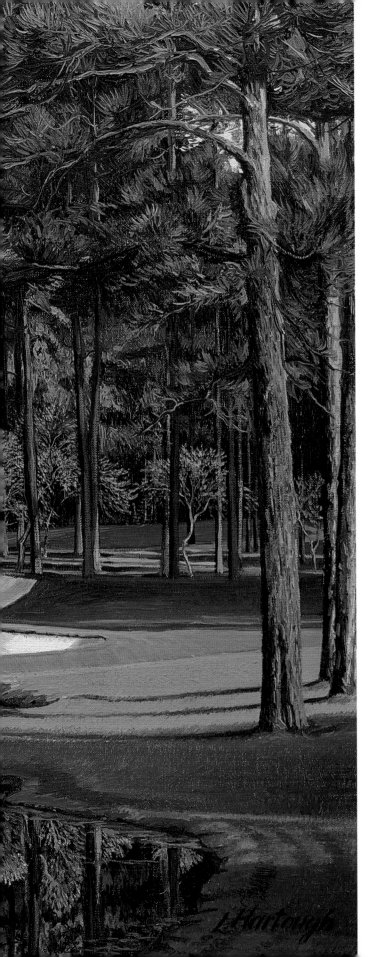

for what those who carry the sensation in their heart call a feel for the game. On Thursday of the first round, (which always falls after the first Sunday in April), Augusta's enduring tradition comes alive. The tournament officially begins with the honorary starters, Gene Sarazen, Sam Snead and Byron Nelson, warming the morning chill by hitting ceremonial drives off the first tee. Shortly before his death in 1999, Sarazen made his final Augusta appearance and was the oldest living champion golfer, born in 1901. Remnants of his compact power were still apparent as he sent a solidly struck line drive down the fairway. Augusta's fairways are magical when graced by these giants, and yet, the course is never more beautiful than at the end of the day. It is after the spectators have cleared, and the shadows have lengthened, that the maintenance crews and their mowers finish their choreographed movements, and the fresh smell produces the sensation of a giant oxygen tent. Every year at the Masters, the Augusta National provides a high place to celebrate—silently or otherwise—what is best about golf. It's a feeling shared by the most wide-eyed first-time spectator and the greatest player who ever lived.

"Every golfer wants to remain part of the game, and at Augusta, regardless of your vintage, you are in the midst of things, a member of the clan," Jack Nicklaus wrote in his autobiography, *My Life.* "I find it as hard to picture a year away from the Masters as a year away from my family at Christmas. No other occasion in golf compares with it, and I trust it never changes." As long as the spirit of Jones lives, it never will.

THE 16TH HOLE, "REDBUD"
170 YARDS, PAR 3

*The most fearsome bunker on the course lies behind this*
*difficult green whose surface is divided by a steep ridge.*

## THE 18TH HOLE, "HOLLY"
### 405 YARDS, PAR 4

*The Augusta National Clubhouse, built in 1854,*
*was originally an antebellum plantation mansion, the*
*first cement house built in the South.*

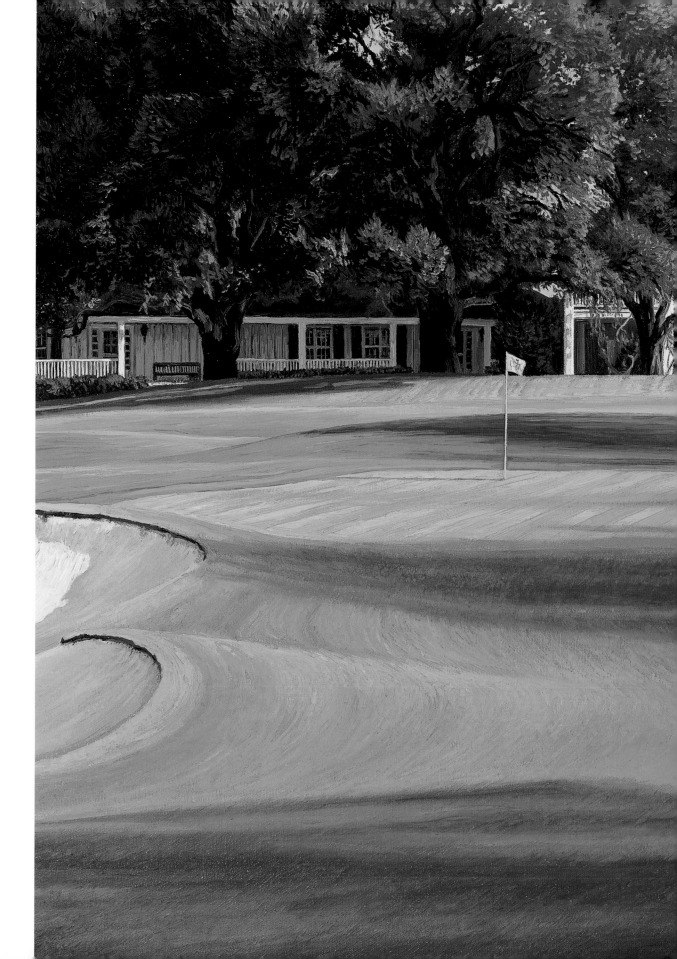

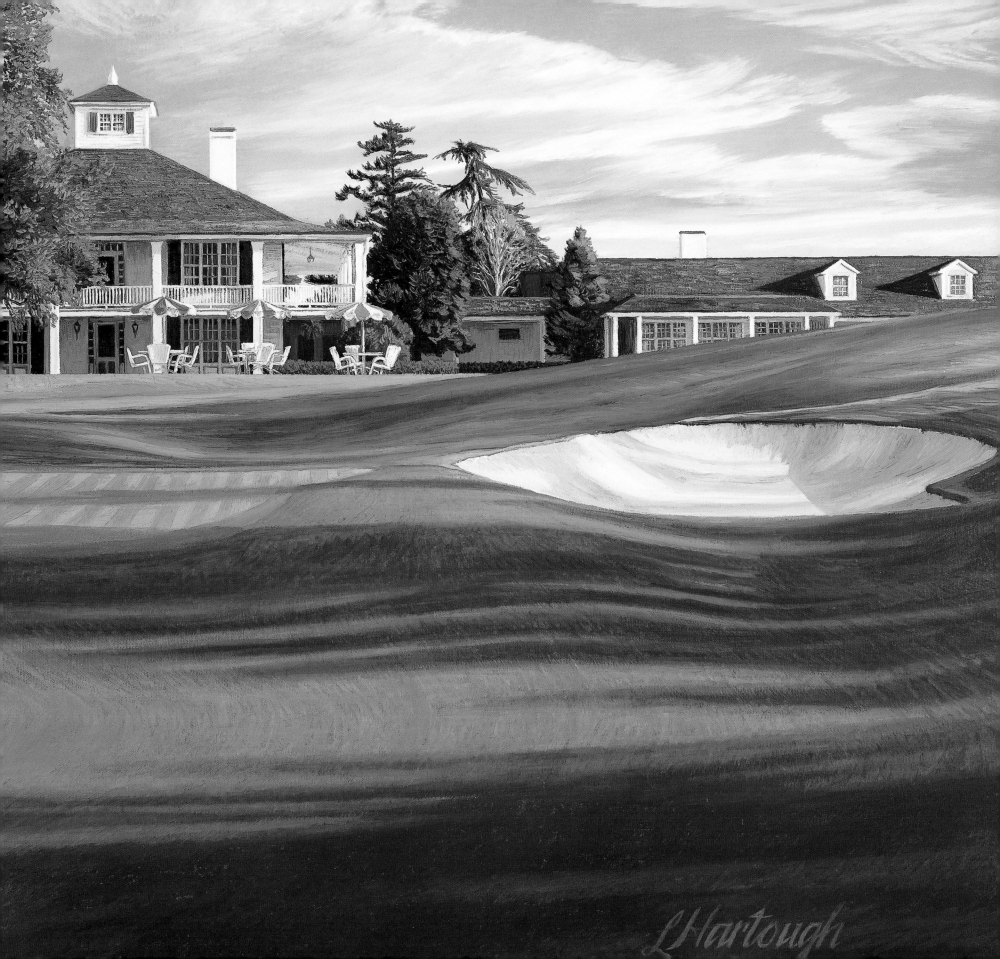

LHartough

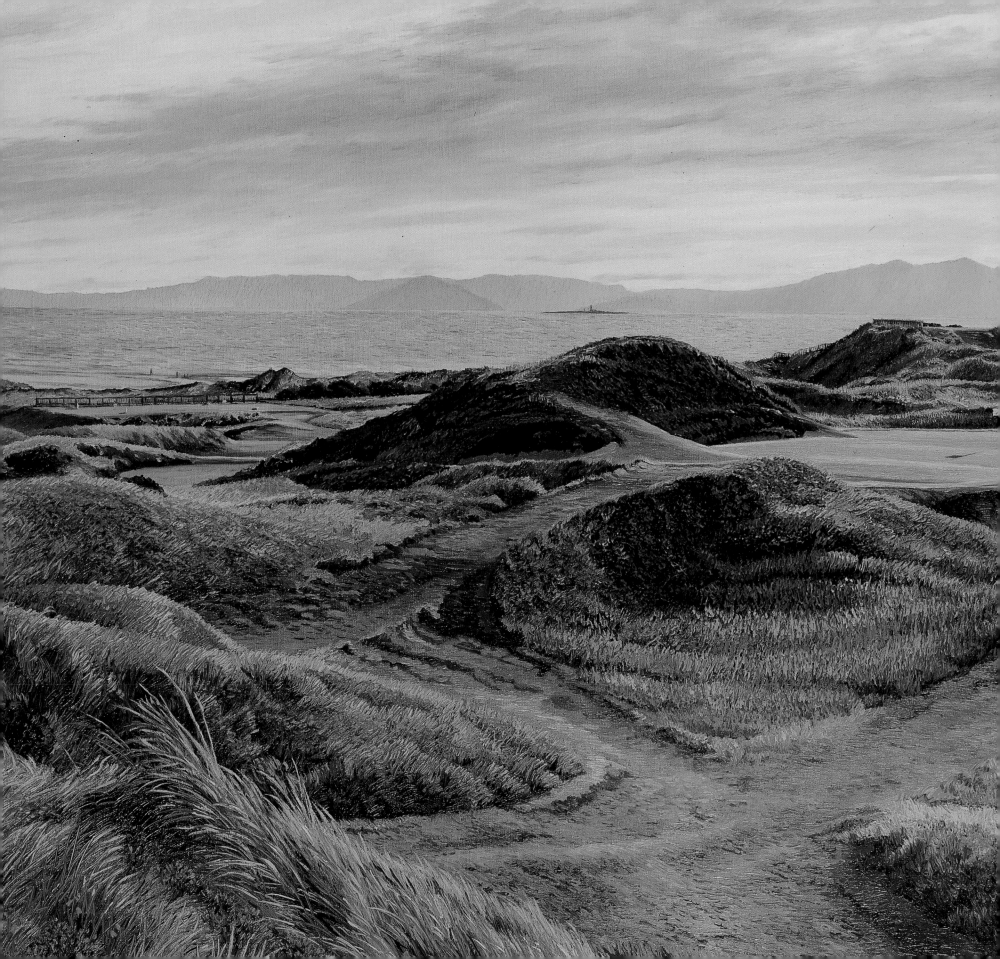

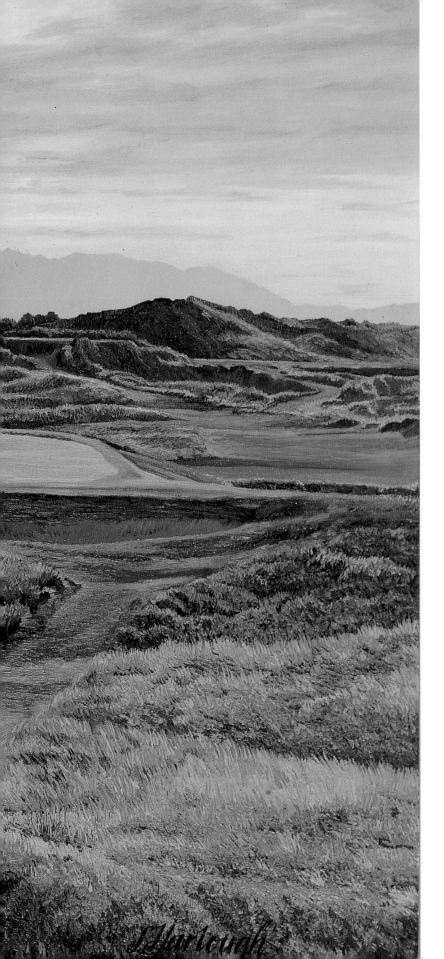

# ENGLAND AND SCOTLAND

## THE CRADLE OF THE GAME

THE ROYAL & ANCIENT GOLF CLUB OF
ST. ANDREWS: THE OLD COURSE

THE TURNBERRY HOTEL, GOLF COURSES AND SPA

THE HONOURABLE COMPANY OF
EDINBURGH GOLFERS (MUIRFIELD)

CARNOUSTIE GOLF LINKS

THE ROYAL LYTHAM AND ST. ANNES
GOLF CLUB

THE ROYAL BIRKDALE GOLF CLUB

THE ROYAL TROON GOLF CLUB

THE ROYAL ST. GEORGE'S GOLF CLUB

ROYAL DORNOCH GOLF CLUB

ROYAL TROON
THE 8TH HOLE, 126 YARDS, PAR 3

*The shortest of all the holes of the British Open courses, the 8th
hole is nicknamed "Postage Stamp" for its diminutive green.*

# INTRODUCTION

The seaside links will always be golf's greatest treasure. As the growing number of golfers generates the urgent call to build more courses into the twenty-first century, it is actually the most ancient classics that ensure that the game will endure. The growing exposure each year of one of the eight championship links courses that hold the British Open sounds a clarion, but when golfers *themselves* are able to play over the hallowed grounds where the game began they are not only captured for life, but transformed into passionate messengers carrying golf's future.

The lure of the links is multidimensional. On the most basic level, it affords pure physical exhilaration. There is something about the rawness of links golf that primes a golfer to simultaneously feel in harmony with nature, and want to conquer it. Never is a golfer more master of his domain than after pulling off a difficult shot on a blustery links. "The thrill of squeezing a ball against the firm turf, trying to keep it low into a buffeting wind, is something that lingers in the mind forever," wrote five-time British Open champion Peter Thomson, a legendarily reserved figure betraying a consuming passion.

Golf's inner game is also richer on a seaside links. "British seaside golf cannot be played without thinking," wrote Bobby Jones. "There is always some little favor of wind or terrain waiting for the man who has judgement enough to use it, and there is a little feeling of triumph—a thrill that comes with the knowledge of having done a thing well—when a puzzling hole has been conquered by something more than mechanical skill. …Our American courses do not require, or foster, that type of golfing skill."

Finally, there is a spiritual, almost Zen-like element to a seaside links. Amid the simplicity of the landscape and the minimalism of the course design, clarity is achieved. Paradox gives way to harmony, confusion to wisdom. Among the pleasant dualities the golfer absorbs on a seaside links is that while it is the oldest form of the game, it is also the most renewing. The most basic, yet the most ethereal. It is played at the most brisk pace, yet it lives in memory the longest. Its colors are the most muted yet the most captivating. It is the most straightforward in design, yet contains the most caprice. It is the most serene, yet the most haunting. It can be the easiest form of golf or the hardest. The more a golfer is able to play a seaside links, the more he comes to realize that its profound simplicity contains every experience in the game.

Seaside links is the original golf. It has remained free of the distorting influences and artificiality of the modern golf culture. Links golf is about essence rather than excess. On a links, the golfer must improvise, must invent, be intuitive, must *play*. Likewise, the links charms us with its topographical flow. Even its bad holes—the blind or contrived or impossible—are evidence of a sort of existential sense of humor about the game, and they charm us all the same. Underscored on a links is the notion that golf is a game to be enjoyed—never taken too seriously—and, of course, never conquered. Ireland's Pat Ruddy, the founder and designer of Dublin's European Club, one of the last true links built in the world, describes the experience as "the beautiful golf."

Of the world's 40,000 courses, fewer than 200 are genuine links.

All lie on wind-lashed, ancient ground that is primal in its ruggedness and remoteness. It's easy to imagine a primitive culture worshipping such land for its portent, and, of course, the golf culture has. A seaside links is a sensually different experience. At first sight, it appears dismal, barren and disappointing. There are no trees, no shimmering on-course water hazards, and the colors lack the vividness that sells American golf resorts. Instead, there are low bushes, meandering burns and canals. The hardware of the course is similarly unimpressive. Everything from the rakes in the bunkers, to the flagsticks, to ancillary structures like the starter's house, tend toward the spartan and worn. Sam Snead, upon getting his first glimpse of the Old Course at St. Andrews from a train in 1946, innocently blurted, "Say, that looks like an old abandoned golf course. What did they call it?"

To appreciate a links, the golfer must be open to sensations different than he experiences on inland courses. Linksland is vast. Unusable for farming, industry or basic habitation, it appears desolate even when a town sits nearby. Shaped by wind in essentially the same way that waves are formed on the open sea, linksland is heaving, craggy, rumpled, wooly, gnarled and indescribably old. Its colors belong to a muted palette of greens and browns and mauves. Under gray skies, the linksland's colors don't dance so much as meld in a way that adds to its somber dignity. Linksland sounds different. The wind off the sea fills the ears with a dull roar. On those rare occasions when the wind is still, there is silence, pierced by the call of birds, or perhaps the faintest lapping of distant waves. It smells different. The air is fresh, free of humidity or toxins, and full of salt and chlorophyll. It even feels different.

Extra clothing encumbers, the chill constricts the muscles, and the skin feels dry and tight from the wind. The sand-based turf provides a firm but springy quality that makes walking a pleasure.

Golfers have been feeling and sharing these sensations for centuries. Golf began on links because the smooth, fast-running surface and invigorating environment made an ideal field for a stick-and-ball game. Linksland was formed in Britain after the Ice Ages when the sea receded from the cliffs of the island, leaving large sandy wastes as well as furrows that became rivers, burns and streams. As the sands dried out, the wind shaped them into dunes that became the nesting and breeding grounds for birds whose droppings brought vegetation. Soon these areas were covered in grasses and more rugged plants like heather, whin and gorse. The fine grasses of bent and fescue took root in sheltered areas and near river estuaries, and became what historian Sir Guy Campbell called "thick, close growing, hard-wearing sward that is such a feature of true links turf wherever it is found." When small mammals like rabbits and foxes made the areas their homes, they wore out trails along the dunes which man widened as he hunted. These leveled-out places eventually became the fairways of the links.

Along such land, people found golf's stick-and-ball allure and adventurous cross-country aspect hard to resist. In the high northern latitudes' summer months, which provided nearly twenty hours of daylight, golf took on its original democratic bent. Everyone could play, before or after work. British golf writer Bernard Darwin wrote about the way links golf took over entire communities. "It may be immoral," Darwin wrote, "but it is delightful to see a whole town given up to golf; to see the butcher and the baker and the candlestick maker shouldering his clubs as soon as his day's work is done and making a dash for the links."

There are times when a links can play ridiculously easily. With no wind, or a freshening downwind breeze, the holes play short on the fast turf, and if the greens are holding, an expert can demolish par. But at other times, a links can be incredibly difficult. In heavy wind—especially into strong headwinds—or in heavy rain, links golf becomes more a test of emotional control and fortitude than skill. At times like these, an approach from 120 yards to

an open green becomes the severest of challenges, and even championship golfers have a hard time breaking 80. Links golf is not neat and tidy. Fairways and greens are missed with good shots, and there is a lot of recovering, chipping and long putting to do to save pars. At times, links can be cruel, with bunkers so deep and awkward that escapes must be aimed sideways; with rough that causes near unplayable lies; with wind that makes even short putts—especially short putts—a nightmare.

Such an exercise is good for the soul. Golf appealed to the Scottish character, according to Alistair Cooke, because they "saw in the eroded seacoasts a cheap battleground on which they could whip their fellow men in a game based on the Calvinist doctrine that man is meant to suffer here below and never more than when he goes out to enjoy himself." In the classic view of links golf, overcoming the inequities of fate is part of being a champion. Fairness—the more American idea that each shot should be rewarded

exactly according to the skill and judgement with which it was played—is considered unrealistic and soft-headed by the adherents of the links. "We have been so anxious," wrote Robert Browning in 1955, "to take all the element of luck out of the game, that we have to a proportionate extent destroyed its value as a test of each man's ability to stand up to bad luck."

Such conviction was what lay behind the decision by the Royal & Ancient in 1922 that "the Open shall always be played on seaside links." And so it has been. It might also be the key factor in why, in the last thirty years, the British Open has produced the most impressive list of champions among the four majors. There are currently eight seaside links in the rota. In Scotland they are St. Andrews, Muirfield, Carnoustie, Troon and Turnberry, while in England they are Royal Birkdale, Royal Lytham and St. Annes, and Royal St. George's. All are the genuine article, and all are genuine treasures.

# THE OLD COURSE, ST. ANDREWS

The great British golf writer Bernard Darwin once noted that he felt the same magic the whole of his long career whenever the train that carried him the seven hours between London and the Kingdom of Fife in Scotland's northeast quadrant would finally approach the small station at Leuchars. "We have already worked ourselves up into a state of some excitement," Darwin wrote, "looking out the window for landmarks and up into the rack to be sure our clubs are still there." When the porter finally sang out, "Change for St. Andrews!" it would turn Darwin's excitement "into ecstasy."

Outmoded by the massive Forth Road Bridge and the M90 superhighway, the Leuchars railway station is no longer the favored route to the game's mecca, but the pulse still quickens when a modern visitor turns onto the two-lane ribbon of A92 at Kirkcaldy and heads east past stone fences and farmland. A few miles past Cupar, spires rise in the distance, and when the first glimpse of the majestic Royal & Ancient clubhouse appears, the sensation is like no other. The golfer is home and what's most wonderful about St. Andrews is that arriving is only the beginning.

The town bustles with energy, its three wide shopping streets busy with people, 70 percent of whom play golf. There is no sweeter feeling of anticipation than waiting one's turn by the first tee before a round on the Old Course. With the weather-beaten but stately R&A only a few steps behind you, and the expanse of the wide dual fairway of the 1st and 18th holes inviting a full and free hit, the heart alternately races and basks at occupying the very spot where anybody who has been anybody in the game over the last 150 years has stood and swung at least once. The tingling doesn't dissipate until the approach shot is safely over the Swilcan Burn, the only water hazard on the course. "It is an inglorious little stream enough: we could easily jump over it were we not afraid of looking foolish if we fell in," wrote Darwin with mock dismissiveness. Most of all, of course, the Swilcan flows with history.

So it goes on the Old Course. What at first impression seems a layout impossible to discern amid a mostly flat, seemingly uninspired two-mile-long neck of links, becomes a memorable journey. There are several blind tee shots and even more strokes where the lack of definition along the borders of holes makes line of play a mystery, but St. Andrews gradually reveals itself to the player who pays attention.

Even for the befuddled, it is a living museum of the game. At St. Andrews, the golfer will see things that he will find nowhere else: seven double greens as wide as seventy yards across; deep, bearded bunkers with names like Scholar's, Principal's Nose, The Beardies, Lion's Mouth, Deacon Sim's, Miss Grainger's Bosoms (side by side on the 15th), Strath, Hell (next to the Elysian Fields); and Coffin, a "loop" in the middle of the course where the 7th fairway crosses the par-3 11th. The experience continues to build—there is the short 12th, with its hidden bunkers and classic pitch to a green that slopes away, and the 567-yard 14th, called "Long," which into the wind forces the golfer to risk carrying the immense Hell bunker, where several British Open contenders have lost their chances. Then there is the 17th, the famed 461-yard Road hole with its tee shot over part of the five-star Old Course Hotel, and its approach to the "horribly small and narrow" green, Darwin says, "that lies between a greedy little bunker on the one side and brutally hard road on the other." It is arguably the hardest par 4 in the world.

Still, St. Andrews tops itself with its home hole, named Tom Morris, the par 4 adjacent to the 1st that is lined on the right with the ornate architecture of the "auld grey toun," its citizens braced against the white wooden railing, taking in the age-old scene. Despite the precipitous dip of the Valley of Sin that fronts the green, it's the easiest closing hole in all of championship golf, a final gesture from a confounding, yet ultimately generous course. No wonder pilgrims never tire of returning to St. Andrews. "The Old Course is, and must remain forever, the true golf," says the Australian champion Peter Thomson, who won the 1955 British Open at St. Andrews and keeps a home there. "It's an eternal place."

The basic allure of St. Andrews is simple: like the Egyptian pyramids, Greece's Parthenon or the Taj Mahal, it is a monument of sheer, awe-inspiring age. The oldest place in golf, it was founded in the seventh century as a Celtic ecclesiastical center, and later became the headquarters for the Roman Catholic Church in Scotland. The linksland at the low end of town was given to the bishops by King David in 1123 and was gradually inherited by the town, always to be open to the public. The links had already been used for centuries when, in 1764, it was decided that it would be reduced from twenty-two to eighteen holes along the long sward between the town's beach and the River Eden, forever setting the standard for what constitutes a full round. When shadows descend, the Old Course looks its age, the humps and hollows of its playing field seeming to reflect the eruptions and irregularities of nine hundred years. "The Old Course needs a dry clean and press," American touring pro Ed Furgol once said. Yet no matter how primal its allure, St. Andrews never gets old. It is continually renewed by the game.

The game is how its most famous denizen, Old Tom Morris, stayed vigorous. Born in St. Andrews in 1821, the son of a handloom weaver, Morris began playing at age six. Although he did not play in the British Open until he was thirty-nine, he won four of them, remaining the oldest winner at forty-six for his 1867 victory, and went on to play in every championship until 1896, when he was seventy-five. A short, thick man with a long, white beard, Old Tom bathed in the North Sea every day. He drank in what was consid-

THE OLD COURSE, ST. ANDREWS
THE 14TH HOLE, 567 YARDS, PAR 5

*No course in the world better blends into the sweep of its*
*town than St. Andrews, the oldest course in the world.*

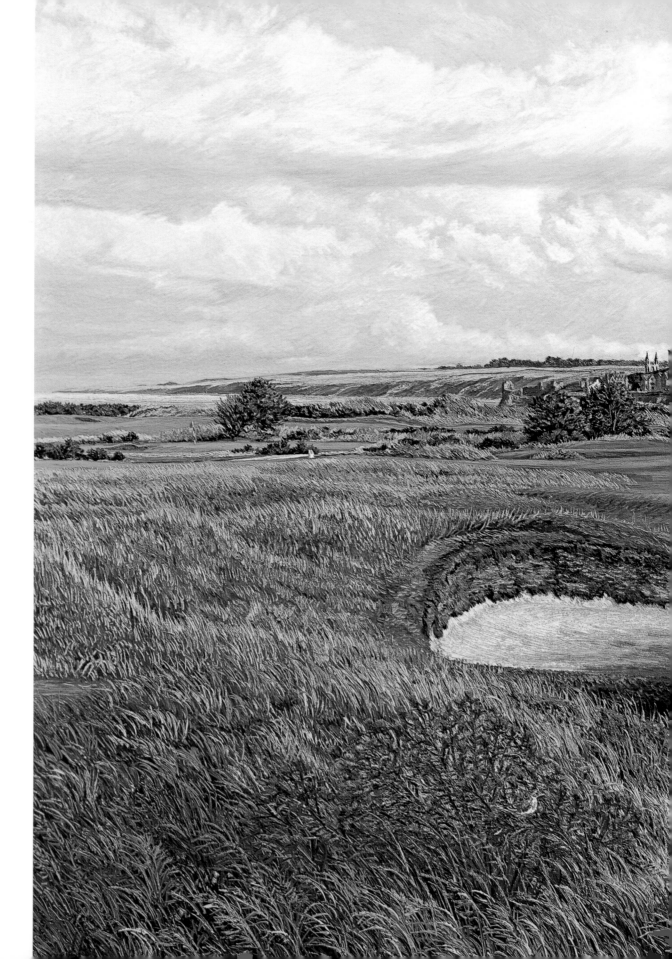

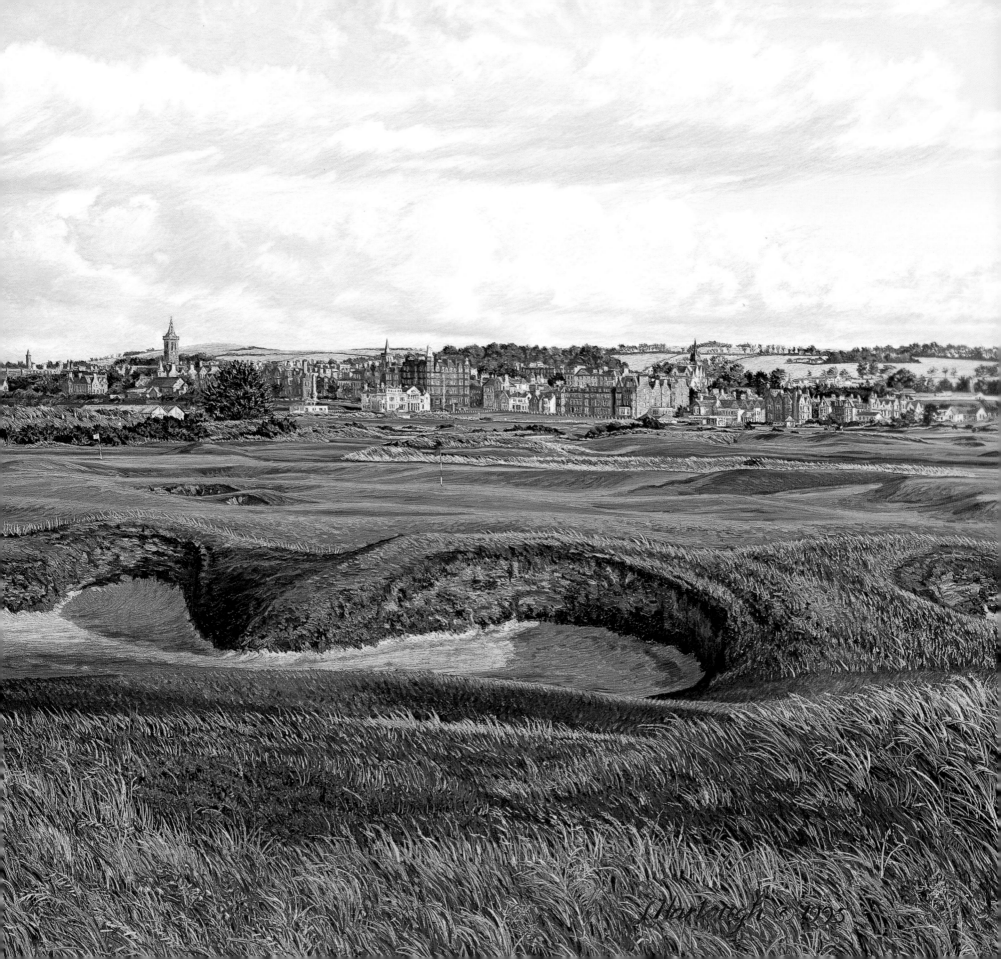

ered moderation: only two or three glasses of whisky each day and a bottle of dark stout called Black Strap. To his sadness, he outlived his daughter and all three of his sons, including Young Tom Morris, who won four consecutive British Opens beginning in 1868 when he was seventeen, but who died in 1875 at age twenty-four on Christmas Day, despondent over the death a few months earlier of his wife and daughter in childbirth. "I've had my sorrows, so that, at times, to lie down and die looked all that was left," Old Tom once said. "It was as if the very soul had gone out of me, but with the help of God and golf, I have managed to survive." He retired his position as "Keeper of the Green" at the Old Course in 1903. Five years later, he fell down a flight of stairs and died later the same day, a month short of his eighty-eighth birthday.

• • •

St. Andrews has held more British Open championships than any other site, and the 2000 Open will mark the twenty-sixth time it has been the host. Its champions have ranged from James Braid to Sam Snead to John Daly. But it has been the passion the town has elicited from its greatest champions that has most added to its aura. The most celebrated love affair between a town and a champion in the history of the game was between St. Andrews and Bobby Jones. He first came to the town for the 1921 British Open, a prodigy of nineteen who had not yet learned to control an explosive temper. In the third round with the course buffeted by a stiff breeze, Jones turned in 46, double-bogeyed the easy 10th, and was about to triple-bogey the short 11th when he picked up his ball, tore up his card and tossed the fragments into the River Eden. He was later so ashamed of this act that it transformed him into a model sportsman. By the time Jones returned to St. Andrews to win the 1927 British Open by six strokes, he had become a beloved figure. In 1930, he would return again to win the British Amateur in his first step to the Grand Slam.

St. Andrews became Jones' favorite golf course, one that, for Jones as well as for another Old Course adherent, Alister Mackenzie, would in many important ways serve as a model for the Augusta National. "The more I studied the Old Course, the more I loved it; and the more I loved it, the more I studied it," Jones wrote, "so that I came to feel that it was for me the most

favorable meeting ground for an important contest. I felt that my knowledge of the course enabled me to play it with patience and restraint until she might exact her toll from my adversary, who might treat her with less respect and understanding."

Jones made his last visit to St. Andrews 1958 to captain the US team in the World Amateur Team Championship. While there, he was made a Freeman of the Burgh of St. Andrews, the first American so honored since Benjamin Franklin. Crippled from syringomyelia, a disease of the spinal cord, Jones nevertheless managed to stand at the podium at the university's Younger Hall and deliver a moving twelve-minute speech that included the famous phrase "I could take out of my life everything except my experiences at St. Andrews and I'd still have a rich, full life." When he left the stage in a specially provided golf cart, guiding it slowly down the center aisle of the hall, the auditorium spontaneously broke into a rendition of "Will Ye No' Come Back Again?" "It had all the strange, wild, emotional force of the skirl of the bagpipe," wrote Herbert Warren Wind. "For many minutes afterward it was impossible for anyone to speak."

Jack Nicklaus first encountered St. Andrews at the 1964 British Open, where he ultimately finished second to Tony Lema. Although immediately drawn to the golf course for the way it began and ended in the town, he valued even more the frank and open character of the Scottish people who seemed to appreciate the intensity of his golf and personality more than Americans, who still resented his displacing of Arnold Palmer. When he returned for the Open in 1970, Nicklaus hadn't won a major championship in three seasons and had just lost his father to cancer the year before. He got into an eighteen-hole playoff when Doug Sanders missed a three-foot putt on the 72nd hole. The next day, Nicklaus was a stroke up in the playoff on the 358-yard Home hole when he dramatically shed his sweater on the tee and smashed a driver that nearly hit the pin before rolling into the rough over the green. When he made a six-foot birdie putt to defeat Sanders, he flung his putter high into the air. The club nearly crowned the loser as it came down. "The excitement was uncontainable," Nicklaus wrote. "I had never shown emotion like that before, and it was totally out of character. But then

I had never before won the oldest golf championship in the world at the cradle and home of the game." Later he confided to his wife, Barbara: "They've all been for Dad in a way, but never quite like this one." Now Nicklaus says, "I feel the same today, and I'm sure I will for the rest of my days."

At the Open in 1978, Nicklaus put together what he still considers his four finest days of ball-striking ever in a major championship. As he walked up the final hole with a two-stroke lead, people were crammed into the bleachers and seemingly every open window, thirty thousand strong, cheering louder and louder as he crossed the ancient stone bridge over the Swilcan and then to the nearer green that is called Grannie Clark's Wynd.

"I had never received such a huge ovation, and haven't since, and don't expect I ever will again," wrote Nicklaus. "A lump started to grow in my throat and my eyes began to tear up...I had done it at St. Andrews, my favorite place on earth to play golf." In 1984 Nicklaus became the first sportsman ever made Honorary Doctor of Law of the University of St. Andrews. "There has been no prouder moment since I first picked up a golf club," he said. Nicklaus will return in 2000 for the last time as a competitor. And as his private jet lands at the airport in Leuchars, he, too, will experience the thrill of anticipation that everyone who loves the game feels when arriving in St. Andrews.

# TURNBERRY

For simple physical beauty, Turnberry is by consensus unsurpassed among the courses on the championship rota. The original course, built in 1903, had lacked championship values. No sooner had it been revised and improved than its fairways were used for airstrips in both World Wars. But reparations were made to the owners of the property in 1948, and Scottish architect Mackenzie Ross did a masterful job in putting together Turnberry's current layout.

Fully seven of its holes, the 4th through the 11th, hug the craggy curve of coastline above the Firth of Clyde on Scotland's west coast. It makes Turnberry a legitimate challenger to Pebble Beach's unofficial title as the most dramatic meeting of land and sea in golf. The holes also possess wonderful shot values. The 4th, 6th and 11th are all in the upper echelon of par

3s in championship golf, while the 8th, 9th and 10th holes are among the toughest par 4s. Most spectacular is the 9th, with its tee set high over the roiling sea hard by the famed lighthouse. In one direction, the large granite bird sanctuary, Ailsa Craig, rises from the water, and in another the ancient castle of the Scottish liberator Robert the Bruce can be seen. Indeed, to overcome the visual intimidation and strike a true drive from that precarious promontory requires a brave heart.

Turnberry is the most recent course to be accepted into the Open rota, having made its debut in 1977. Despite a severe drought that almost eliminated the rough, the 1977 championship will never be forgotten. It featured Tom Watson and Jack Nicklaus going head-to-head for thirty-six

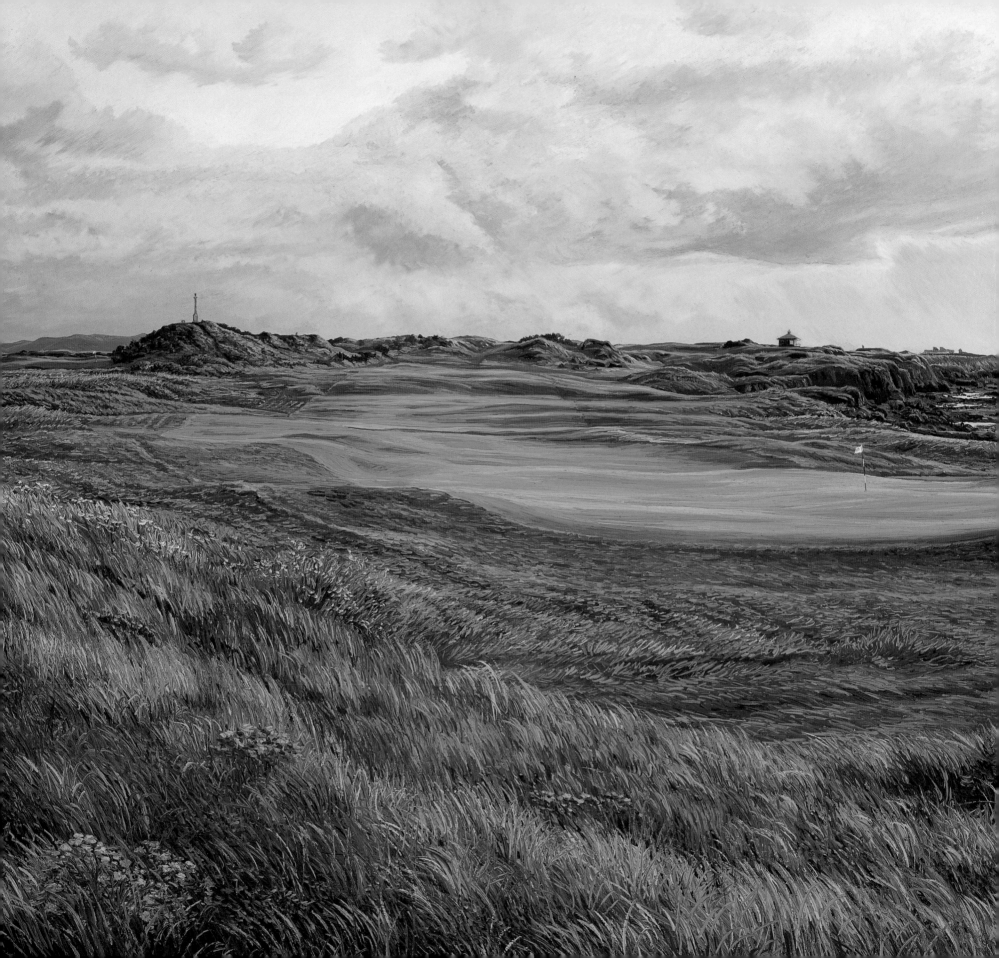

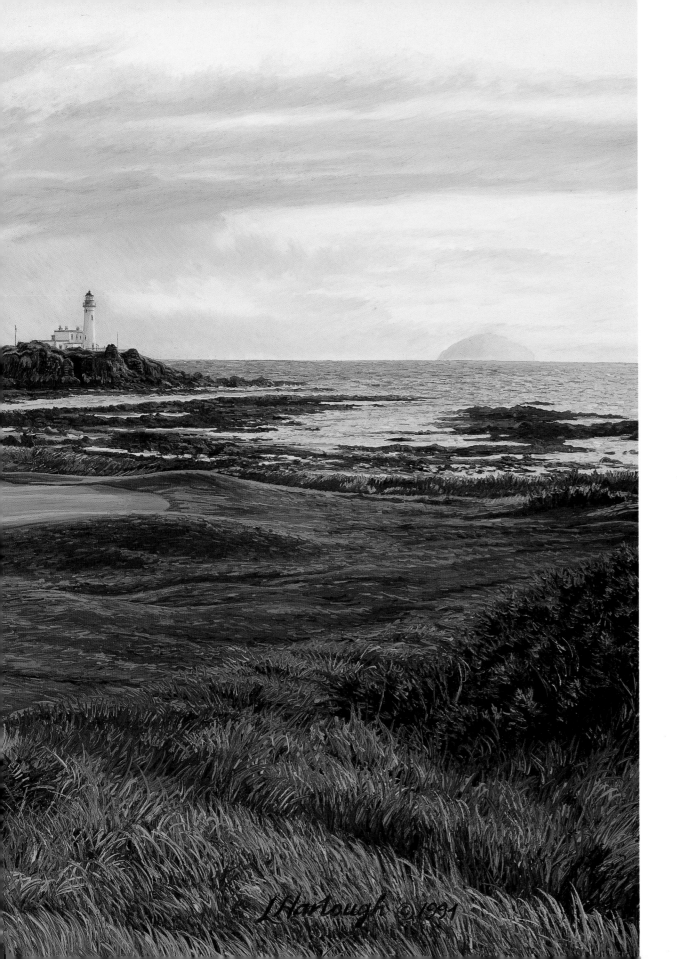

### TURNBERRY HOTEL, GOLF COURSES AND SPA
### THE 10TH HOLE, 452 YARDS, PAR 4

*Seven of its holes, the 4th through the 11th, hug the craggy curve of coastline above the Firth of Clyde on Scotland's west coast.*

127

holes in perhaps the greatest two-man duel championship golf has ever seen. After both played the first thirty-six holes in 138 strokes, they went head-to-head in the third round and matched each other's 65s. In the final round, Nicklaus opened an early three-stroke lead, but Watson, who had beaten Nicklaus at the Masters three months earlier with a late birdie, battled back. Showing that he relished the challenge, Watson filled a tense moment on the 14th tee by looking Nicklaus in the eye and saying, "This is what it's all about, isn't it, Jack." Answered Nicklaus, "You're darn right." On the 15th, Watson tied Nicklaus by clattering a sixty-foot putt from off the green against the flagstick and into the hole, and took the lead with a birdie on the par-5 17th, when Nicklaus missed a six-footer of his own.

On the 18th, Watson drove well and then nearly holed his 7-iron approach, stopping it thirty inches above the cup. It looked hopeless for Nicklaus, whose drive had ended in a nearly unplayable lie in gorse. But he slashed an 8-iron onto the green and then holed the thirty-foot birdie to force Watson to make his. Unshaken, Watson did, and the two walked off the green arm in arm. Watson finished at 268 and Nicklaus at 269, with the next closest finisher Hubert Green at 280.

In 1986, conditions were cold and blustery, and the rough was extremely high. In the second round, on a day when conditions made 75 a respectable score, Greg Norman shot perhaps the greatest single round in the history of the British Open, a 63 that included a three putt from twenty feet on the final green. Norman hung on to win his first major championship. In 1994, Turnberry was the site of one of the greatest late turnarounds in championship history. Nick Price trailed Jesper Parnevik by three strokes with three to go. But while Parnevik was bogeying the 18th, Price birdied the 16th, eagled the 17th, and parred the 18th to claim his life's ambition, the Claret Jug.

Exposed as it is on the cliffs, Turnberry can receive some of the most severe winds of any course in the British Isles: during a 1973 tournament, winds clocked at 120 miles-per-hour howled through the property. But it can also be the most sundrenched of sites. On those days, with the expanse of its red-roofed hotel shimmering on a hill adjacent to the golf course, and the sea a bright blue against the links, Turnberry is one of the most enchanting sights in all of golf.

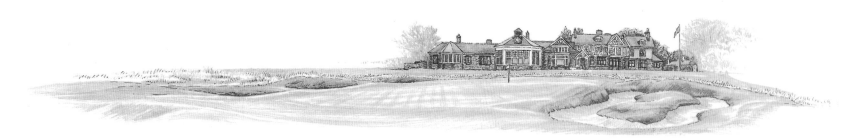

# MUIRFIELD

Muirfield is often considered the best test of pure golf on the championship rota, in part because it lacks some of the common features of the seaside links. Unlike St. Andrews and other links that hug the shoreline, Muirfield does not have an out-and-back routing, but rather a circular one constructed on two nine-hole loops, the second essentially contained within the first.

This creates hole-by-hole changes in the angles of the wind, increasing the variety of shots a golfer is asked to play.

But this configuration is also considered by some an aesthetic weakness because it gives Muirfield the enclosed feel of a more conventional inland course. That sensation is accentuated by a stone wall that borders the

perimeter of about half the course. Psychologically, it cuts Muirfield off from the southern shore of the Firth of Forth, which is only a few hundred yards away but whose sight, sounds and smells are essentially nonexistent for the golfer. Nevertheless, Muirfield is the most carefully rendered of the seaside links, having been redesigned and dramatically improved in the 1920s by the famed architect Harry Colt.

Its greatest challenge is the placement and shape of 170 bunkers. To many experts on golf course architecture, Muirfield represents the best and most imaginative bunkering of any course in the world. The visual definition provided by these bunkers, and by rough that is thicker and more consistent than on most other links, creates an honest and unambiguous test of shot-making. With only one blind shot and no water hazards, Muirfield is a seaside links in which fairness is a prime attribute.

Muirfield is steeped in elitist tradition. Its founders are the Honourable Company of Edinburgh Golfers, which established the first golf club in 1744 and drafted the game's first code of rules. Its legacy continues in that Muirfield is the most exclusively private of the championship seaside links. The rarefied atmosphere is accentuated by the austere red-roofed clubhouse and the dignified air of the adjoining but secluded Greywalls Inn. The membership takes pride in an ascetic philosophy that presents its course in the purest possible state, free of paraphernalia such as tee signs indicating the number of the hole, its yardage and par. The only hardware on the tees are understated markers. But the best measure of Muirfield's greatness is the Open champions it has produced since it first hosted the championship in 1892. They include Harry Vardon, Walter Hagen, Henry Cotton, Gary Player, Jack Nicklaus, Lee Trevino, Tom Watson and Nick Faldo.

In the 1929 Open Hagen was infamous for the carousing he did at night between rounds. When told that his closest challenger, Leo Diegel, had been in bed for several hours, Hagen replied famously, "Yeah, but is he sleeping?" Hagen went on to win the next day. Cotton's victory in 1948 was notable for the great show he made of parking his Rolls Royce in front of the clubhouse and changing clothes and taking all his meals in it. At that time, professionals were not allowed in the Muirfield clubhouse, a policy

that changed shortly thereafter. Player's victory in 1959 was his first major championship. A double bogey on the 72nd hole left him devastated, but contender after contender struggled and no one matched him. Less than six years later, Player became only the third golfer to win all four major championships.

Jack Nicklaus' 1966 British Open victory at Muirfield completed his Grand Slam at the age of twenty-six. In a year when Muirfield's rough was particularly brutal, Nicklaus devised a strategy that first and foremost kept the ball in play. In the words of Muirfield veterans, "He one-ironed her." So much did Nicklaus respect Muirfield and treasure his victory that he named his own masterpiece, constructed in his hometown of Columbus, Ohio, Muirfield Village. In 1972, Nicklaus was making his most serious bid ever to win all four major championships in one year when he was stopped at Muirfield by Lee Trevino, who chipped in for a par on the 71st hole to win by one. Starting the final day six strokes behind, Nicklaus had mounted a tremendous charge that put him six under par after eleven holes to take the lead. But he bogeyed the 188-yard 16th hole and failed to birdie the par-5 17th, finishing with 66.

Faldo won two British Opens at Muirfield, in 1987 and 1992, each time capping off a courageous last-day performance with a classic long-iron approach to the difficult 18th. "I was so nervous I could only hit from memory," remembers Faldo of his first victory. "In a split second it was all over— the ball was going straight at the flag. I wanted to shout, 'Look at that!' I was hot and cold all over at the same time." Producing such drama, and such champions, is what Muirfield does as well as any course in the world.

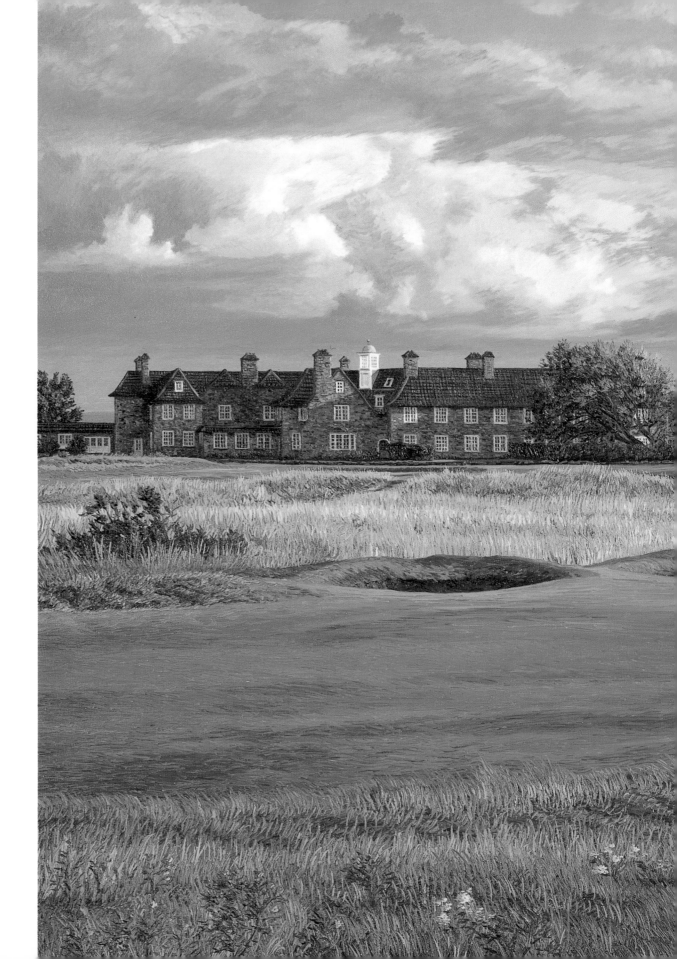

## MUIRFIELD
### THE 18TH HOLE, 447 YARDS, PAR 4

*Home of the Honourable Company of Edinburgh Golfers,*
*Muirfield was redesigned and dramatically improved in the*
*1920s by the famed architect Harry Colt.*

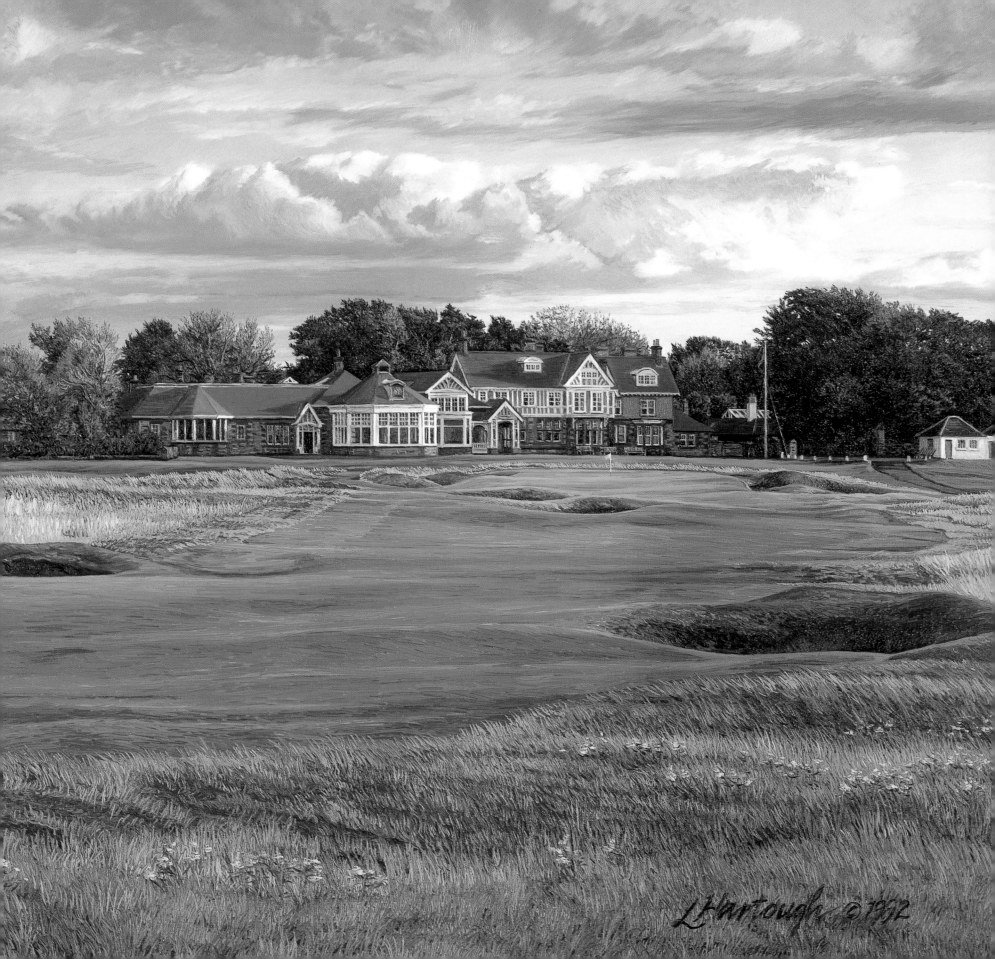

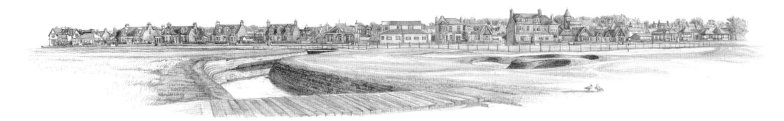

# CARNOUSTIE

As a purely rugged and relentless test, no other course on the British Open rota can compare with Carnoustie. Located on the northern shores of the Firth of Tay across the water from St. Andrews, Carnoustie is visually plain, with no mountains, beach or town to provide a backdrop. Its remoteness creates a foreboding sensation, one that is only intensified by the golf course itself. "Natural almost to the verge of roughness" was how Darwin described it. Its holes start off hard and never let up. Indeed, its last four holes—three long par 4s and a 235-yard par 3—are widely considered the most difficult finish in championship golf. Everything about Carnoustie tells the golfer there will be nothing easy about his day.

Although founded in 1842, Carnoustie was not the course we know today until it was reconfigured by former Open champion James Braid in 1926. With a wonderful circular routing, Carnoustie is a course for the accomplished player: not unnecessarily penal, but unforgiving of the careless shot. It's no coincidence that in the early part of the century, dozens of America's best pros—including Stuart Maiden, the famous mentor of Bobby Jones—came from Carnoustie. The Smith brothers of Carnoustie—Willie, Alex and MacDonald—won three US Opens among them.

Carnoustie has hosted some of the most memorable Opens ever played. Its first, in 1931, was won by Tommy Armour after Jose Jurado of Argentina finished double bogey, bogey on the closing two holes that are dominated by the serpentine Barry Burn. In 1937, England's Henry Cotton reached the pinnacle of his career, winning his second Claret Jug in a frightful rainstorm with a closing 71 that was the round of his life. Carnoustie became the stuff of legend in 1953 as the site of Ben Hogan's only appearance in the British Open. When Hogan won, he became the only player ever to take the Masters, US Open and British Open in the same year, a feat that ranks with Jones' 1930 Grand Slam in golf history.

"Some twelve thousand people lined the fairway deep and there was a great stillness as he came to the green," wrote Pat Ward-Thomas of Hogan's last hole at Carnoustie. After holing out, "…Hogan stood bowing impassively to all points of the crowd. There was no exultant waving of the putter, no signs of joy or relief, simply the gentle bows such as a great actor might make after a long and exhausting part. Hogan seemed quite alone, humble in the presence of his mighty achievement, and indeed at that moment he was alone, on that supreme peak of greatness where, in all the history of golf, only Bob Jones had stood before him."

The Open didn't return to Carnoustie until 1968, when Gary Player out-dueled Jack Nicklaus by mustering all the grit and ingenuity he was famous for. Early in the round, he got a break when Nicklaus hooked his drive out-of-bounds into the rifle range adjoining the par-5 6th hole, becoming so angry with himself that he kicked his golf bag hard enough to remove it from caddy Jimmy Dickinson's grasp. Leading by two on the par-5, 14th (called "Spectacles" for a pair of bunkers that loom in the fairway), Player hit a perfect 4-wood to two feet and eagled, then hung on to win by two as Nicklaus loosed his massive power over the last four holes. "I leave it to others to ponder on the nature and source of such a match-winning stroke," Player wrote in his autobiography. "To the onlooker it may have seemed an effortless demonstration of judgment and skill, but it required the pressure of that moment—that bleak awareness that nothing else but this precise shot would do—to trigger the act."

Tom Watson had a similar response to the crucible of pressure when

he won the Open at Carnoustie in 1975 to capture his first major championship and the first of his five Claret Jugs. On the 448-yard 18th, Watson hit a big drive and a short iron to twenty feet, holing it to get into a playoff with Jack Newton of Australia. In the playoff, Watson holed a short pitch on the 14th for an eagle. Tied with Newton on the final tee, Watson hit a good drive and 2-iron approach to win with a par. It was a performance that gave Watson, who had until that point been shaky in the fourth round of major championships, the confidence to begin an eight-year reign as the best player in the game.

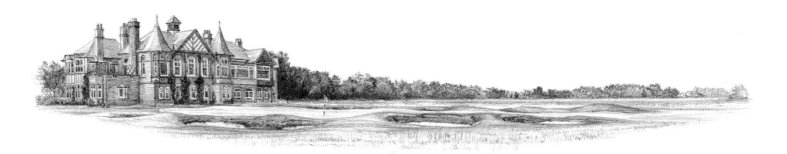

# ROYAL LYTHAM AND ST. ANNES

Lytham is a course with a look all its own. Unlike other seaside links, it is surrounded by a suburban setting of brick Victorian row houses, giving the layout a compressed, confined feel that suggests a short, sporty course. In fact, Lytham is a beast that requires all the firepower a tournament golfer can summon. Although its front nine, which is bordered by a busy railway, is a par 34 that can be quite easy when it plays downwind, Lytham's back nine is among the most difficult in championship golf. The 14th and 15th, two par 4s of 468 yards each, are among the toughest back-to-back holes found anywhere. The 17th is famed for the history it has produced in the Open Championship, and the 18th is the most demanding driving hole among the finishers on the British Open rotation.

For all its difficulty, Lytham has a endearing grace. The grounds around its brick and green-trimmed clubhouse are landscaped like a traditional English garden and suggest the perfect setting for an outdoor tea party. A large variety of flora grows on the course, making it one of the more colorful and intimate of the championship courses. (Ironically, the course is located only a few miles from the Blackpool promenade, one of Britain's tackier areas.)

Lytham's first Open was held in 1926 and was a rousing success. It marked the first time admission was charged at the championship, which led to a humorous incident before the final round. The leader, Bobby Jones, had gone to his hotel for lunch and returned without his player's badge. When the guard did not recognize him and refused to let him in, Jones simply got into the spectators' line and paid two pounds, six pence for a ticket. He went on to win by two strokes over Al Watrous, keyed by one of the greatest shots of his career. On the 17th, after pulling his drive badly into a sandy waste area, Jones chose a mashie (4-iron) from 175 yards and deftly picked the ball cleanly while disturbing only a puff of sand. "A teaspoonful more would have meant irretrievable ruin," wrote Darwin of the shot, which landed on the green and is commemorated with a plaque that marks the spot from where it was hit. After Jones finished, Walter Hagen, needing an eagle two to tie him and with typical panache, dramatically had his caddy tend the pin on the final hole as he hit his approach. The ball nearly pitched into the hole before going over the green.

The 1963 Open was notable for being one of the few major championships Jack Nicklaus ever blew. Leading by two with four to play, he

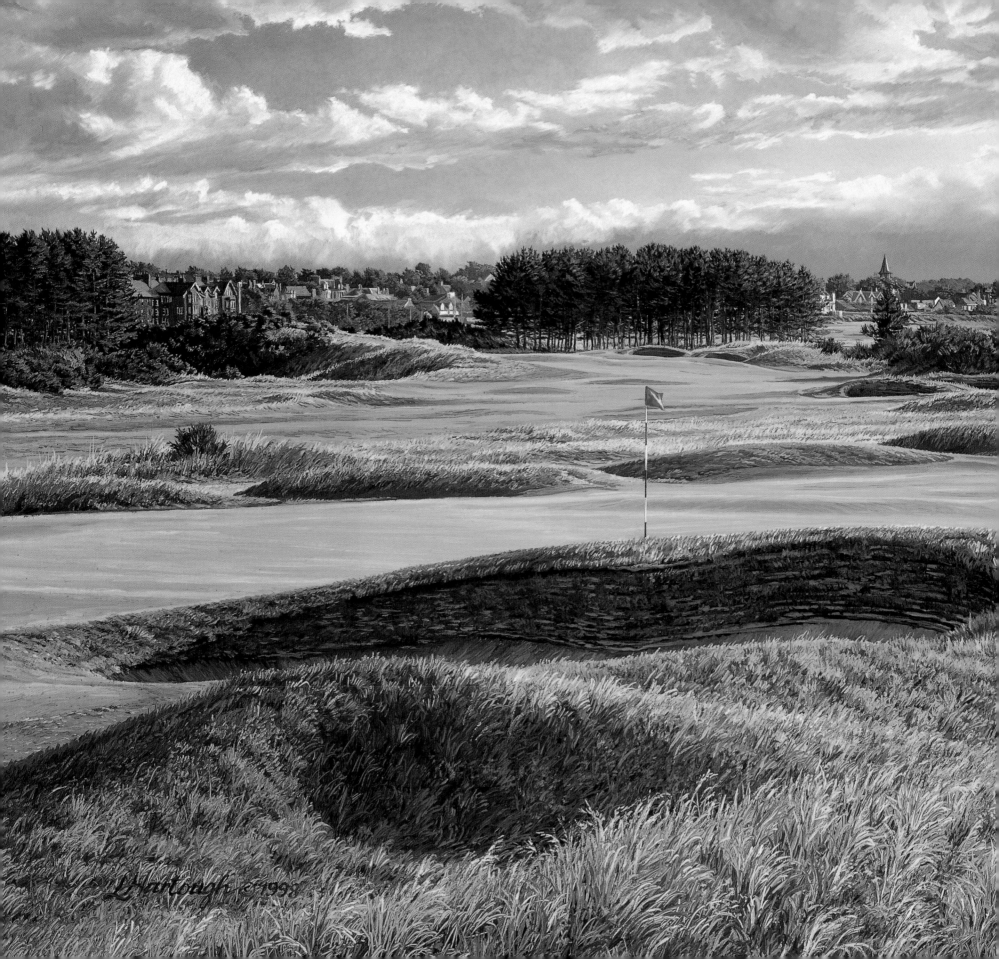

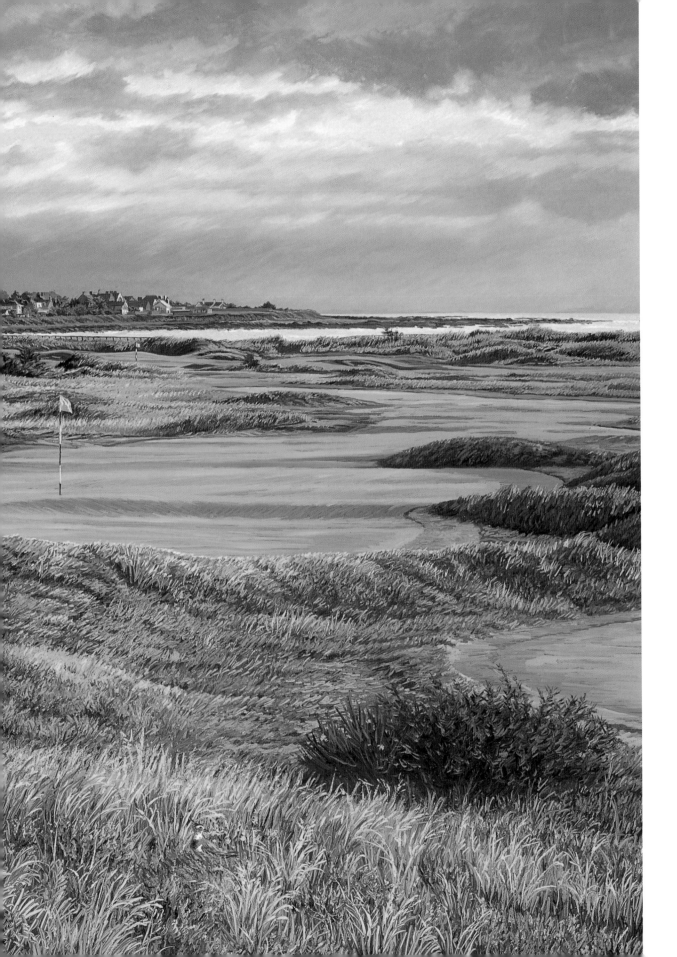

## CARNOUSTIE GOLF LINKS
## THE 14TH AND 4TH HOLES

*Carnoustie's circular routing places the first*
*nine essentially around the second. In*
*this place, the 4th and 14th drive toward each*
*other, ending in adjacent greens.*

135

ROYAL LYTHAM AND ST. ANNES
THE 18TH HOLE, 412 YARDS, PAR 4

*The charming brick clubhouse at the end of the 18th belies what is considered the most demanding driving hole among the finishers on the classic seaside links.*

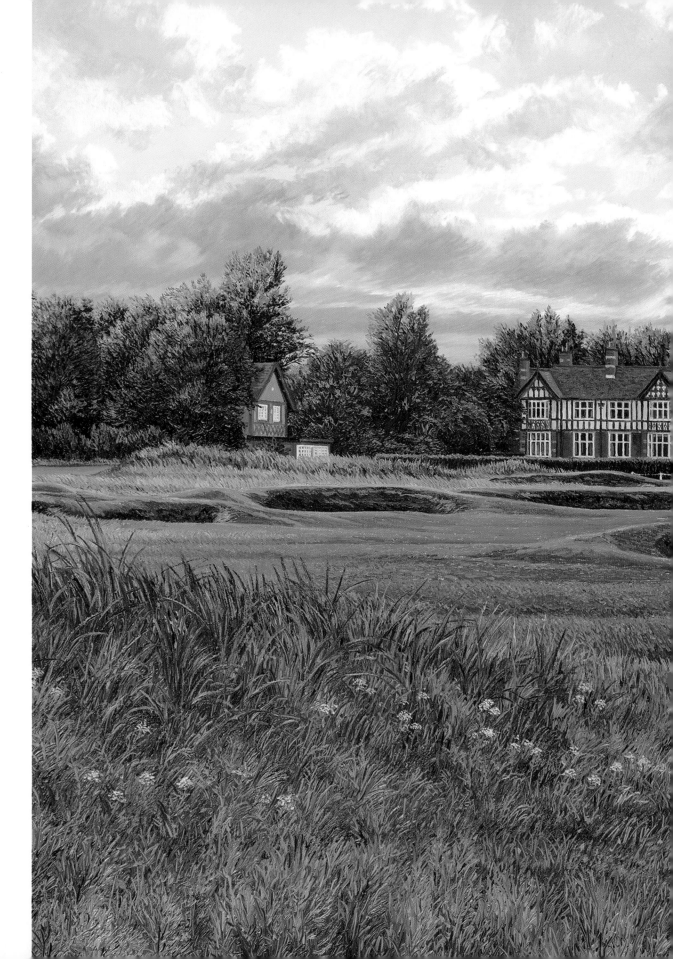

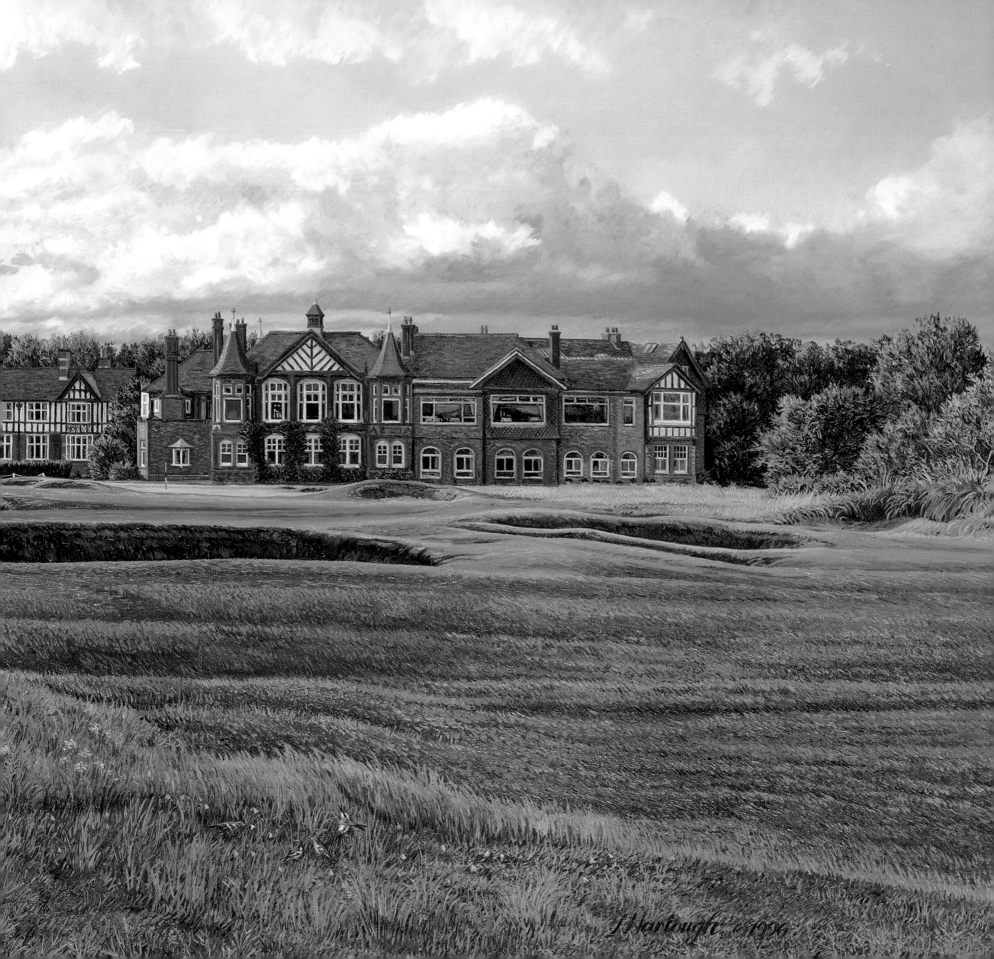

three-putted the 15th from fifteen feet. He then bogeyed the 17th when his 2-iron approach went through the green. On the 18th green, Nicklaus miscalculated the scores of his pursuers, Bob Charles and Phil Rodgers, and made a final, fatal error when he pulled his drive into a deep bunker and bogeyed. He finished one stroke out of a playoff, which Charles eventually won to become the first, and so far only, left-handed major champion.

In 1969, Tony Jacklin became the first British-born player in nineteen years to win the Open. Leading by one on the last tee, Jacklin overcame the pressure with a huge drive down the middle. Commenting on the BBC, Henry Longhurst was silent until the ball landed in the fairway, at which point he broke the tension by piping, "What a corker."

In 1974, Gary Player dominated despite some anxious moments on the final two holes. With a five-shot lead on the 17th, Player pulled his approach into deep rough and was on the verge of taking a lost ball penalty when a spectator found it with only seconds to go on his allowed five-minute search time. Then, on the 18th, his approach ran through the green and lodged against the side wall of the clubhouse. Rather than taking a penalty, Player chose to play the next shot left-handed and won in style.

Seve Ballesteros tempted even more disaster at Lytham in 1979 when, at twenty-two, he became the youngest winner of the championship. Much was made of the Spaniard's pushing his tee shot into a car park well right of the 16th fairway, from where he made a crucial, final-round birdie. But after he had won by three strokes over Jack Nicklaus and Ben Crenshaw, it was clear that Ballesteros had done it with an imaginative all-round game, much more than luck. In the four rounds of the championship, he was in fifteen greenside bunkers, and he holed out in two shots fourteen times. Ballesteros answered his doubters when he won again at Lytham in 1988, this time with a closing 65 that overtook Nick Price.

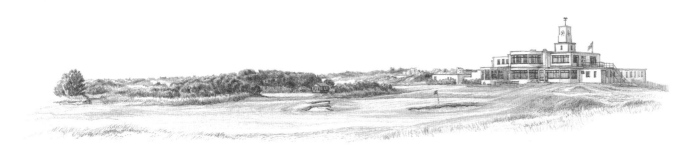

# ROYAL BIRKDALE

Royal Birkdale's location on England's Lancashire coast lies amid tumbling linksland as authentic and spectacular as any in the world. Its much-depicted par-3 12th hole, with its green mounted between dunes like a jewel in an exquisite setting, presents a quintessential classic links scene. The rolling, cresting nature of Birkdale's topography is underscored by the nautical motif of its white clubhouse, intentionally evocative of an ocean liner churning through a restless sea.

Still, there is something that traditionalists consider benign about Birkdale, which lies on the edges of Southport, a quiet resort on the Irish Sea.

Along with Muirfield, Birkdale is often considered the "fairest" of the courses on the British Open rota. Its holes are laid out in valleys between the tall sand hills, rather than astride them. The real challenge is to drive straight, for the willow scrub along the dunes that border the fairways is nearly unplayable. The fairways are mainly flat, which prevents the capricious bounce and uneven lies so common on other links. The dunes also block the wind, making the approaches to the somewhat protected greens less problematic. To some purists, Birkdale is too sterile a test, lacking the random punishment and unpredictability of a less refined links. Whether or not that is true, its layout

has produced some of the most exciting championships ever played, a fact that validates Birkdale as one of the world's great golf arenas.

The course's first Open champion was Australia's Peter Thomson, who won the first of his five Claret Jugs in Birkdale's 1954 debut on the rota. Thomson did it with the clean, efficient manner and uncanny sense for the roll of the ball that made him the ideal links player. After his rounds, the erudite Thomson would go to the press room and type a report on the tournament for Australian newspapers. Birkdale became a historic site in 1961 when Arnold Palmer made his second pilgrimage across the Atlantic and this time won the championship. In gale-force winds, Palmer powered his low drives under the tops of the dunes and drilled piercing iron shots that whistled through the wind. His charismatic manner captured the galleries, and the excitement of his victory inspired other Americans to come across "the pond." Palmer made the Open a true world championship again.

Birkdale has made plenty of history ever since. Beating a strong contingent of Americans in 1965 made Thomson's fifth Open championship his most satisfying. In 1971, Lee Trevino blew into Birkdale having just won the US Open and the Canadian Open. By the end of the week, he had his third

national Open in twenty-four days, an unprecedented feat. In 1976, Johnny Miller put the cap on four years of some of the best golf ever played with a dominating performance at Birkdale. His chief rival, the nineteen-year-old Seve Ballesteros, led until being undone by wild driving in the final round. Still, Ballesteros' ingenious pitch and run on the 72nd hole, which salvaged a second-place tie with Jack Nicklaus, announced him as a player who would make his mark. Tom Watson won his fifth Claret Jug in 1983, closing the door with a classic 2-iron approach to the final green. In 1991, Ian Baker Finch stormed home with 64-66, including a 29 on the outgoing nine of his final round, to take the championship. Finally, Mark O'Meara won a stirring Open in 1998, overcoming a fast finish by Tiger Woods and defeating Brian Watts in a four-hole playoff.

Regardless of how critics regard Birkdale's quality as a test of golf, the championships it hosts are always a success from a practical standpoint. In recognizing the game's evolution through the twentieth century, Birkdale is unsurpassed among the rota courses in the space and comfort it provides for roads, parking and spectator movement. And from the standpoint of producing pure golf theater, Birkdale is indisputably in the game's top echelon.

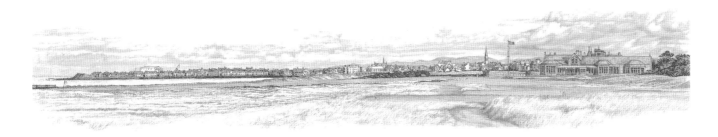

# ROYAL TROON

Of all the names for a golf course, Troon might be the best. At once simple and exotic, it succinctly suggests a magical place that is authentic, mysterious and rugged. As the scene of seven British Opens, Troon, spoken with an irresistible trill, resonates through golf history. Troon means "nose" in Gaelic, in reference to the protruding shape of the town's coastline. Yet some would

argue that it also refers to the snobbishness of the club's membership, which is among the most haughtily private in the British Isles.

Alas, Troon the golf course is not quite as good as its name. It's a solid course but not a brilliant one. Hard by the noise and congestion of Prestwick Airport, it lacks the beauty of Turnberry, the natural dunes of

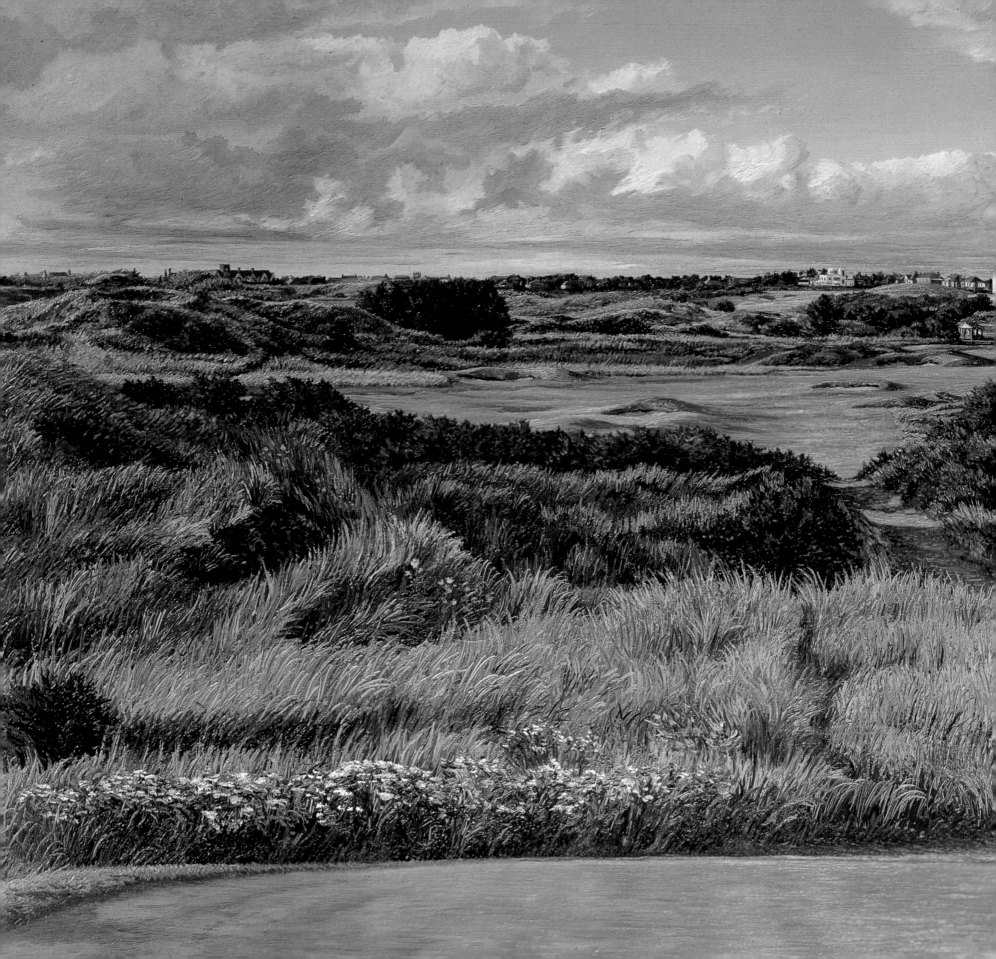

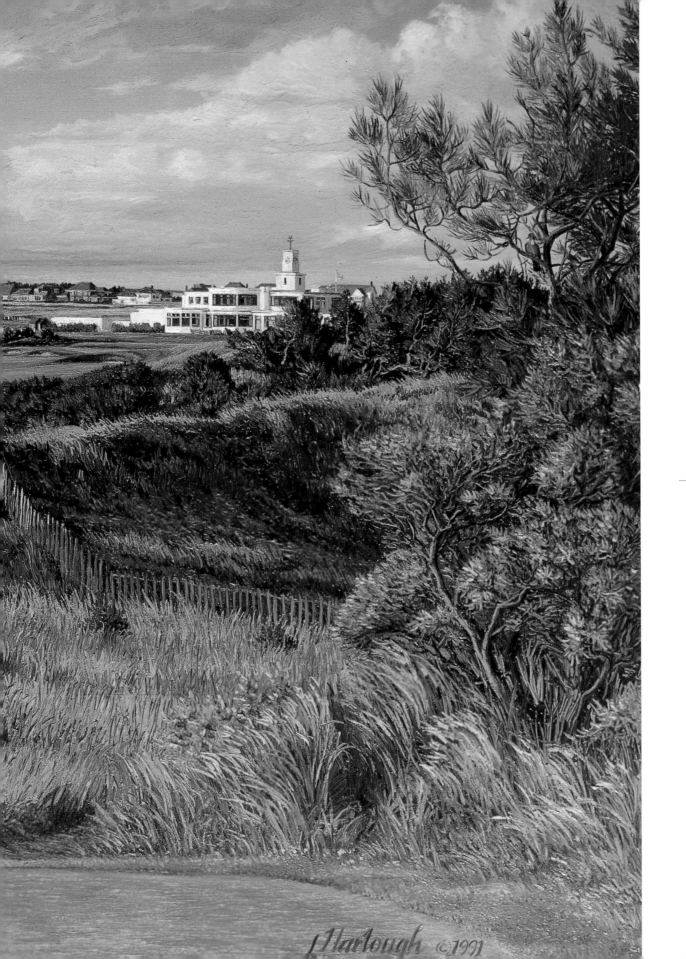

ROYAL BIRKDALE
THE 18TH HOLE, 473 YARDS, PAR 4

_The real challenge is to drive straight, for the willow scrub
along the dunes that border the fairways is nearly unplayable._

141

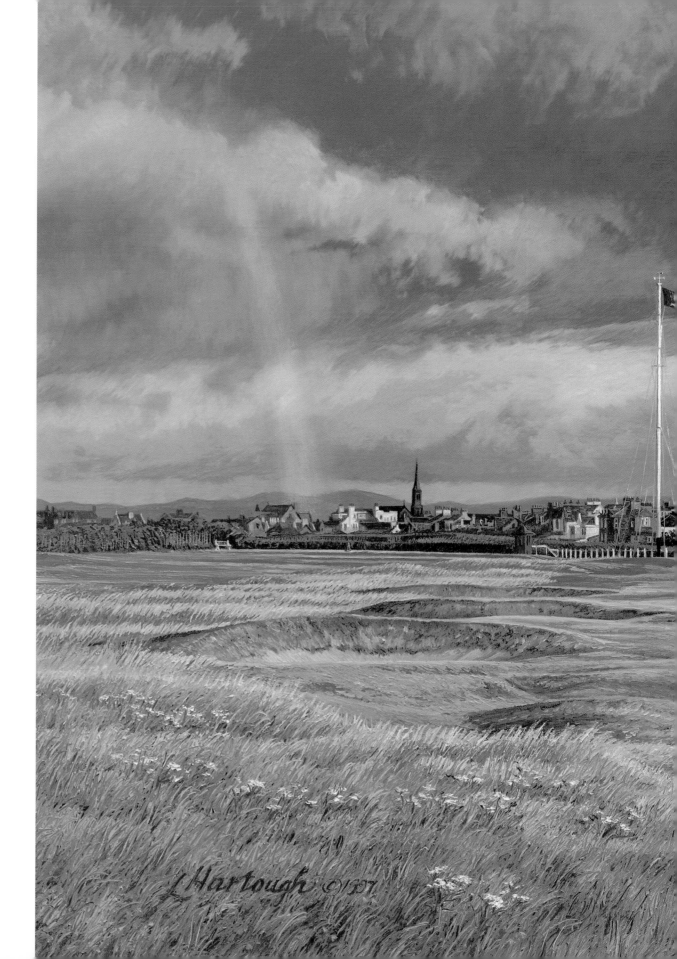

### ROYAL TROON
### THE 18TH HOLE, 452 YARDS, PAR 4

*The motto of the Royal Troon Golf Club, founded in 1878, is* Tam arte quam marte, *As much as by skill as by strength.*

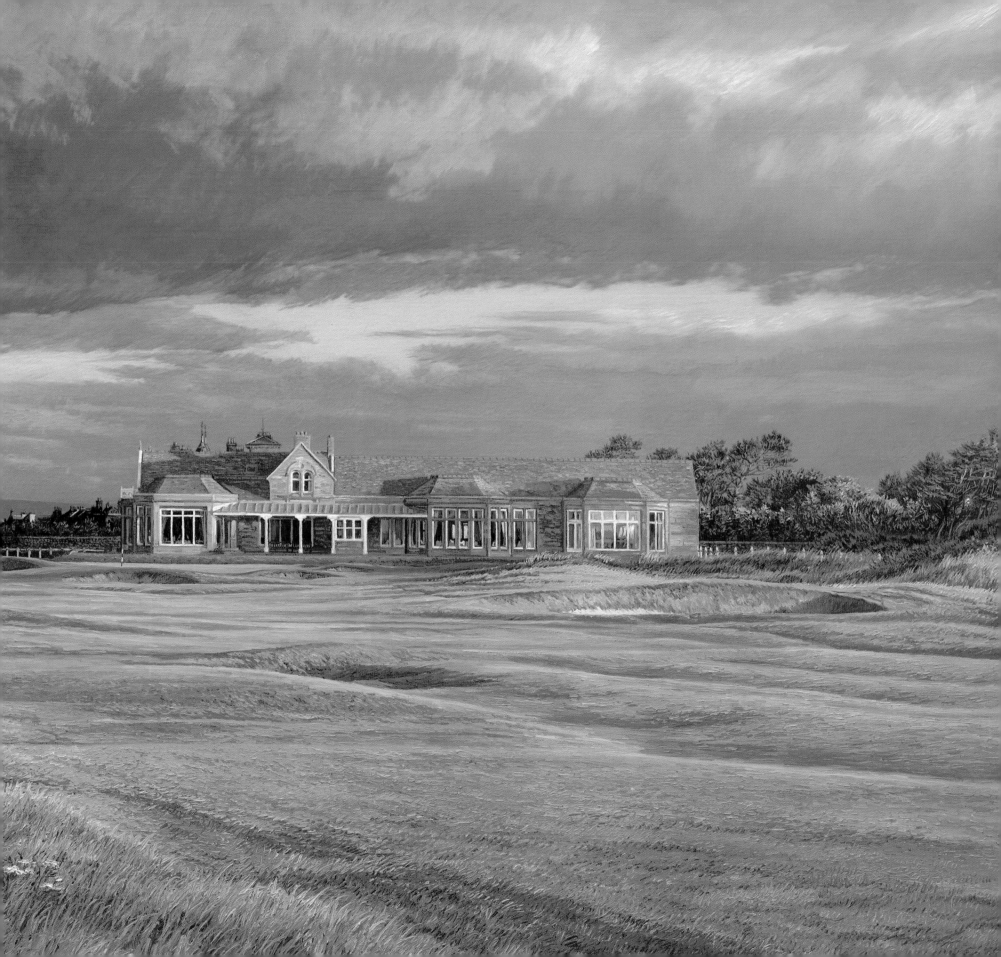

Birkdale, the soundness of Muirfield, the scale of St. George's, the difficulty of Carnoustie, the charm of Lytham and the timeless atmosphere of St. Andrews. Troon's most remarkable golf comes when the weather turns mean.

The outgoing nine, which tends to play downwind, can be easy, with some of the par 4s drivable, especially when Troon is bone-dry, as it is wont to be. The best hole is the par-3 8th, called "Postage Stamp," a miniaturist masterpiece of 126 yards that can be maddeningly difficult in high wind. In 1923, Walter Hagen double-bogeyed in the last round to lose by one. In the brilliant 64 Greg Norman shot in the final round of 1989, his only bogey came at the 8th, a stroke that loomed large when he lost a play-off to Mark Calcavecchia. That hole was also the site of one of the most nostalgic moments in British Open history in 1973 when the diminutive Gene Sarazen, then seventy-one years old, holed his 5-iron tee shot for an ace. The next day, wearing his trademark plus fours, the 1932 champion holed for a two from one of the five bunkers that surround the green.

When Troon turns for home, its incoming nine can be as difficult as any in the rota. Against the wind, the four consecutive, long par 4s beginning with the 10th can be all but unreachable in two shots. The most severe of the quartet is the 11th, called "Railway" because it is tightly bordered on the right by train tracks. From tee to green, the hole is a narrow alley along a bumpy fairway that routinely sends otherwise straight shots bounding into rough or, worse, the thorny, yellow-blooming whins. In 1962, Railway was a 485-yard par 5 that nonetheless gave the field fits, as evidenced by the 10 that Jack Nicklaus made in the last round. Arnold Palmer, however, basically won the championship at the 11th, playing it four under par by hitting a 1-iron off the tee and running up brilliant 2-iron approaches. Palmer shot 276 to win by six strokes, and pronounced it the best golf he ever played.

Troon's finish demands honest golf to win the championship, in accordance with the club motto, "as much by skill as by strength." In 1982, Nick Price was leading by three but gave away four shots on the final six holes to lose by one to Tom Watson. The 452-yard par-4 18th is a classic closer, similar in length and bunkering to the Home holes at Muirfield and Lytham. Calcavecchia birdied the hole with two perfect shots to get into the four-hole playoff with Norman. On the final hole of the playoff, Norman met disaster when he smashed a 320-yard drive only to see it roll into a pot bunker on the right side of the fairway, and lost to Calcavecchia's par. When Palmer won in 1962, the adoring crowd so engulfed him on his victorious march of the fairway that there were anxious moments until he popped out near the green, looking momentarily like he had gone through a heavy-spin cycle. Wrote Palmer in his autobiography, "I still get chills remembering that final walk through the crowds." It remains Troon's finest hour.

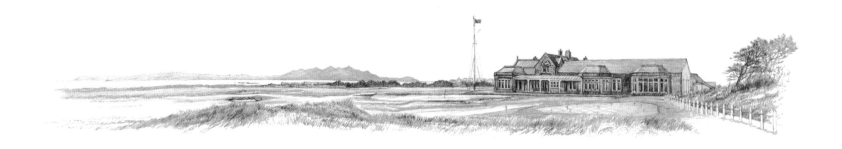

# ROYAL ST. GEORGE'S

According to reputation, no seaside links can be as bleak, desolate and haunting as St. George's. Part of the image is due to the gnarled links' penchant for huge sandhills, blind shots, unpredictable bounces, awkward lies and accompanying high scores, as well as its geographic remoteness from other Open venues. However, St. George's is also in the charming town of Sandwich, just off the Straits of Dover on England's picturesque southeast coast. From another point of view, that of the amateur golfer, it is an idyllic spot. "One great characteristic—I think it is a beauty—of Sandwich is the extraordinary solitude that surrounds the individual player," wrote Bernard Darwin. "We wind about in the dells and hollows among the great hills, alone in the midst of a multitude, and hardly ever realize that there are others playing on the links until we meet them at luncheon…the rest is sandhills and solitude."

Nevertheless, as a championship site, it had an onerous image. Jack Nicklaus, who never played well in three appearances at St. George's, indirectly rated the course his least favorite Open venue by saying, "The farther south you go, the less I like them."

Founded in 1887, St. George's in 1894 became the first course outside Scotland to hold the British Open, and that year, J.H. Taylor became the first Englishman to win the Claret Jug. St. George's became known for firsts in this regard, when Walter Hagen became the first American champion in 1922. That year, to show his disdain for the club's refusal to allow professionals in the clubhouse, he gave his entire purse, £150, to his caddy, Skip Daniels. Sandwich was conquered for two rounds by Henry Cotton in 1934, when he set a thirty-six-hole mark of 67-65 that stood for more than fifty years. Cotton built a ten-stroke lead after fifty-four holes, but during a delay between the morning and afternoon rounds on the final day, he sat alone in a small room. Notoriously high-strung and with a chronically bad stomach, the Englishman began to construct scenarios in which he could lose his lead and disastrously blow the championship. By the time play resumed, he was suffering from severe stomach cramps and unable to make a full swing. "I was all limp, and perspiration was cold on my forehead," he wrote. By the 13th hole, all but four of the shots were gone, but Cotton managed to hole a ten-foot putt and relaxed enough to finish with a 79 and a five-stroke victory.

In the 1993 championship at St. George's, Greg Norman reached his zenith as a professional, finishing with a 64 that was marred only by a missed fourteen-inch putt on the 17th hole, which reduced his winning margin to two. "In my whole career, I'd never gone round a golf course and not mis-hit a single shot," he said. "I hit every drive perfect, and every iron perfect." Norman's final score of 13 under par 267 is the seventy-two-hole British Open record, indicating that the gradual elimination of many of St. George's more rugged bunkers have made the course a more manageable test. There are still some frightening shots, like the fifty-foot-tall hummock that sits on the right edge of the fairway, two hundred yards off the tee at the brutal 468-yard, par-4 4th hole, but in general the course has become a test of skill more than attrition. Gradually, even for the professionals, St. George's is becoming regarded more and more as Darwin found it in the early part of the century: "As nearly my idea of heaven as is to be attained on an earthly links."

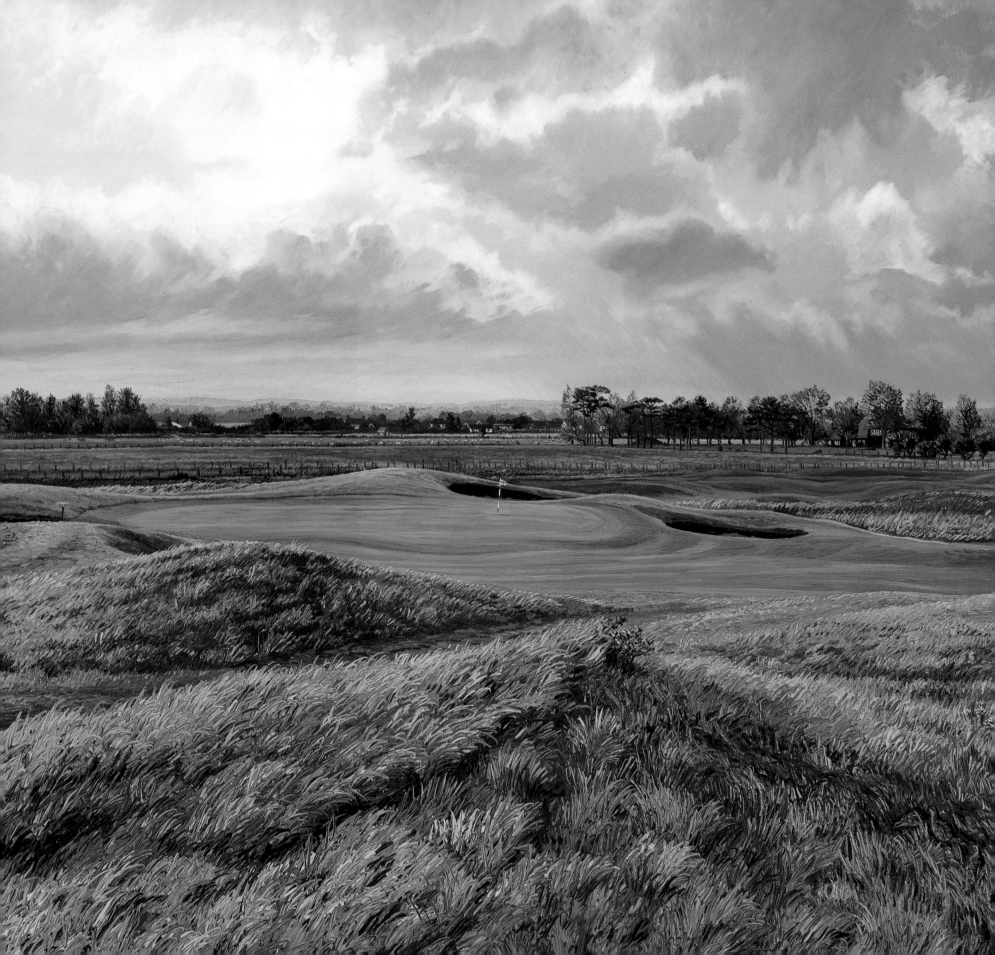

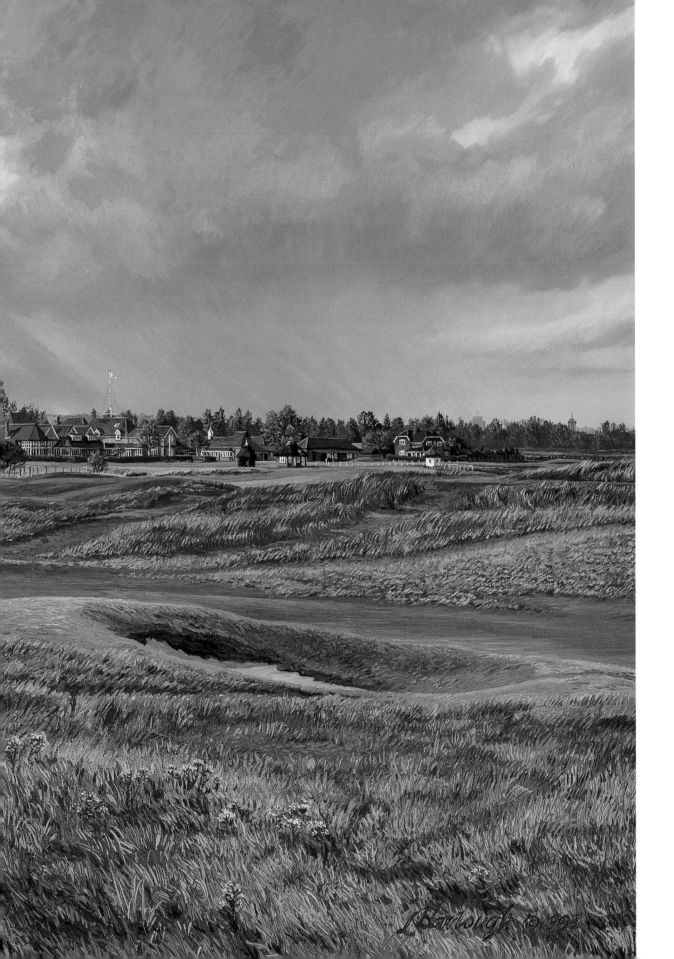

ROYAL ST. GEORGE'S
THE 17TH HOLE, 427 YARDS, PAR 4

_Founded in 1887, Royal St. George's hosted its first
British Open seven years later, and J.H. Taylor became
the first Englishman to win the Claret Jug._

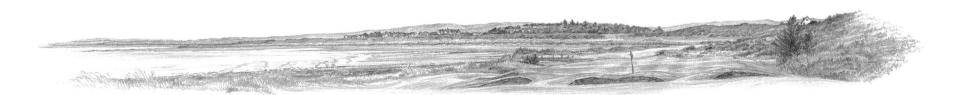

# ROYAL DORNOCH

Royal Dornoch is not part of the British Open rota, never has been and almost surely never will be. Because of the impracticality of its northern location in the Highlands of Scotland—it lies on the fifty-eighth parallel, the same latitude as Juneau, Alaska—the only real championship it has ever held was the 1985 British Amateur. But any examination of seaside links would be incomplete without honoring Dornoch. Simply put, Dornoch is the very definition of "the beautiful golf." Add up all its intangibles, all the subjective data that a golfer takes in when he plays a course, and Dornoch is perfect. The more you play it, the more you want to play it. And in the summer, when a day in the Highlands is filled with eighteen hours of sunlight, that is what golfers at Dornoch do, both natives and pilgrims: play thirty-six holes, and perhaps eighteen more after supper. No place on earth better provides the golfing version of Nirvana.

"Easily the finest course in the world—the absolute number one," wrote the late Peter Dobereiner. "I am not going to tell anyone about Royal Dornoch. I want to keep it to myself and come back every year until I die." According to Tom Doak, a course architect who has published a discerning and highly personal ranking of the world's best courses, Dornoch is one of only a handful of courses that rate a perfect 10, joining St. Andrews and Ballybunion as the only seaside links he so designates. Herbert Warren Wind, the venerated golf writer for *The New Yorker*, "discovered" Dornoch in 1964 and noted its "equipoise of charm and character." And Dornoch's most famous native son, Donald Ross, in his book, *Golf Has Never Failed Me*, devoted a short chapter to his home course which in its entirety reads: "Modesty forbids me saying more than it is the most beautifully situated links in the world, and that no American golfer should omit to go there,

where he will find the best golf, a royal welcome and no rabble."

Dornoch's setting is indeed superb, intimate, classic and all its own. The course flows from the center of a small, ancient town of about one thousand permanent residents in Sutherland County, the largest and least-populated of the former counties of Scotland. A cathedral is the most prominent landmark in town. (The Roman Catholic clergy is credited with bringing golf to Dornoch from St. Andrews.) Dornoch has a fine beach along Embo Bay on the Dornoch Firth, a view of Tarbat Ness lighthouse, excellent trout fishing in its streams and hill walking along the bluffs. The people of the Highlands are known for their expansive friendliness. The weather, though it can turn fierce, is generally more moderate than in other parts of Scotland.

The golf course is a vision of natural beauty. On a sunny day, Dornoch has a golden cast, with burnt yellow gorse accenting its slopes. More than at almost any seaside links, the water is visible and omnipresent, adding to the tranquillity of the scene. Although more and more golfers have discovered its delights, the course is rarely crowded or overrun. Walking the fairways of Dornoch gives the golfer the combination of excitement and serenity that is the magical mixture promised by the game at its best. Dornoch's holes are wonderfully staged along its simple yet ingenious routing. Although the course has an open look, each hole is clearly separate from the other and exists in its own defined arena. The walks from green to tee are invariably short, and there is no confusion about where to go next, just as there are no blind shots anywhere on the entire links. Dornoch points the way. The type of golf that Dornoch evokes is endearing, for it is manageable for the average player but endlessly challenging for the expert. The

fairways are generous, bordered by rough that is not severely penal. But there are few flat lies on the firm and tightly woven turf, and with the wind a constant, approaches must be finely wrought to get close to the pin.

Dornoch's greens are generally open in the front so that forced carries are not required. But they are also set on plateaus several feet above the fairway, so that any shot that is bounced in has to be truly struck or it will deflect left or right, usually into a deep bunker. The banks and falloffs make the short shots more interesting, and the standard pitch and run much more difficult to pull off successfully. Because the greens are fast, firm and undulating, one shot that Dornoch demands of the expert more than most seaside links is the controlled wedge pitch that is nipped cleanly off the turf, bores through the wind with heavy backspin and sits down promptly. It's one of the most aesthetically pleasing shots in the game, consistent with Dornoch's proclivity for rewarding the artful golfer. It is no accident that Joyce Wethered, often considered the greatest woman golfer ever, learned her golf during summers in Dornoch.

Dornoch remains remote. Other than private aircraft, there is really no easy way to get there. It is six hundred miles from London and a four-hour car trip from St. Andrews. But the game's most ardent aficionados seek it out. Tom Watson, Ben Crenshaw, Greg Norman and Pete Dye have all made pilgrimages to Dornoch and returned to sing its praises. "No other links has quite the ageless aura Dornoch does," says Dye. Records show that only St. Andrews (1552) and Leith (1593) are older links than Dornoch, where the first written record of golf is dated 1616. The links earned early distinction for its scenery and turf when Sir Robert Gordon wrote, in the seventeenth century, "About this town are the fairest and largest links of any pairt of Scotland, fitt for Archery, Goffing, Ryding and all other exercises; they doe surpasse the fields of Montrose and St. Andrews."

In 1885, Old Tom Morris was commissioned to lay out the course. What he did was well received and was refined by Ross during his days as the superintendent in the 1890s. Forever a Dornoch man, Ross grew up playing golf but had trained to be a carpenter. But when the town needed a pro to make clubs and give lessons, Ross went to St. Andrews to apprentice under Morris, and later continued his training at Carnoustie. He returned to work at Dornoch in 1893, doing every job on the course. Ross remembered going "out in overalls and get down on my hands and knees, and care for the turf and the bunkers and the greens. And how I used to hate it. But, as it turned out, that was the best training I could have had for what turned out to be my future." In 1898, Ross left to build courses in America, where raised greens with sharp falloffs would be his signature, particularly on his masterpiece, Pinehurst Number 2, in North Carolina. In 1904, John Sutherland, who served as the club's secretary for more than half a century, further remodeled Dornoch into the delightful test it remains today.

Dornoch opens pleasantly, with the first two holes, a 333-yard par 4 and a 180-yard par 3, relatively gentle and benign. But the course comes into its own on the par-4 3rd, climbing next to a gorse-covered bank, where it stays until the second shot to the 8th falls down toward the shore. From there, Dornoch gains momentum, the 9th through the 17th hugging the curve of shimmering sand along Embo Bay. That stretch of utterly untamed holes, with the beach on the left and hills offering a picturesque frame on the right, represents seaside golf at its very best.

The 14th, named "Foxy," is by consensus Dornoch's most interesting hole. A double-dogleg par 4 of 459 yards bordered by a hummock of dune on the right, it does not have a bunker, but the natural undulations give it endless variety. The raised green sits diagonally in a dell, making the approach especially tricky. Six-time British Open winner Harry Vardon called the 14th "the finest natural hole I've ever played." In fact, Dornoch is the finest natural course anyone has ever played. As a pure golf experience, it is at least the equal of any great course in the world.

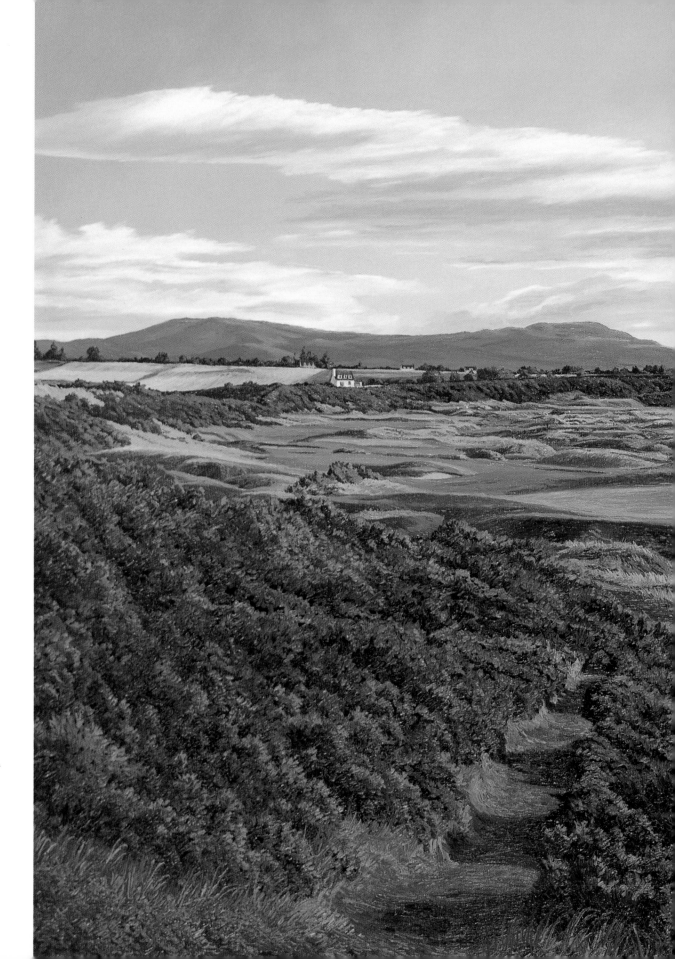

ROYAL DORNOCH
THE 17TH HOLE, 407 YARDS, PAR 4

*A long drive into the valley must be followed by the pitch
up to the plateau green for a par 4. In Old Tom Morris'
words, "There canna be better found for gowf."*

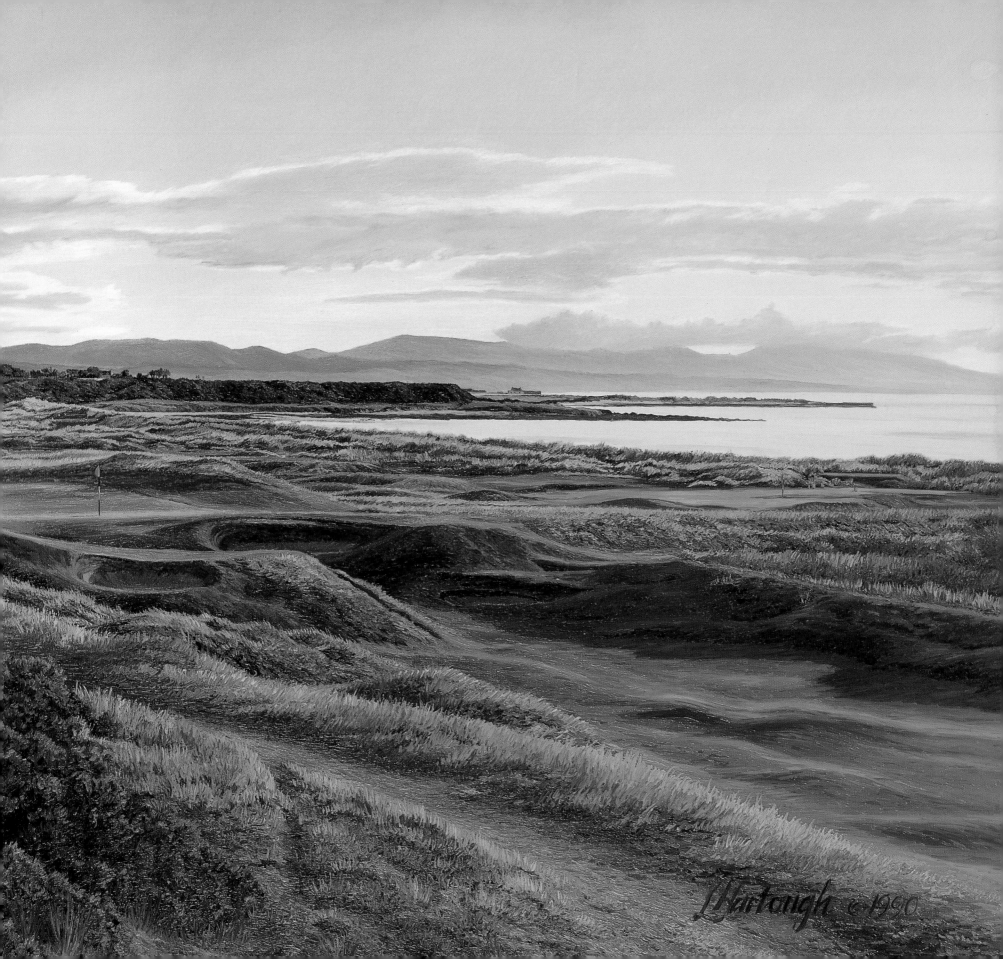

# SELECTED BIBLIOGRAPHY

*A Golf Story.* Charles Price. Atheneum, 1986.

*A Golfer's Life.* Arnold Palmer with James Dodson. Ballantine Books, 1999.

*Classic Golf Links of Great Britain and Ireland.* Donald Steel. Weidenfeld & Nicholson, 1996.

*Following Through.* Herbert Warren Wind. Ticknor & Fields, 1985.

*My Story.* Jack Nicklaus with Ken Bowden. Simon & Schuster, 1997.

*Sports Illustrated's The Best 18 Golf Holes In America.* Dan Jenkins. Time Inc., 1966.

*The Architects of Golf.* Geoffrey S. Cornish and Ronald E. Whitten. HarperCollins, 1993.

*The Confidential Guide to Golf Courses.* Tom Doak. Sleeping Bear Press, 1996.

*The Golf Courses of the British Isles.* Bernard Darwin. The Classics of Golf, 1988.

*The Greatest of Them All: The Legend of Bobby Jones.* Martin Davis. The American Golfer, 1996

*The Official U.S. Open Almanac.* Salvatore Johnson. Taylor Publishing, 1995.

*The U.S. Open: Golf's Ultimate Challenge.* Robert Sommers. Oxford University Press, 1996.

*The World Atlas of Golf.* Pat Ward-Thomas, contributing editor. Mitchell Beazley Publishers, 1986.

# LIST OF PAINTINGS

AUGUSTA NATIONAL
THE 13TH HOLE, "AZALEA"
465 YARDS, PAR 5

*This view of the famous 13th hole is from the spectator's
stands – a favorite spot during the Masters.*

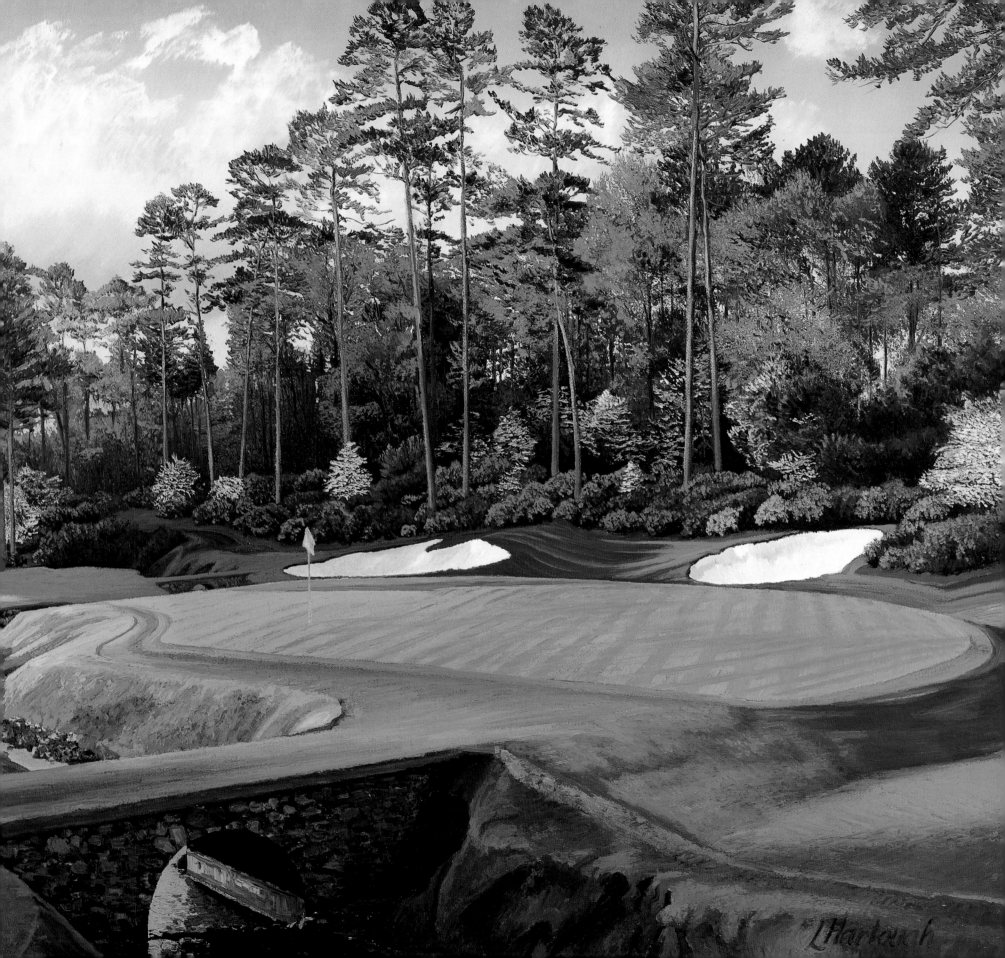